New Tax Guide

for Writers, Artists, Performers, & Other Creative People

2010 Edition
with 2009 Tax Year Forms

New Tax Guide

for Writers, Artists, Performers, & Other Creative People

2010 Edition

with 2009 Tax Year Forms

Peter Jason Riley, CPA

Contents

Introduction

I must thank you for reading this book and tell you how I came to write it. This volume is a revised follow up to the esteemed *"New Tax Guide for Performers, Writers, Directors, Designers and Other Show Biz Folk"* written by R. Brendan Hanlon. I originally discovered Mr. Hanlon's book quite by accident while browsing in the Bleecker Street Bookstore many years ago during a trip to New York City. As an amateur guitar player and CPA I had a strong interest in all the arts and wondered why there seemed to be no books that addressed specifically the unique tax situations that folks in the arts encounter. I remember I was very excited when I saw the book and rushed to tell my wife that this was the book I had long been looking for. I purchased Mr. Hanlon's subsequent revisions, and as a testament to the book's value I would often have clients bring the book into their appointment with me. I periodically thought of contacting Mr. Hanlon but sadly never did. When I heard about Mr. Hanlon's death several years ago my first thought was that I hoped his valuable book did not pass away with him. I contacted Proscenium Publishers and offered to pick up authorship of the book. Although the book you hold is entirely rewritten I would like it to serve the same purpose of being an easy to read guide for the arts practitioner to help you understand your tax situation and thereby make the tax preparation process less onerous and most importantly SAVE TAX DOLLARS!

While this book is not primarily intended to be a "how to prepare your income tax return" book (for this I recommend *J.K Lasser's™ Your Income Tax*), I have added in this revised 2nd edition sample tax returns that will help the reader better understand what the finished product might look like. I still feel strongly that the actual preparation of income tax returns for folks in the arts is best left to professionals because of the inherent complications. I think that good tax preparers and advisors should be able to save you more money than they charge by helping you with tax planning. Consequently, I am not necessarily going to attempt to give the reader line-by-line or form-by-form instructions–something guaranteed to put you to sleep! My goal is to give you an overall understanding of the unique aspects of taxation of people in the arts. By reading this book and using my deduction checklists found on www.artstaxinfo.com I want you to do a better job at collecting the

data through the year and be better prepared to present your tax information to your income tax advisor. I will use a lot of real life examples to illustrate the many situations an artist may encounter. By understanding your specific situation you will be better prepared to choose an appropriate income tax advisor. Keep in mind that no matter how good your tax advisor is, YOU are the one who has to develop a basic understanding of your taxable income and what is deductible, so that you are saving the proper receipts and documentation for your tax return.

I am going to focus mainly on your professional income and deductions and will not really discuss other income you may have, such as interest, dividends, capital gains, pensions, rents, and other deductions, such as mortgage interest or charitable contributions.

The website for the book – **www.artstaxinfo.com** will always be updated with the latest information, including tax tips, a glossary, FAQs as well as our "TaxQuik Guide" that will always give you the latest information on tax rates, mileage deductions, exemptions, deadlines and tax law changes.

Our cast of characters throughout the book will be four artist friends whose professional lives will illustrate what the heck we are talking about:

1. **Ima Starr**–Actor, model and writer. Ima (our only holdover from Mr. Hanlon's book) is very busy as both actor and model. She is also a part-time singer and has even written a book. She is a member of Actors' Equity Association and the Screen Actors Guild (SAG).

2. **Sonny Phunky**–Musician. Sonny is a freelance bass player, songwriter and does some teaching on the side. He works both as an employee, a contract player and is a member of an LLC.

3. **Liz Brushstroke**–Artist and College Professor. Liz is a tenured college professor but she also has an active life as an independent visual artist and is represented by a gallery in New York City and Dublin.

4. **Guy Focal**–Writer. Guy has a full-time magazine staff writer job but also has earnings writing freelance book reviews and articles for other publications, and he has published children's books.

In each of the chapters that focus primarily on our above characters (Chapters 3 thru 6) we will feature completed tax returns. Annually you will be able to visit our website www.artstaxinfo.com and download updated returns to accompany the illustrations. As you read the chapters centered on

each of the above characters you will be able to follow along by reviewing a finished 1040 tax return.

Now the main thing that most folks worry about when they prepare their income taxes is the dreaded audit! Luckily, because of the Freedom of Information Act the Internal Revenue Service (IRS) is required to actually publish its internal audit guidelines. These Market Segment Specialization Program (MSSP) guides give us direct insight into what the IRS agent would be looking for in an audit (the actual MSSP guides are available for download on our website www.artstaxinfo.com). We will be discussing audits in chapter 7.

Finally, I intend the book to be approached in the following fashion: The book begins with two primary chapters everybody should read:

1. Income

2. What Can I Deduct?

Next choose the chapter that best describes your primary activity:

3. For Actors, Directors, Dancers and Other Performers

4. For Musicians and Singers

5. For Visual Artists

6. For Writers

Finally, you will all read the last five chapters:

7. Setting up a Business Entity

8. The Audit Process, Recordkeeping and Your Taxpayer Rights

9. Choosing a Tax Advisor

10. Tax Planning

11. In Closing

Remember to visit and bookmark www.artstaxinfo.com to keep up with the latest information.

Disclaimer

Information

The information provided in this book is only intended to be general summary of information to the reader. It is not intended to take the place of either the written law or regulations. Tax law changes frequently and tax strategies must be individually designed for specific persons or companies.

Before using any of the information supplied in this book, please consult your professional tax advisor.

Listings of External Web Sites

Web sites other than Peter Jason Riley C.P.A., Riley & Associates PC & www.artstaxinfo.com web sites are listed for the convenience of the reader. Such use does not constitute an official endorsement or approval by Peter Jason Riley C.P.A. or Riley & Associates of any web site, product, or service.

IRS Circular 230 Disclosure

To ensure compliance with requirements imposed by the IRS, Peter Jason Riley C.P.A. and Riley & Associates, PC informs you that any U.S. federal tax advice contained within this book is not intended or written to be used, and cannot be used, for the purpose of (i) avoiding penalties under the Internal Revenue Code or (ii) promoting, marketing or recommending to another party any transaction or matter addressed herein.

Dedication

Thanks to,

- ✓ My lovely wife and extraordinary visual artist Ruth Riley who puts up with my endless discussions and ruminations on taxes and who patiently proofreads my work
- ✓ My brother Mark T. Riley for editing and proofreading early versions of this book and offering suggestions
- ✓ To Thomas F. Ryan, editor and chief of the (sadly missed) journal "The Undertoad" for offering me a regular outlet for my writing years ago. Without you Tom, this book would never have happened!
- ✓ My Bro' Rick Coleman who opened up my eyes to the deep joys of the great R&B music of New Orleans and the great Fats Domino
- ✓ My first employers when I entered the accounting profession many years ago, Peter Mandragouras, CPA and Jim Powers, CPA. They forever showed me that caring about the client is the very heart of our business
- ✓ To "Dr. Ike" Padnos who honors me by allowing me to be a part of the AMAZING Ponderosa Stomp festival in New Orleans and the Ponderosa Stomp Foundation

1.

Income

I will address the types of income a person involved in the arts might earn and introduce the most important point in the book: the difference between employment income and self-employment/contract income. In these days of multidisciplinary artists, it is common for folks to have income and expenses from both employment and self-employment. According to this differentiation, income and expenses will appear in different places on the income tax return. But first things first: *What is income?*

In essence, income is practically everything of value you receive in exchange for your products or services as a performer, visual artist or writer (hereafter referred to as "artist"). You can be "paid" in cash, services, or property; you can even have barter income. Taxable income may or may not be reported on a tax form such as a 1099-MISC, W-2 or K-1 at year-end. Most of you will be familiar with the first two tax forms, but perhaps not with the K-1. The form K-1 is a means of transferring income from a partnership to a partner, an LLC to a member, or an S type corporation to the stockholder. In other words, if the artist is a member of an LLC, then he or she will get a K-1 that will show their share of income from the business and this amount will be reported as income on their personal income tax return.

As well as the obvious form of cash payments for services directly performed or artwork delivered, your income may come in the form of "free" merchandise that a company gives you in exchange for a product endorsement. Actors often receive free or discounted products in exchange for the use of their name in advertisements. Musicians receive free merchandise for endorsing a particular instrument, brand of strings or other supplies. The types of activities and/or products for which an artist may receive income include:

✓ Book publishing
✓ Recording
✓ Acting

✓ Product endorsements (including samples of the products endorsed)

- ✓ Personal appearances
- ✓ Sales of artwork
- ✓ Performance art
- ✓ Modeling
- ✓ Voice-overs
- ✓ Touring
- ✓ Dance performances
- ✓ Choreography
- ✓ Lecturing
- ✓ Teaching
- ✓ Master classes
- ✓ Instructional videos
- ✓ Commissions
- ✓ Studio and art work rentals
- ✓ Stipends
- ✓ Website design fees
- ✓ Publication of articles
- ✓ Sales or rental of photographs
- ✓ Sales of CDs
- ✓ Sales of videos
- ✓ Directing
- ✓ Consulting
- ✓ Television and radio appearances

While not exhaustive, the list gives a sense of the many activities that produce taxable income for the artist. These types of professional income will be added to your other income, whether *unearned income* (such as interest, dividends, capital gains, rental income, alimony, prizes, unemployment income) or other *earned income* that is unrelated to your professional life (for instance, the musician who moonlights as a music store clerk or the actor who works as a waiter). These types of *unearned income* and unrelated *earned income* are handled on your income tax return in exactly the same fashion as they would be on anybody else's income tax return. It is with your professional income that things diverge.

What Type of Income Is It, and Why? ~ Employee Wages vs. Contract Income

It is important to understand the difference between being paid as an employee who receives a form W-2, and receiving income for self-employment or as a contractor, which is typically reported on a form 1099-MISC (this is sometimes referred to as "freelance" income). When you are paid as an employee on a W-2, the employer withholds federal, state and local (if applicable) income tax, as well as the FICA taxes, Social Security and Medicare. If you are hired and paid as a contract worker, you will receive a form 1099-MISC at year-end and generally no taxes will have been withheld.

Understanding this distinction is critical because it determines how and where your income will be reported and where your professional expenses will be deducted. It is significant because if you have a substantial amount of contract income, you can end up the year with a large amount of income for which no taxes have been paid (withheld)—yet!

So who and what decide how your income is going to be treated? Generally the payer/employer will decide whether you are a contractor or employee. He or she will use the IRS rules cited below to arrive at the handling of your situation. In many cases the decision is fairly obvious. The key to whether someone is an employee or a contractor rests largely on how much independence the worker has or, conversely, how much control the person hiring the artist has over how the artist performs his or her duties (state rules can vary in the treatment and definition of contractors vs. employees). IRS publication 15-A discusses the three-part test that establishes the distinction between an employee and an independent contractor:

> In any employee-independent contractor determination, all information that provides evidence of the degree of control and the degree of independence must be considered.
>
> Facts that provide evidence of the degree of control and independence fall into three categories: behavioral control, financial control, and the type of relationship of the parties as shown below.
>
> 1. **Behavioral control.** Facts that show whether the business has a right to direct and control how the worker does the task for which the worker is hired include the type and degree of instructions the business gives the worker. An employee is generally subject to the business' instructions about when, where, and how to work. All of the following are examples of types of instructions about how to do work:
> - When and where to do the work
> - What tools or equipment to use
> - What workers to hire or to assist with the work
> - Where to purchase supplies and services
> - What work must be performed by a specified individual
> - What order or sequence to follow
>
> The amount of instruction needed varies among different jobs. Even if no instructions are given, sufficient behavioral control may exist if the employer has the right to control how the work results are achieved. A business may lack the knowledge to instruct some highly specialized professionals; in other cases, the task may require little or no instruction. The key consideration is

whether the business has retained the right to control the details of a worker's performance or instead has given up that right.

- Training the business gives the worker. An employee may be trained to perform services in a particular manner. Independent contractors ordinarily use their own methods.

2. **Financial control.** Facts that show whether the business has a right to control the business aspects of the worker's job include:

- The extent to which the worker has unreimbursed business expenses. Independent contractors are more likely to have unreimbursed expenses than are employees. Fixed ongoing costs that are incurred regardless of whether work is currently being performed are especially important. However, employees may also incur unreimbursed expenses in connection with the services they perform for their business.

- The extent of the worker's investment. An independent contractor often has a significant investment in the facilities he or she uses in performing services for someone else. However, a significant investment is not necessary for independent contractor status.

- The extent to which the worker makes services available to the relevant market. An independent contractor is generally free to seek out business opportunities. Independent contractors often advertise, maintain a visible business location, and are available to work in the relevant market.

- How the business pays the worker. An employee is generally guaranteed a regular wage amount for an hourly, weekly, or other period of time. This usually indicates that a worker is an employee, even when the wage or salary is supplemented by a commission. An independent contractor is usually paid by a flat fee for the job. However, it is common in some professions, such as law, to pay independent contractors hourly.

- The extent to which the worker can realize a profit or loss. An independent contractor can make a profit or loss.

3. **Type of relationship.** Facts that show the parties' type of relationship include:

- Written contracts describing the relationship the parties intended to create.

- Whether the business provides the worker with employee-type benefits, such as insurance, a pension plan, vacation pay, or sick pay.

- The permanency of the relationship. If you engage a worker with the expectation that the relationship will continue indefinitely, rather than for a specific project or period, this is

generally considered evidence that your intent was to create an employer-employee relationship.

- The extent to which services performed by the worker are a key aspect of the regular business of the company. If a worker provides services that are a key aspect of your regular business activity, it is more likely that you will have the right to direct and control his or her activities. For example, if a law firm hires an attorney, it is likely that it will present the attorney's work as its own and would have the right to control or direct that work. This would indicate an employer-employee relationship.

So let's look at some examples of how these IRS rules might play out in your life.

Example One: Actor Ima Starr recently appeared in a production of *Godspell* at the Goodwrench Theatre in Philadelphia where she was obviously under the direct control of the production company and the theatre. She also did some modeling and a product endorsement for which she received contractor income. At year-end she will receive a W-2 for her work at the Goodwrench Theatre, but for her modeling work may receive either a W-2 or a 1099-MISC form depending on how the agency treats the situation.

Example Two: Our good friend musician Sonny Phunky signed to do a national tour playing with a famous rock band. He was considered to be an employee and received a W-2 from the band's production company at year-end. In the same year he gave private lessons, did some occasional studio work, played club dates, touring and did other things that were considered contractor income. Sonny will not necessarily receive 1099's for all this income; for example, his students would not issue him a 1099.

Example Three: Next is our painter, Liz Brushstroke. Liz is a tenured professor of art at a local college for whom she is an employee. Liz sells her independently produced artwork through a prominent New York City and Dublin art gallery. Sales of her artwork generate self-employment income for Liz, as she is clearly not under the control of the gallery owner in any way. At year-end she will receive her W-2 from the college. She will probably not receive any tax form from the gallery, as her income was derived from the sale of tangible property.

Example Four: Finally we will visit our writer friend Guy Focal. In his regular job, Guy is a staff writer for *Swamp Life Living*, a Louisiana magazine that celebrates living life on the swamp. As a staff writer, Guy reports daily to the magazine offices in New Orleans, he uses equipment owned by the

magazine, is not reimbursed by the magazine for his expenses, and is given assignments and deadlines for articles and features to write. This is clearly an employment situation. In his spare time Guy writes and publishes children's books and does freelance book reviews and articles for other publications. Any royalties from his children's book sales will be self-employment income, as will income from his freelance writing (though it could be employment income). Both of these activities are clearly independently produced. At the end of the year Guy will receive a W-2 from Swamp Life Magazine Inc., a 1099-MISC from the publisher (or agent) of his children's books for his royalties income, and 1099-MISC forms from the various magazines that published his reviews and articles.

Why are we spending so much time on this esoteric IRS stuff, and how does this relate to your activities as an artist? In a single year, an artist will often have both employment (W-2) AND contractor/freelance (1099-MISC) income. As we will soon see, the type of income you receive will guide how and where the income is reported on your income tax return and, most importantly, how and where the expenses are deducted.

The Mysteries of the W-2 Revealed

W-2s are sometimes issued on the completion of a particular job, but are supposed to be received no later than January 31 of the following year. Keep in mind that it is up to you to let your various employers know your correct address. I recommend that artists keep a diary of their employers during the year, as the number of W-2s due can add up and it is easy to forget one. Start a checklist at the beginning of the year (why not use the one found in the appendix of this very volume or download the one from the website, www.artstaxinfo.com?) so you can use it as a guide at year-end. As you do this, be sure to retain copies of all pay stubs. Note not only the name of the employer, but also the name of the payroll company, since the W-2 may be issued in the payroll company's name. You may also receive unexpected W-2s for residual work in prior years (an issue for actors and musicians). I advise clients who move often to obtain a central, stable mailing address for W-2s and other tax forms, such as a manager's, business agent's or accountant's address. Some artists use a family address or a post office or private mailbox that can be instructed to forward mail to their current address.

The following is a key to the twenty-one boxes found on the 2008 W-2 form:

Box 1	Federal taxable wages and tips—This is where federal taxable wages are reported; other taxable fringe benefits may be reported here.
Box 2	Federal income tax withheld—This is the amount of federal income taxes withheld from your income.
Boxes 3, 4 & 7	Social Security wages and withholdings—Social Security taxes are withheld at a rate of 6.2%, capped at the first $106,800 in 2009 (adjusted annually, *see* www.ssa.gov).
Boxes 5 & 6	Medicare wages and tax withholdings—Medicare taxes are withheld at a rate of 1.45% with no cap.
Box 8	Allocated tips—If you worked in a restaurant with at least 10 employees, your employer will report your share of 8% of gross receipts unless you reported tips at least equal to that share.
Box 9	Advance earned income payments—If you filed form W-5 asking for part of the credit to be added to your wages, it will be included here.
Box 10	Dependent care benefits—Advances from your employer for dependent care benefits under a qualifying plan.
Box 11	Nonqualified plan distributions—Distributions for nonqualified deferred compensation plans.
Box 12 (A-D)	Catch-all box for such things as retirement plans, life insurance, moving expenses, travel allowance reimbursements, etc. Coding printed on back of your W-2 indicates exactly what the items in this box pertain to.
Box 13	Checkboxes to inform the IRS of pension plan availability and other information.
Box 14	Miscellaneous payments—Where employers can choose to put other items they wish to report to the employee.
Boxes 15-20	State and local tax information-These boxes will show your state and local taxable income as well as state and local taxes withheld (if applicable).

The taxable income amounts totaled from all your W-2s in the year will be reported on line 7 of your 1040.

a Control number			OMB No. 1545-0008	Safe, accurate, FAST! Use	IRS *efile*	Visit the IRS Web Site at www.irs.gov.

b Employer identification number	1 Wages, tips, other compensation	2 Federal income tax withheld
22-1500020	4,905.00	779.00

c Employer's name, address, and ZIP code	3 Social security wages	4 Social security tax withheld
Goodwrench Dinner Theatre, Inc.	4,905.00	304.11
P.O. Box 157	5 Medicare wages and tips	6 Medicare tax withheld
Philadelphia, PA 19999	4,905.00	77.12
	7 Social security tips	8 Allocated tips

d Employee's social security number	9 Advance EIC payment	10 Dependent care benefits
111-22-3333		

e Employee's first name and initial Last name	11 Nonqualified plans	12a See instructions for box 12 Code
Ima Starr		
	13 Statutory employee Retirement plan Third-party sick pay X	12b Code
5th Avenue	14 Other	12c Code
New York, NY 10019		12d Code

f Employee's address and ZIP code						
15 State Employer's state ID number	16 State wages, tips, etc.	17 State income tax	18 Local wages, tips, etc.	19 Local income tax	20 Locality name	
PA 22-1500020	4,905.00	81.90	4,905.00	168.96	PHILA	

Form **W-2** Wage and Tax Statement

Copy B To Be Filed with Employee's FEDERAL Tax Return.
This information is being furnished to the Internal Revenue Service.

Department of the Treasury — Internal Revenue Service

Plate One

Now let's look at the W-2 live and in person:

Our resident actor, Ima Starr, receves a W-2 from her work at the well-known Goodwrench Dinner Theatre in Philadelphia. Even though Ima resides in New York City, the fact that she is performing in Philadelphia means she is subject not only to Pennsylvania state tax, but also to a Philadelphia municipal tax. This may mean that Ima will have to file Pennsylvania AND Philadelphia income tax returns at year-end (see W-2 boxes 16-21). Note that in Box 15 the "Pension Plan" box is checked, which indicates to the IRS that Ima has a retirement plan available to her; in this case it is her Actors Equity Association union plan. This fact will limit her ability to take an IRA deduction.

Our bass player, musician Sonny Phunky, has been hired to play on a national tour with the Butterball Kings rock band. In this case, Sonny was considered an employee and the Butterball Kings, Inc., production company was his employer. Prior to their tour, the group rehearsed in New York City for three weeks. Sonny is not a New York City resident, so he was given a $400 a day per diem by the production company to cover his living expenses. This is indicated in Box 12A with a code "L." Sonny rehearsed with the Butterball Kings for 3 weeks (21 days) in New York City. The IRS per

WKB F00497-001 3

22222	Void	a Employee's social security number 222-33-4444	For Official Use Only ▶ OMB No. 1545-0008	

b Employer identification number (EIN) 22-0000000		1 Wages, tips, other compensation 31071.00	2 Federal income tax withheld 3462.00
c Employer's name, address, and ZIP code The Butterball Kings 5th Ave New York, NY 10019		3 Social security wages 30000.00	4 Social security tax withheld 1860.00
		5 Medicare wages and tips 30000.00	6 Medicare tax withheld 435.00
		7 Social security tips	8 Allocated tips
d Control number		9 Advance EIC payment	10 Dependent care benefits
e Employee's first name and initial Sonny	Last name Phunky Suff.	11 Nonqualified plans	12a See instructions for box 12 L 7329.00
RR 1		13 Statutory employee Retirement plan Third-party sick pay	12b
Rockridge, ME 03905		14 Other	12c
			12d
f Employee's address and ZIP code			

15 State Employer's state ID number NY	16 State wages, tips, etc. 31071.00	17 State income tax 2171.00	18 Local wages, tips, etc.	19 Local income tax	20 Locality name

Form W-2 Wage and Tax Statement

Copy A For Social Security Administration — Send this entire page with Form W-3 to the Social Security Administration; photocopies are **not** acceptable. 0000/1246

Department of the Treasury—Internal Revenue Service
For Privacy Act and Paperwork Reduction Act Notice, see Page 10.

Do Not Cut, Fold, or Staple Forms on This Page — Do Not Cut, Fold, or Staple Forms on This Page

Plate Two

diem in Manhattan for the first half of 2009 was $349 per day (lodging of $285 and meals of $64). Therefore, Sonny's per diem was higher than the IRS-approved rate (www.gsa.gov) by $51 a day. In Box 12A you will see the amount of $7,329 ($8,400 less $1,071). The $7,329 is the actual IRS approved per diem rate for three weeks in Manhattan ($349 × 21 days). The excess $1,071 will be reported as taxable wages in Box 1 on Sonny's W-2. In other words, Sonny has to pay taxes on the per diem rate paid him because it is higher than what the IRS allows. If he has the receipts to back up the additional deduction, he can certainly write off living expenses to offset the extra $1,071 in income on Form 2106. You will also note that Sonny, even though he is a resident of Rockridge, Maine, will be paying New York state taxes on this income and may need to file a New York income tax return.

While we are reviewing what the W-2 (and the IRS) tells us, it is interesting to note what the W-2 does *not* tell us. It does not indicate when the money was earned, how long the artist worked, or the weekly gross. Often, because the issuer will be a generic payroll service or production company, it does not indicate who the artist was working for. Although the Social Security income ceiling in 2009 is $106,800 (adjusted annually, *see* www.ssa.gov), if the artist

works for a number of different employers and earns more than that amount, he or she will quite likely overpay into Social Security. This amount of over-payment will be refunded when you file your 1040 at year-end.

As an employee, you control the amount of federal income taxes with-held by filling out the federal form W-4 with the employer. This is something that your tax advisor can help you with. By calculating the total amount of expected annual income, you can arrive at a reasonable estimation of what your withholdings should be.

In Search of Form 1099

While there are a multitude of different 1099 forms (including the common ones issued for interest and dividend income), the artist is mainly concerned with the 1099-MISC. The 1099-MISC is fairly straightforward, with thirteen self-explanatory boxes. The IRS requires payers to issue a form 1099-MISC for each person to whom they pay at least $10 in gross royalty payments or $600 for services in the course of a calendar year. If you receive a form 1099-MISC for your services as an artist, you are generally considered self-employed, especially if these services constitute a substantial part of your income for the year. You may even be issuing a form 1099-MISC *yourself*, if you have paid anyone in excess of $600 for personal services or compensation. Let's look at a few examples of 1099 forms that the artist might receive.

Our author Guy Focal may receive a 1099 from his children's book publisher that looks like this:

Plate Three

Guy will report this income on the federal form Schedule C, not on the often misused Schedule E. While there is a line on federal Schedule E for royalties (and it is not uncommon to see royalties for writers reported on that line), schedule E royalties are gas, oil and mining royalties. Royalty income for authors is considered self-employment income for tax purposes.

For some miscellaneous studio work that looked like this, our friend and bass player Sonny got a 1099-MISC:

CORRECTED (if checked)				
PAYER'S name, street address, city, state, and ZIP code Hogs Breath Recording Studio, LLC Main St Chicago, IL 22331	**1** Rents $ **2** Royalties $	OMB No. 1545-0115 Form **1099-MISC**	**Miscellaneous Income**	
	3 Other income $	**4** Federal income tax withheld $	**Copy B** **For Recipient**	
PAYER'S Federal identification number 30-4552222	RECIPIENT'S identification number 222-33-4444	**5** Fishing boat proceeds $	**6** Medical and health care payments $	
RECIPIENT'S name Sonny Phunky	**7** Nonemployee compensation $ 2,150	**8** Substitute payments in lieu of dividends or interest $	This is important tax information and is being furnished to the Internal Revenue Service. If you are	
Street address (including apt. no.) RR 1	**9** Payer made direct sales of $5,000 or more of consumer products to a buyer (recipient) for resale	**10** Crop insurance proceeds $	required to file a return, a negligence penalty or other	
City, state, and ZIP code Rockridge, ME 03905	**11**	**12**	sanction may be imposed on you if this income is taxable and the IRS	
Account number (optional)	**13** Excess golden parachute payments $	**14** Gross proceeds paid to an attorney $	determines that it has not been reported.	
15	**16** State tax withheld $ $	**17** State/Payer's state no.	**18** State income $ $	
Form **1099-MISC**	(Keep for your records.)	Department of the Treasury - Internal Revenue Service		

Plate Four

Sonny's studio work will be shown in Box 7 as non-employee compensation and will be reported on Schedule C.

Ima Starr won a prize when she entered a contest while back in Philadelphia. She won a historic, fully restored Yugo automobile that was worth $1,000. Her 1099-MISC will reflect this in Box 3 and look like this:

CORRECTED (if checked)			
PAYER'S name, street address, city, state, and ZIP code	1 Rents $	OMB No. 1545-0115	**Miscellaneous Income**
Muddy Mudskippers BBQ, Inc. Main St Philadelphia, PA 19999	2 Royalties $	Form **1099-MISC**	
	3 Other income $ 1,000	4 Federal income tax withheld $	Copy B For Recipient
PAYER'S Federal identification number	RECIPIENT'S identification number	5 Fishing boat proceeds $	6 Medical and health care payments $
22-3232320	111-22-3333		
RECIPIENT'S name Ima Starr		7 Nonemployee compensation $	8 Substitute payments in lieu of dividends or interest $
Street address (including apt. no.) 5th Avenue		9 Payer made direct sales of $5,000 or more of consumer products to a buyer (recipient) for resale	10 Crop insurance proceeds $
City, state, and ZIP code New York, NY 10019		11	12
Account number (optional)		13 Excess golden parachute payments $	14 Gross proceeds paid to an attorney $
15		16 State tax withheld $ $	17 State/Payer's state no.

This is important tax information and is being furnished to the Internal Revenue Service. If you are required to file a return, a negligence penalty or other sanction may be imposed on you if this income is taxable and the IRS determines that it has not been reported.

18 State income $ $

Form **1099-MISC** (Keep for your records.) Department of the Treasury - Internal Revenue Service

Plate Five

I cite this example because Box 3, "Other," is often used as a real catch-all box when the issuer does not know where to put a particular item. It is not uncommon to find products given in product endorsement situations put in here. In the case of Ms. Starr's Yugo, since she did not give any services in exchange, the value of the car is not considered self-employment income. If she had done a product endorsement (for example, if she had done a commercial for Yugo) the value of the auto would be reported as self-employment income because the product would have been given in exchange for services, namely the endorsement.

Another point to bear in mind is that, as an artist, the IRS treats you as a "cash basis taxpayer." Cash basis means that, generally speaking, your income is the value of what you *receive* during the calendar year. So income reported on the 1099 form is not necessarily income for the recipient in the same year. For example our musician Sonny did some studio work at the end of the year. The studio wanted the deduction on that year's tax return so they issued and mailed the $925 check on December 31 and correctly put the payment on the 1099-MISC they issued to Sonny for that year (after all, they had in fact paid it that year). Sonny did not receive the check until January 4 of the following year; consequently he does not have to consider that payment

as income in the same year as the 1099 would indicate. In these cases the artist can show the income not received as an adjustment to the 1099 and add the income to his or her return in the subsequent year.

The Joys of Being Self-Employed

So what does it mean to be self-employed and have self-employment income? Understand that, when you receive a substantial part of your income reported on Form 1099, you are considered self-employed. It is critical to understand how self-employment income is taxed. Self-employment income is subject to *two separate taxes* on your federal tax return: income tax and self-employment tax. Self-employment income is reported on federal Schedule C and self-employment tax is calculated on federal Form SE (for self-employment). The following diagram indicates how self-employment income is taxed on the 1040:

Self-employment income is reported on the federal Schedule C. The Schedule C is an attachment to the taxpayer's federal Form 1040; *it is not filed separately.*

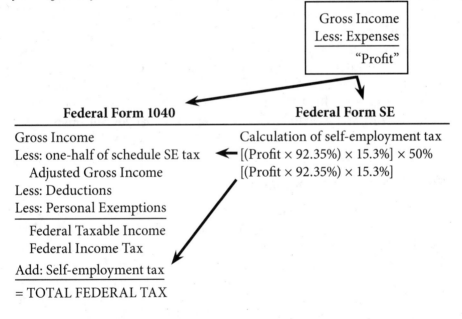

Gross Income
Less: Expenses
"Profit"

Federal Form 1040	**Federal Form SE**
Gross Income	Calculation of self-employment tax
Less: one-half of schedule SE tax	[(Profit × 92.35%) × 15.3%] × 50%
Adjusted Gross Income	[(Profit × 92.35%) × 15.3%]
Less: Deductions	
Less: Personal Exemptions	
Federal Taxable Income	
Federal Income Tax	
Add: Self-employment tax	
= TOTAL FEDERAL TAX	

We can see from this diagram that income from self-employment is subject to two levels of taxation:

✓ The first is the 15.3% self-employment tax. This tax has two
 elements: 2.9% is Medicare tax and 12.4% is Social Security
 taxes that the IRS collects on behalf of the Social Security
 Administration. Medicare tax is calculated on all the self-em-
 ployment income. Social Security tax is applied only on the first
 $106,800 of income in 2009 (adjusted annually, *see* www.ssa.
 gov). Remember that your personal exemptions and deductions
 for your home mortgage interest, real estate tax, and state taxes,
 etc., do not affect the calculation of this tax.

✓ The second level is the federal income tax.

Estimated Taxes

Because self-employment income will not generally be subject to with-
holding tax it is **very easy** to get into trouble and end up owing unexpect-
ed amounts of money on April 15. Therefore, as a self-employed artist you
will probably be required to pay estimated taxes quarterly. If a substantial
amount of your income is going to be in the form of self-employment in-
come, I say, get thee to a good tax advisor! Your tax advisor will help you
estimate what your potential federal and state tax liability might be for the
year. Keep in mind that your taxable income is your gross income LESS your
expenses and deductions. Estimated taxes are paid quarterly on April 15,
June 15, September 15 of the current year and January 15 of the following
year on federal form 1040-ES. To make a reasonable estimate of your poten-
tial tax liability you have to be able to determine what your income-related
expenses are going to be. This is where the record keeping becomes vital
(more on that later)!

So What's All the Hubbub, Bub?

The hubbub is that you must understand the mix of your W-2 and 1099
income to properly organize and be prepared to do your income taxes. Very
few folks in the arts are involved purely in one activity; it's that multi-disci-
pline *thang!*

Our own Ima Starr is a member of the Actors' Equity Association and
received multiple W-2 forms this year. These W-2s will be added up and the
total put on line 7 of her 1040 income tax form. Her expenses associated with
these activities will be found on Form 2106 – Employee Business Expense
(more on that later). Ima is also the sultry lounge singer in the group The
Blue Jazzbos. She published a tell-all book about her life in show business

last year. That means she has four streams of self-employment income: one for music, one for writing, one for acting and one for modeling! She must, to the best of her abilities, allocate her business expenses among these various activities, as they will need to be entered on various forms on her personal income tax return. She might even have to pay estimated income taxes on her self-employment income, especially if the movie rights for her book are sold!

In the world of the arts, actors play in rock bands, musicians write books, dancers perform and teach dance, visual artists teach and design websites, writers lecture and teach, etc. These various activities require you to compartmentalize your income and expenses to a certain degree. Next we will look at the other side of our equation: expenses and deductions.

2.

What Can I Deduct?

In this chapter I will take a bird's eye view of expenses and deductions to show how the IRS interprets the general deductibility of the more common expenses that all artists have, such as automobile use, travel, meals, entertainment, and the controversial home office. I will also look at the Qualified Performing Artists (QPA) provision, start up costs, and the also-controversial "hobby loss" rules. Following chapters will deal more specifically with the deductible expenses in the various disciplines, but for now let's get an overview.

The heart of saving money on your tax return is making sure you do not miss any deductions or expenses. As we have said, the artist has to be concerned about the type of income the deduction is associated with. This is the core of where the deduction goes on the tax return, i.e., does this expense relate to W-2 employment earnings or 1099 self-employment income?

Let's look at what the IRS says regarding expense deductions in general in its Publication 583:

> You can deduct business expenses on your income tax return. These are the current operating costs of running your business. To be deductible, a business expense must be both ordinary and necessary. An ordinary expense is one that is common and accepted in your field of business, trade, or profession. A necessary expense is one that is helpful and appropriate for your business, trade, or profession. An expense does not have to be indispensable to be considered necessary

And from Publication 334:

> You cannot deduct expenses that are lavish or extravagant under the circumstances.

So we can see the IRS has only three fairly simple criteria for deductible business expenses:

1. Must be incurred in connection with your trade, business, or profession.

2. Must be ordinary and necessary.

3. Must *not* be lavish or extravagant.

As I mentioned in the last chapter, as an artist you are treated as what the IRS calls a "cash basis taxpayer." This means that, generally speaking, your expenses and deductions are anything you expend money or value on during the calendar year. If you pay for a tax-deductible expense via check, cash, barter, or charge card (even if you don't pay off the credit card until the following year), the expense will qualify as a deduction in the current year. This all seems straightforward but, as the saying goes, "the devil is in the details."

First, let's tackle the matter of whether the deduction is related to employment (W-2) income or self-employment (Form 1099 or K-1) income. While the types of expenses that are deductible will usually not change between employment and self-employment, the manner in which the deduction is taken and its effect on your tax return can be critical. Important point: the deductibility of specific items can be largely identical for employees and for the self-employed; it is basically a mechanical matter as to how they are treated during the preparation of the income tax return. Put another way, the "employee" artist might (and will indeed often) have the exact group of deductions as the "self-employed" artist. The following chart illustrates the flow of income and deductions:

Employment	Self-employment
Income from W-2 Form	Income from Form 1099-MISC/K-1
↓	↓
Expenses found on Form 2106, Employee Business Expenses	Expenses found on Schedule C or Form 2106 or 2106 type form

So what is the key difference between these two methods? Form 2106 will usually become an itemized deduction on Schedule A of the 1040 and be subject to a 2% floor (except for the Qualified Performing Artist). In other words, if your adjusted gross income is $100,000 you will *automatically* lose $2,000 ($100,000 × 2%) of your professional expenses. In addition, if the

artist does not have any other itemized deductions, such as home mortgage interest, real estate taxes, or state tax payments, then the value of the employee business expenses can be reduced even further. On the other hand, deductions against self-employment income are written off dollar for dollar directly against the self-employment income on the Schedule C.

The exception to this is the form K-1. If the artist is a member of an LLC, a partner in a partnership or a shareholder in an S corporation, they will be able to take allowable business deductions directly against the K-1 income through the use of a type of 2106 substitute form on schedule E (we will see an example of this in Sonny Phunky's 1040 in Chapter 4).

Let's see how this plays out with our four artists:

Ima Starr is a member of Actors' Equity so the bulk of her annual income is reported on the W-2 forms she received. That means that all of her acting expenses will be reported on Form 2106 as employee business expenses. For self-employment, Ima sings in a jazz group, did some modeling and even wrote a book! She and her accountant will be allocating expenses associated with those activities to her Schedule C. These expenses might include auto usage, publications, music equipment purchase, CDs, and home office. It is not always easy to figure out this "allocation" I refer to. What if all of Ima Starr's incomes were earned only in New York City where she lives? By which I mean all the acting jobs, music gigs, modeling assignments, etc., are in NYC. How does one allocate expenses in a situation like that? The answer is: very carefully and systematically! In cases where a clear-cut differentiation is impossible, try for a methodical and consistent approach. This might be done, by allocating the expenses according to income received, days worked, or some other formula (an income based allocation is what the Internal Revenue Service discusses in its audit guidelines). In other words, first assign the expenses you can clearly and directly associate with each type of income, then allocate general expenses via a formula. It is clear that Ima's Actors' Equity dues would be an expense on Form 2106 against her employment income. The sound system and CDs she purchased for her singing career would be deducted against her self-employment income. For her home office and her new MacBook Pro® computer it can be argued that they benefit all her activities equally, so these expenses might be allocated according to an income-based formula (the formula the IRS prefers). If 25% of her gross earnings were from her self-employment activities, she may choose to assign 25% of her home office and computer expenses to her Schedule C.

While this gross income method is not perfect, it is logical, defensible and easy to explain in an IRS audit situation!

Now for our bass player, Sonny Phunky. Let's deal with just four of Sonny's expense line items for the year: the purchase of a new bass guitar, music supplies, auto mileage, travel & meals. When Sonny arrives at his accountant's office he will have his W-2 from Butterball Kings, Inc., for his tour. He will also have 1099-MISC forms for some of his studio work and gigs. And he will have some unreported income from teaching the bass guitar to his students. So how will Sonny and his accountant differentiate the expenses for these items on the tax return? It turns out that the Butterball Kings specifically requested that he play a chartreuse colored bass to match their other stage equipment, which forced Sonny to purchase a new custom painted bass guitar for the tour. This would be grounds for Sonny's accountant to write off (*depreciate* – more on this later) the new bass against his W-2 by using Form 2106. In regard to the music supplies, Sonny and his accountant may choose to take all the expenses purchased during his time with the Butterball Kings as a deduction against the W-2, since that was his primary professional activity in that time frame. They would probably use the same approach for auto mileage. Sonny's use of his car to drive from Maine to NYC and for transportation in and around New York while he was in the city for rehearsals could all be used as a deduction against the W-2.

For his living expenses while in NYC, Sonny may not have any deductions. You will remember that the Butterball Kings' W-2 indicated to the IRS (Box 13-Code L) that Sonny was given a per diem allowance to cover them. If this allowance did cover all his meals and lodging, then Sonny would have no write-off for these expenses. In his case Sonny's allowance was less than he actually paid to be in NYC, and he was able to avail himself of additional write-offs on his Form 2106 of the amount over and above the allowance.

Sonny's expenses for the rest of the year for music supplies, travel, mileage to the studio and gigs, etc., would become a deduction on his Schedule C against his self-employment income and against the K-1 he is receiving. We can see from this example that Sonny will have many of the same expense line items on both his 2106 and his Schedule C forms.

Let's look at our visual artist, Liz. As a college professor she may have no deductions at all because the college would probably be supplying all her teaching materials. But Liz would indeed have expenses for her work as an independent artist. Her expenses for framing, art supplies, home studio and

mileage to visit the gallery in NYC and travel to the gallery in Dublin would all be deductions on her Schedule C form.

Finally, our writer, Guy. The magazine Guy works for will probably be supplying all his materials and equipment, as well as reimbursing him for his auto use on the job, so the only deduction he had against his W-2 (found on Form 2106) was a trip to NYC (*Swamp Life Magazine* does not reimburse this type of travel). Guy would indeed have expenses for his work as an independent writer, which might include the use of a home office, purchase of books, travel, and home computer. These expenses would appear on Schedule C as deductions against his royalties and other freelance writing income.

It's time to delve into some of the larger expense line items that typically affect all artists.

The Automobile

The use of a car for business is the most common expense an artist has, and is often the single largest deduction. The IRS has two basic methods for writing off the business use of your automobile. It allows you to use either the annually adjusted IRS standard mileage rate or the actual expense of operating your car. The IRS sums it up in the following language in Publication 334:

For local transportation or overnight travel by car or truck, you generally can use one of the following methods to figure your expenses:

Standard Mileage Rate

You may be able to use the standard mileage rate to figure the deductible costs of operating your car, van, pickup, or panel truck for business purposes. For 2009, the standard mileage rate is 55 cents and 50 cents for 2010 (this is adjusted annually—see the TaxQuickGuide on www.artstaxinfo.com for the latest rate) a mile for all business miles.

Caution: If you choose to use the standard mileage rate for a year, you cannot deduct your actual expenses for that year except for business-related parking fees and tolls.

Choosing the standard mileage rate. If you want to use the standard mileage rate for a car or truck you own, you must choose to use it in the first year the car is available for use in your business. In later years, you can choose to use either the standard mileage rate or actual expenses.

If you want to use the standard mileage rate for a car you lease, you must choose to use it for the entire lease period. For leases that began on or before December 31, 1997, the standard mileage rate must be used for the entire portion of the lease period (including renewals) after that date.

Standard mileage rate not allowed. You cannot use the standard mileage rate if you:

1. Use the car for hire (such as a taxi),
2. Operate two or more cars at the same time,
3. Claimed a depreciation deduction using ACRS or MACRS in an earlier year,
4. Claimed a section 179 deduction on the car,
5. Claimed actual car expenses after 1997 for a car you leased, or
6. Are a rural mail carrier who received a qualified reimbursement.

Parking fees and tolls. In addition to using the standard mileage rate, you can deduct any business-related parking fees and tolls. (Parking fees you pay to park your car at your place of work are nondeductible commuting expenses.)

Actual Expenses

If you do not choose to use the standard mileage rate, you may be able to deduct your actual car or truck expenses.

TIP: If you qualify to use both methods, figure your deduction both ways to see which gives you a larger deduction.

Actual car expenses include the costs of the following items:

Depreciation	Lease payments	Registration fees
Garage rent	Licenses	Repairs
Gas	Oil	Tires
Insurance	Parking fees	Tolls

If you use your vehicle for both business and personal purposes, you must divide your expenses between business and personal use. You can divide based on the miles driven for each purpose.

Example

You are the musician. You drove your van 20,000 miles during the year. 16,000 miles were for going to gigs, including delivering equipment, and 4,000 miles were for personal use. You can claim only 80% (16,000/20,000) of the cost of operating your van as a business expense.

The easiest method for most folks is to use the generous IRS standard mileage allowance. This option does not require retention of receipts of any kind. All you need to have is a record in your diary or appointment book of business miles driven.

As a rule, personal miles (going to the grocery store, the dentist, out to dinner, etc.) and commuting mileage are not deductible. If you have a legitimate office at home it tends to make all business miles deductible; after all, there can be no commute if you work at home. Otherwise your commute would normally be the first and last trip every day. To illustrate, if our visual artist Liz left her college job at noon, drove to pick up some art supplies, stopped by to speak to a gallery owner, then drove back to school to check in before going home, all her miles from the time she left school until she arrived back to school would be deductible business miles; the balance would be non-deductible commuting miles.

By keeping an accurate appointment book you should have all the info you need to estimate your business miles.

The Home Office/Studio

The home office has been a contentious subject among tax professionals for a number of years, but with recent legislation, it has clearly returned to its rightful place as an allowable deduction for many folks in all aspects of the arts. If you use a room (or rooms) in your home exclusively as your office AND you have no other office space available to you, you will most likely qualify for the home office deduction. To qualify as a deductible home office the space must generally be:

1. The principal place of business
2. The place where the taxpayer meets with clients, customers or colleagues

The room can be used as an office, a storage area for equipment, manuscripts and supplies, for recordkeeping for the business, marketing, etc. For the actor, dancer, filmmaker, and musician it can be a space for keeping business records, preparing correspondence, promotional activities, rehearsing and library/manuscript storage. For the writer and visual artist the home office is where you write, paint or sculpt. It can be a home darkroom for the photographer.

The home office is a fairly straightforward deduction to calculate on federal Form 8829. It simply utilizes a formula based on the square footage of the business portion (the home office) of your home vs. the total square footage of the house or apartment and then applies that percentage to all associated costs. The costs might be rent, mortgage interest, real estate taxes, condo fees, utilities, insurance, repairs, etc. If you own your own home, you can even depreciate that portion of your house for an additional write-off.

For example:

Business use (square footage)	250
Total square footage of home	1250
Business use percentage (250/1250)	20%

Mortgage Interest	$ 7,500
Real Estate Tax	$ 2,500
Utilities	$ 1,820
Water & Sewer	$ 820
Insurance	$ 400
Repairs	$ 225
Total home expenses	$ 13,265

Potential home office deduction:
($13,265 × 20%) **$2,653**

Other rules that come into play here include the "exclusive use" requirement. This rule states that the home office must be used only for the business—no "mixed use" is allowed. Put another way, the home office or studio cannot be a part of a larger room (such as the living room) unless the business part is partitioned off somehow. Be careful when allocating home office expense. The Internal Revenue Service could decide that one of the activities is really a "hobby" and not a legitimate business and then the entire home office will be blown off the return. Why? Because it would no longer be "exclusive use."

For instance, if Ima Starr's accountant felt that her book writing would not pass muster as a true business, he would do well to not allocate any home office expense to it.

If you are planning on selling your home in the near future, you are probably assuming that there will not be a tax, thanks to the $250,000 ($500,000 if a jointly owned residence) exclusion of gain on the sale of a principal residence. However, if you have a home office, or have taken home office deductions in the past, you may have an extra bit of planning to do in order to make sure you receive the full benefit of the exclusion.

Prior to issuing corrective regulations in December 2002, the IRS operated under the rule that if you used your principal residence for both personal and professional purposes, you would be treated as having sold two distinct properties for purposes of the home sale exclusion: a principal

residence and a business property. Profit realized on the residence portion would be entitled to the exclusion, while profit realized on the business portion would be subject to tax.

Fortunately, the IRS recently fixed this problem. Current IRS rules no longer require most taxpayers who claim the home office deduction to allocate the gain between business and personal use if the business occurred within the same dwelling unit as the residential use. Instead, only the amount of depreciation you deducted in the past as a home office expense will be subject to tax.

Equipment Purchases and Depreciation & Amortization of Recordings, Films & Books

This first section concerns the purchase of equipment used by the artist. It pertains to the purchase of any large assets such as computers, printers, handheld computers, personal digital assistants (PDAs), mp3 players, digital cameras, cell phones, software, musical instruments and equipment, cameras and photographic equipment, sculptor's welding equipment, presses or other devices used by visual artists, video cameras and equipment, and sound and audio devices. The purchase of a violin or computer is considered intrinsically different from paying the phone bill, in that when you purchase the violin or computer it will have a life beyond the year it is bought, unlike the phone service, which has no "life." Therefore, depreciation of equipment is a method of dividing the cost of the asset over its IRS-defined "useful life" and deducting it a little bit at a time, year by year, until the entire purchase price has been deducted.

In Publication 334 the IRS discusses depreciation this way:

> If property you acquire to use in your business is expected to last more than one year, you generally cannot deduct the entire cost as a business expense in the year you acquire it. You must spread the cost over more than one tax year and deduct part of it each year on Schedule C, C-EZ or Form 2106. This method of deducting the cost of business property is called depreciation.
>
> **What can be depreciated?** You can depreciate property if it meets all the following requirements:
>
> ✓ It must be used in business or held to produce income.
>
> ✓ It must be expected to last more than one year. In other words, it must have a useful life that extends substantially beyond the year it is placed in service.

✓ It must be something that wears out, decays, gets used up, becomes obsolete, or loses its value from natural causes.

What cannot be depreciated? You cannot depreciate any of the following items:

✓ Property placed in service and disposed of in the same year.

✓ Inventory.

✓ Land.

✓ Repairs and replacements that do not increase the value of your property, make it more useful, or lengthen its useful life. You can deduct these amounts on Schedule C, C-EZ or Form 2106.

Depreciation method. The method for depreciating most tangible property placed in service after 1986 is called the Modified Accelerated Cost Recovery System (MACRS). (Tangible property is property you can see or touch.) MACRS is discussed in detail in Publication 946.

Section 179 deduction. You can choose to deduct a limited amount (for 2009, up to $250K and for 2010, $134K) of the cost of certain depreciable property in the year you buy it for use in your business. This deduction is known as the "section 179 deduction." For more information, see Publication 946. It explains what costs you can and cannot deduct, how to figure the deduction, and when to recapture the deduction.

Listed property. Listed property is any of the following.

✓ Most passenger automobiles.

✓ Most other property used for transportation.

✓ Any property of a type generally used for entertainment, recreation, or amusement.

✓ Certain computer and related peripheral equipment.

✓ Any cellular telephone (or similar telecommunications equipment).

You must follow additional rules and recordkeeping requirements when depreciating listed property. For more information about listed property, see Publication 946.

What are the typical "lives" of commonly purchased assets according to the IRS?

✓ Computer and technology type assets = 5 years

✓ Automobiles and light trucks = 5 years

✓ Office furniture, fixtures, musical instruments and machinery = 7 years

✓ Commercial real estate = 39 years

Depreciation is calculated and reported on Form 4562, and is then carried either to the Schedule C if written off against self-employment income, or the Form 2106 if deducted against W-2 employment earnings.

A common depreciation/deduction question that comes up in the arts concerns the purchase of collectables and other antiques. For the actor or director, it can be the acquisition of a film or theatre prop or poster; for the musician it can be a vintage instrument; for the visual artist it could be a piece of artwork; and for the writer it may be a signed, first edition book. While these items may be related directly to your profession, the IRS generally feels such items are personal in nature and not deductible or subject to depreciation. That is because they are often not used directly in the artist's profession, but are decorative in nature. The other reason the IRS does not allow a deduction is because the nature of a collectable is to appreciate in value, not depreciate. The IRS has lost several court cases over a musician writing off an antique instrument. In two cases it was critical that the musician used the instrument in actual performance and recording. By doing this one taxpayer argued that the use of the bass viol did diminish the value of the instrument due to the perspiration from the performer's hands and through oxidation of the wood. In tax court cases the IRS can either agree with the court or not agree. In these cases, the IRS did not acquiesce in the decisions of the tax court. So you cannot rely on these court rulings as a precedent. If you do decide to depreciate an antique or collectable, be sure that you are actually using it in your job as an artist and prepare for an argument!

The creation of film, videos, books and recordings follows a concept similar to depreciation: they are assumed to have some value beyond the year in which they are created and are written off over a period of time. In the case of film and recordings, the term used is *amortization*. The total cost of creating the film or recording is capitalized and then written off using one of two IRS-approved formulas. Unlike the purchase of a computer, the IRS does not define a pre-determined life for film and recordings. The two methods are:

1. The income forecast method (the most common method) – the creator estimates the amount and timing of the income stream from sales of the film, book or recording and expenses the costs associated with the creation or acquisition over that period of time. For instance, if the recording or film cost $50,000 to produce and the income was expected to be earned over 3 years in the following formula: 65%-25%-10%, then the $50,000 would be written off $32,500-$12,500-$5,000.

2. Straight-line over the useful life – if the creator expects the film, book or recording to have a useful life of 5 years (probably the shortest life the Internal Revenue Service would generally allow), then he or she would divide the $50,000 production cost by 5 and take approximately $10K in expense each year.

An exception to the above concerns music videos. If the artist creates a music video to be used primarily for shopping the artist to record companies, then the cost of the video is immediately deductible as advertising expense, not subject to amortization.

Travel and Meal Expenses

After the business use of the automobile, travel can be the next most common (and thorny) issue for the artist. Before we discuss travel for the artist, let's see what the IRS says about business travel in its Publication 463, which includes an excellent chart (Table 1) of what types of items are deductible:

Deductible travel expenses include those ordinary and necessary expenses you have when you travel away from home on business. The type of expense you can deduct depends on the facts and your circumstances.

Table 1 summarizes travel expenses you may be able to deduct. You may have other deductible travel expenses that are not covered there, depending on the facts and your circumstances.

Records. When you travel away from home on business, you should keep records of all the expenses you have and any advances you receive from your employer. You can use a log, diary, notebook, or any other written record to keep track of your expenses.

Travel expenses for another individual. If a spouse, dependent, or other individual goes with you (or your employee) on a business trip or to a business convention, you generally cannot deduct his or her travel expenses.

Employee. You can deduct the travel expenses you have for an accompanying individual if that individual:

 1. Is your employee,

 2. Has a bona fide business purpose for the travel, and

 3. Would otherwise be allowed to deduct the travel expenses.

Business associate. If a business associate travels with you and meets the conditions in (2) and (3) above, you can claim the deductible travel expenses you have for that person. A business associate is someone with whom you could reasonably expect to actively conduct business. A business associate can be a current or prospective (likely to become)

customer, client, supplier, employee, agent, partner, or professional advisor.

Bona fide business purpose. For a bona fide business purpose to exist, you must prove a real business purpose for the individual's presence. Incidental services, such as typing notes or assisting in entertaining customers, are not enough to warrant a deduction.

Example: Jerry drives to Chicago to audition for a play and takes his wife, Linda, with him. Linda is not Jerry's employee. Even if her presence serves a bona fide business purpose, her expenses are not deductible.

Jerry pays $115 a day for a double room. A single room costs $90 a day. He can deduct the total cost of driving his car to and from Chicago, but only $90 a day for his hotel room. If he uses public transportation, he can deduct only his fare.

Travel expenses you can deduct

This chart summarizes expenses you can deduct when you travel away from home for business purposes.

TABLE 1:

IF you have expenses for:	THEN you can deduct the costs of:
Transportation	Travel by airplane, train, bus, or car between your home and your business destination. If you were provided with a ticket or you are riding free as a result of a frequent traveler or similar program, your cost is zero. If you travel by ship, see additional rules & limits on luxury water travel & cruise ships.
Taxi, commuter bus, and airport limousine	Fares for these and other types of transportation that take you to or from: 1) The airport or station and your hotel, and 2) The hotel and the work location of your staff, crew, band members, customers or clients, your business meeting place, or your temporary work location.
Baggage and shipping	Sending baggage, wardrobes, sets & props, sample or display material between your regular and temporary work locations.

Car	Operating and maintaining your car when traveling away from home on business. You can deduct actual expenses or the standard mileage rate, as well as business-related tolls and parking. If you rent a car while away from home on business, you can deduct only the business-use portion of the expenses.
Lodging and meals	Lodging and meals if your business trip is overnight or long enough that you need to stop for sleep or rest to properly perform your duties. Meals include amounts spent for food, beverage, taxes, and related tips.
Cleaning	Dry cleaning and laundry.
Telephone	Business calls while on your business trip. This includes business communication by fax machine, cellular phone or other communication devices.
Tips	Tips you pay for any expenses in this chart.
Other	Other similar ordinary and necessary expenses related to your business travel. These expenses might include transportation to or from a business meal, public stenographer's fees, computer rental fees, and operating and maintaining a house trailer.

In short, deductible travel is when you are taken away from your home for a direct, clearly identifiable business purpose. Keep in mind: meals are almost always only 50% deductible.

Examples:

- On Wednesday, Liz Brushstroke drives to NYC to deliver some artwork to the gallery for a new show. The opening is taking place two days later, on Friday. Both Liz and the gallery owner know that it will be good for business if Liz is at the opening, so she stays on in NYC through Friday and drives back on Saturday. This is primarily business. Consequently, Liz will be able to deduct almost 100%

of the costs of the trip. She can use either the IRS per diem rates for meals while in NYC or keep her actual receipts (remember that meals are only 50% deductible).

- Guy Focal has a chance to go to Chicago to promote his new children's book at a well-known book fair. The publisher has agreed to pay for his flight to Chicago, but he will have to cover all his expenses while there personally. Guy has a good friend in Chicago who he stays with, so his lodging expenses will be zero. What deductible travel expenses will he have? He will be able to deduct all his meals, taxi fares and other ground transportation; he has some entertainment expenses for taking his publisher out to lunch; and he purchases some other children's books at the show for research purposes, etc.

Use of the IRS Per Diem rates

The US Government publishes and continually adjusts per diem rates for meals, incidentals and lodging worldwide (www.gsa.gov). Per diem rates for meals and incidentals work a little like the standard mileage allowance discussed earlier. If the artist decides that keeping receipts is too time consuming, he or she can choose to use these standard rates for all their meals and incidentals while traveling in a particular year. The IRS explains the standard rate in its Publication 463:

> You generally can deduct a standard amount for your daily meals and incidental expenses (M&IE) while you are traveling away from home on business. In this publication, "standard meal allowance" refers to the federal rate for M&IE (which varies based on where and when you travel).
>
> **Incidental expenses.** These include, but are not limited to, your costs for the following items:
>
> 1. Laundry, cleaning and pressing of clothing.
> 2. Fees and tips for persons who provide services, such as porters and baggage carriers.
>
> Incidental expenses do not include taxicab fares, lodging taxes, or the costs of telegrams or telephone calls.
>
> The standard meal allowance method is an alternative to the actual cost method. It allows you to deduct a set amount, depending on where and when you travel, instead of keeping records of your actual costs. If you use the standard meal allowance, you still must keep records to prove the time, place, and business purpose of your travel.

Caution. There is no optional standard lodging amount similar to the standard meal allowance. Your allowable lodging expense deduction is your actual cost.

Who can use the standard meal allowance? You can use the standard meal allowance whether you are an employee or self-employed, and whether or not you are reimbursed for your traveling expenses. You cannot use the standard meal allowance if you are related to your employer.

Use of the standard meal allowance for other travel. You can use the standard meal allowance to prove meal expenses you have when you travel in connection with investment and other income-producing property. You can also use it to prove meal expenses you have when you travel for qualifying educational purposes. You cannot use the standard meal allowance to prove the amount of your meals when you travel for medical or charitable purposes.

Amount of standard meal allowance. The standard meal allowance is the federal M&IE rate. For travel in 2009, the rate is $39 a day for most areas in the United States. This rate moves to $46 in 2010. Other locations in the United States are designated as high-cost areas, qualifying for higher standard meal allowances of up to $64 per day in 2009 and $71 in 2010 (visit www.gsa.gov for the most current information).

If you travel to more than one location in one day, use the rate in effect for the area where you stop for sleep or rest.

50% limit may apply. If you are not reimbursed or if you are reimbursed under a non-accountable plan for meal expenses, you can generally deduct only 50% of the standard meal allowance. If you are reimbursed under an accountable plan and you are deducting amounts that are more than your reimbursements, you can deduct only 50% of the excess amount.

Standard meal allowance for areas outside the continental United States. The standard meal allowance rates do not apply to travel in Alaska, Hawaii, or any other locations outside the continental United States. The federal per diem rates for these locations are published monthly in the Maximum Travel Per Diem Allowances for Foreign Areas.

The general CONUS (continental US) per diem rate for 2010 is $116 a day. This is allocated as $70 for lodging and $46 for meals and incidentals. Locations deemed to be "high cost" localities, such as New York City and Los Angeles, will have higher meals and incidental per diem rates. The US Government also publishes foreign per diem rates OCONUS (outside continental US) to be used for foreign travel. Rates vary from city to city; to get the latest per diem rates go to our website www.artstaxinfo.com for a link or visit the U.S. General Services Administration website, www.gsa.gov.

Artists can choose to use the meals and incidentals per diem rates for all their business travel in lieu of keeping receipts. Please note: you cannot use a per diem rate for lodging; for that you must always have receipts. If your employer reimburses you using the US Government per diem rates, you may be able to deduct any amount that you spend in excess of the per diem.

A question frequently asked is whether the artist has any tax deductions if the employer covers or reimburses the artist for all expenses. The answer centers on what type of expense plan the employer operates. The IRS allows two basic plans:

1. Accountable Plan - If the employer has what is called an "accountable plan," the artist will typically not have any tax-deductible costs. In this scenario, either the artist is reimbursed using the US Government per diem allowances or the artist submits all receipts and details on an expense report (or similar document) and the employer reimburses the artist directly for all the costs. Sometimes the employer may pay a hotel bill and other expenses directly. In an accountable plan, if all the costs are being covered by the employer, the artist will have not have any tax deductions. If your employer would have covered a particular expense but you forgot to submit it, can you deduct the expense? Absolutely not! Say our bassist, Sonny Phunky, notices when he is doing his tax returns that he forgot to submit a hotel bill to a band he was employed with during the year. If his contract clearly stated that all living expenses would be covered (the IRS will review these contracts if they audit him), he will not be able to deduct the bills, even if he is past the point of getting reimbursed by the employer. This hotel bill becomes what I call a "tax orphan" that nobody gets to deduct!

2. Non-Accountable Plan - This plan allows the employer simply to give the artist a flat amount in addition to wages on the W-2 to "cover" expenses. Using this system, the artist would be able to deduct all allowable expenses incurred.

Entertainment Expenses

The issue of entertaining, like many others, takes on a different hue for the artist. While some entertaining the artist might do is clearly business related (such as meeting with his or her agent over lunch), a lot of entertaining the artist considers "business related," the IRS views with suspicion. Before looking at specific examples of business entertainment, let's see how the IRS views the subject in their Publication 463:

General rule:

You can deduct ordinary and necessary expenses to entertain a client, customer, or employee if the expenses meet the directly related test or the associated test.

Definitions:

✓ Entertainment includes any activity generally considered to provide entertainment, amusement, or recreation, and includes meals provided to a customer or client.

✓ An ordinary expense is one that is common and accepted in your field of business, trade, or profession.

✓ A necessary expense is one that is helpful and appropriate, although not necessarily indispensable, for your business.

Tests to meet the directly related test:

✓ Entertainment took place in a clear business setting, or

✓ Main purpose of entertainment was the active conduct of business, and

✓ You did engage in business with the person during the entertainment period, and

✓ You had more than a general expectation of getting income or some other specific business benefit.

Associated test:

✓ Entertainment is associated with your trade or business, and

✓ Entertainment directly precedes or follows a substantial business discussion

Other rules:

✓ You cannot deduct the cost of your meal as an entertainment expense if you are claiming the meal as a travel expense.

✓ You cannot deduct expenses that are lavish or extravagant under the circumstances.

✓ You generally can deduct only 50% of your unreimbursed entertainment expenses.

You can see the IRS takes a hard-line view on business entertainment (no surprise there!). It is up to the artist to keep the kind of records necessary to support the deduction. Interestingly, although the IRS does not require a receipt if the cost of the entertainment is less then $75, they are sure going to ask for substantiation. Your main friend here will be a detailed diary in your schedule book, or your printouts from your PDA listing who was present, what business matters were discussed and where the event was held.

Substantiating Your Deductions for Travel, Meals & Entertainment

The area of travel, meals & entertainment presents difficult substantiation issues for the artist. It is easy to keep records when you pay your business phone, buy a professional book or magazine, pay an agent, etc., but when you take a potential employer, buyer, agent, publisher, producer or colleague out to lunch, how do you "account" for that? What will the IRS ask for to substantiate your travel, meals & entertainment deductions?

You will need two types of records in case the IRS comes knocking:

1. A diary, account book, calendar, or schedule book. If you use one of the popular electronic PDAs (Personal Digital Assistants), print out a hard copy of your schedule or back it up to the hard drive of your computer. Record the details of the travel, entertainment and meal, including time, place, who was present, and the specific business purpose.

2. Meals and entertainment instances under $75 don't require a receipt (an entry in your diary will do); lodging, meals and entertainment OVER $75 do. For these costs keep all receipts and itemized bills.

Here are the exceptions (you knew they were coming!):

1. Receipts for transportation expenses of $75 or more are required only when they are readily obtainable. This is in response to our era of "ticketless" travel. In this case, if you do have a boarding pass or receipt, keep it.

2. A canceled check or credit card statement is usually not considered adequate in and of itself, though many IRS agents will accept them as corroborating evidence. If you cannot provide a bill, receipt or voucher, you can use other evidence such as written statements from witnesses.

Receipts should show the following:

✓ Amount of expense
✓ Date of expense
✓ Where the expense occurred

In addition to the above information (which would typically be pre-printed on most receipts), the artist should get into the habit of writing the

"who, why and where" directly on the receipts or in their diary/schedule book. For a meal or entertainment expense jot down:

1. **Who** was there.

2. **Why** they were there – what the business purpose was (and be as specific as possible!).

3. **Where** the event was – was it in an atmosphere conducive to business discussions?

The IRS always wants itemized receipts of such things as hotel bills in order to ferret out personal items such as phone calls, gift purchases and movie rentals that may be lurking on the bill.

Are there excuses for NOT having adequate records?

1. Substantial Compliance – If you have made a good faith effort to comply with IRS requirements, you will not be penalized if you do not satisfy every requirement. In other words, missing one or two receipts or forgetting to make notes on a few meals receipts will not necessarily be grounds for the IRS to throw out an expense.

2. Accidental Destruction of Records – House fire, flood, mudslides or other circumstances beyond your control cause your records to be destroyed. In this situation you are allowed to reasonably reconstruct your deductions.

3. Exceptional Circumstances – I doubt if anyone knows what the heck this means; the IRS certainly doesn't explain it in its regulations. The IRS states that if due to the "inherent nature of the situation" you are unable to keep receipts or records you may present alternative evidence.

Be very careful in relying on these "excuses;" as Internal Revenue Service audits have become more stringent, I am not sure that these would prove very effective.

The "QPA" – Qualified Performing Artist

The concept of the QPA entered the tax code during the tax act of 1986. In that act, many, many deductions were completely abolished or diminished by moving them around on the return. One such move was the Form 2106 used to deduct employee business expenses. Prior to 1986, the 2106 was a very common form quite logically used to take employee business deductions directly on the front page of the 1040, with no need to itemize. In 1986,

the 2106 was moved from the front page of the 1040 and became an itemized deduction on Schedule A. Not only that; it was now subject to a dreaded 2% floor! This means that you automatically lose part of your deductions: the amount that is equal to 2% of your adjusted gross income. Due in part to the work of Actors' Equity Association and of Stage Source (among others), a provision was installed in the code of 1986 for what is termed the Qualified Performing Artist. The IRS defines the QPA this way in its Publication 529:

> If you are a qualified performing artist, you can deduct your employee business expenses as an adjustment to income rather than as a miscellaneous itemized deduction. To qualify, you must meet all three of the following requirements:
>
> 1. You perform services in the performing arts for at least two employers during your tax year. (You are considered to have performed services in the performing arts for an employer only if that employer paid you $200 or more.)
> 2. Your related performing-arts business expenses are more than 10% of your gross income from the performance of such services.
> 3. Your adjusted gross income is not more than $16,000 before deducting these business expenses.
>
> If you do not meet all of the above requirements, you must deduct your expenses as a miscellaneous itemized deduction on schedule A subject to the 2% limit.
>
> **Special rules for married persons.** If you are married, you must file a joint return unless you lived apart from your spouse at all times during the tax year.
>
> If you file a joint return, you must figure requirements (1) and (2) above separately for both you and your spouse. However, requirement (3) applies to your and your spouse's combined adjusted gross income.
>
> **Where to report.** If you meet all of the above requirements, you should first complete Form 2106 or Form 2106-EZ. Then you include your performing-arts related expenses from line 10 of Form 2106 or from line 6 of Form 2106-EZ on line 32 of Form 1040. Then write "QPA" and the amount of your performing-arts related expenses on the dotted line next to line 32 (Form 1040).

There has been great consternation regarding the fact that the QPA is so limited. These thresholds have NEVER been increased since the measure was adopted in 1986! So, the QPA provision is useful to fewer and fewer folks each year, but it is still a great tax benefit for low income performers.

The "Hobby Loss" Issue

When you begin your career in the arts, it is quite likely that your expenses will exceed your income resulting in a loss on your tax return. When this happens in succeeding years you have the potential for the IRS to declare your career as an artist a "hobby."

How does the IRS deem an activity to be a hobby (something "not engaged in for profit" to use its terminology)? This is how it is explained in the Publication 535:

> If you do not carry on your business or investment activity to make a profit, there is a limit on the deductions you can take. You cannot use a loss from the activity to offset other income. Activities you do as a hobby, or mainly for sport or recreation, come under this limit. So does an investment activity intended only to produce tax losses for the investors.
>
> The limit on not-for-profit losses applies to individuals, partnerships, estates, trusts, and S corporations. It does not apply to corporations other than S corporations.
>
> In determining whether you are carrying on an activity for profit, all the facts are taken into account. No one factor alone is decisive. Among the factors to consider are whether:
>
> 1. You carry on the activity in a businesslike manner,
> 2. The time and effort you put into the activity indicate you intend to make it profitable,
> 3. You depend on income from the activity for your livelihood,
> 4. Your losses are due to circumstances beyond your control (or are normal in the start-up phase of your type of business),
> 5. You change your methods of operation in an attempt to improve profitability,
> 6. You, or your advisors, have the knowledge needed to carry on the activity as a successful business,
> 7. You were successful in making a profit in similar activities in the past,
> 8. The activity makes a profit in some years, and how much profit it makes, and
> 9. You can expect to make a future profit from the appreciation of the assets used in the activity.

Many things that one would consider a "hobby" are obvious. Examples would include the attorney who attempts to take his stamp collecting and turn it into a business, thus creating a tax-deductible loss, or the doctor who tries to write off his horse-breeding hobby as a business. Unfortunately, the

IRS has established a codified "test" for deciding what constitutes a hobby. This "presumption of profit" test below is from Publication 535:

> An activity is presumed carried on for profit if it produced a profit in at least 3 of the last 5 tax years, including the current year. You have a profit when the gross income from an activity is more than the deductions for it.
>
> If a taxpayer dies before the end of the 5-year period, the period ends on the date of the taxpayer's death.
>
> If your business or investment activity passes this 3-years-of-profit test, presume it is carried on for profit. This means it will not come under these limits. You can take all your business deductions from the activity, even for the years that you have a loss. You can rely on this presumption in every case, unless the IRS shows it is not valid.
>
> Using the presumption later. If you are starting an activity and do not have 3 years showing a profit, you may want to take advantage of this presumption later, after you have the 5 years of experience allowed by the test.
>
> You can choose to do this by filing Form 5213. Filing this form postpones any determination that your activity is not carried on for profit until 5 years have passed since you started the activity.
>
> The benefit gained by making this choice is that the IRS will not immediately question whether your activity is engaged in for profit. Accordingly, it will not restrict your deductions. Rather, you will gain time to earn a profit in 3 out of the first 5 years you carry on the activity. If you show 3 years of profit at the end of this period, your deductions are not limited under these rules. If you do not have 3 years of profit, the limit can be applied retroactively to any year in the 5-year period with a loss.
>
> Filing Form 5213 automatically extends the period of limitations on any year in the 5-year period to 2 years after the due date of the return for the last year of the period. The period is extended only for deductions of the activity and any related deductions that might be affected.

This "hobby loss" is an audit trap that you do not want to land in, as it can be very expensive. The IRS is not automatically tracking this deduction through its computer (at least not yet) and it is only likely to come up in an audit situation when the agent has the opportunity (or reason) to look at several consecutive years of returns. Are artists dead in the water if they have had three consecutive years of losses? Not necessarily. The Second Circuit Court said in a decision issued in 1995: "Code section 183 [the section where the "hobby loss" provisions live] isn't designed to punish the inept—only those who deliberately engage in unprofitable activities and with a view to sheltering income." There are numerous instances where the tax court has allowed folks to write off continual losses against the wishes of the IRS, but

be prepared for a fight. Complete and detailed records of your ongoing activities can make a huge difference.

To me, the hobby loss is where you see the palpable difference between the person who opens a local hardware store and the artist. That's because success is obviously and historically far more elusive for the artist than it is for the retail store owner. When Fred opens his corner hardware store he will quickly close it if he is not making money, whereas folks in the arts will often go on for years racking up losses searching for that "big break."

Unfortunately for us, when this issue rears its head the IRS agent often views the artist and Fred's Corner Hardware store in exactly the same light. In the same way he or she examines Fred's hardware store, the IRS agent will look at your career in the arts as strictly a business proposition, so you will need to clearly prove that you have a profit motive. The heart of this matter is that you have to show that you are attempting to *make money*. It's that simple. Your records need to show clearly a concerted, consistent, ongoing, business-like effort to land the next acting job, sell the next article, publish the new book, get the gig, land the recording contract or sell the artwork. Your career in the arts needs to have all the attributes of a business in every sense of the word.

Start-up Costs

If you are new to your profession as an artist you may initially incur what the IRS calls "start-up costs." Start-up costs are legitimate, deductible expenses that occur before the business has actually started, for example, a writer who spends the first two years of a career writing his or her first book. Since no manuscripts were produced and, more importantly, no marketing of any of the author's works was undertaken, all the deductions from the first two years would be deemed by the IRS to be start-up costs. If you have start-up costs, the expenses are added together and then written off (*amortized*) over five years.

In Closing...

We have looked at some of the larger expense issues and have seen how the IRS views these matters by looking at their publications. Now let us move on to more specific applications. In the next four chapters we will visit our four artists-in-residence in turn and see how all this information plays out in each of their returns.

3.

For Actors, Actresses, Directors, Dancers and Other Performers

In this chapter I will look in detail at the activities of our good friend Ima Starr and the kind of income and deductions she had for the year.

First, let's walk through some of the expense items for show biz folks specifically. I will also note in parentheses the type of record keeping the IRS would require:

1. Union dues, professional societies and organizations (invoices & checks)

2. Professional fees for agents, attorneys & accountants (invoices & checks)

3. Professional registries (both printed and on the Internet) including Players Guide, Academy Players, Role Call, Funny Face, etc. (invoices & checks)

4. Classes and coaching lessons (invoices & checks)

5. Cosmetics and dressing room supplies – This does not include street makeup, or what you use going to auditions, but does include makeup for showcases. The IRS can be very aggressive on makeup, so write the name of the show the makeup was used for on the back of the receipt (sales receipts, invoices, credit card receipt & checks).

6. Hair care – This must be for a specific job, not general, looking-for-work upkeep. I recommend that if a director wants you to change hairstyle or color and is not going to pay for it, ask to have a rider put into your contract stating this fact (sales receipts, invoice, credit card receipt & checks).

7. Photographs and resumes – including videos, CDs, CD-ROMs, DVDs and digital image transfers for use on the Internet or your personal Website (sales receipts, invoices, credit card receipt & checks)

8. Stationery and postage (sales receipts & checks)

9. Theatre & film books, scripts, musical scores, sheet music, batteries, tapes, CDs, etc. – these fall under the heading of supplies and may need to be allocated between employment income and contract income (sales receipts, invoices, credit card receipt & checks).

10. Telephone and cellular phone – actual business calls on your home phone are deductible, but the IRS does not allow the allocation of the base monthly rate. You can deduct only the actual long distance charges. The same rule is true with your cellular phone service. If you get a second phone line strictly for business then it can be considered 100% deductible (bills & checks).

11. Wardrobe – This is professional wardrobe, not conventional street wear! The rule says if you can wear it on the street, you can't deduct it. Remember that if the wardrobe is deductible, then the cleaning is as well. Write on the back of the bill the name of the show that the wardrobe was used in (sales receipts, invoices, credit card receipt & checks).

12. Viewing theatre, films, and concerts (live and via DVD, video and cable) – I often call this expense line item "research"; others refer to it as "performance audit." Whatever you call it, make sure to allocate some of this expense to personal use. After all you must sometimes take part in these activities for personal enjoyment, it can't be all business. I quote to clients the old Wall Street saying, "the pigs get fat and the hogs get slaughtered." This is the type of deduction that you must not get piggy with. While the IRS typically hates this deduction, it does clearly acknowledge its validity in its audit guidelines. In an audit you would need to explain specifically what the professional value was (ticket stubs, receipts & diary entries).

13. Promotional tickets – Only *your* ticket is deductible, not your date's. That is, unless your date is your agent, a producer or some other professional colleague (ticket stubs, receipts & diary entries).

14. Rehearsal hall rental - (invoices & check)

15. Accompanist, arranger, personal assistant, etc. – This person must have a defined business purpose. For instance if your assistant is paying your personal bills or engaging in non-business activities, their salary will not be deductible (bills, invoices & checks).

16. Office rent – you must be able to prove you need one (bills, invoices & checks)

17. Purchase of equipment – Computers & printers, cameras, video and sound equipment, etc. (bills, invoices & credit card receipt)

18. Repair of equipment used in your profession - Computers, musical instruments, sound & video equipment, cameras, etc. (bills, credit card receipts, invoices & checks)

19. Tax preparation, bookkeeping & accounting fees (bills, invoices & checks)

20. Demo tapes, videos, DVDs & commercial prints used in promotional activities (bills, invoices & checks)

21. Trade advertisements (bills, invoices, checks & credit card receipt)

22. Internet service – for research purposes, business e-mail and e-mail while on the road. Be sure to allocate some of the costs for personal use (bills, invoices & credit card receipt).

23. Trade papers and professional magazines (bills, invoices, checks & credit card receipt)

24. Backstage workers' tips – Remember, you cannot give these folks gifts (checks & diary entry).

25. Insurance (bills, invoices & checks)

26. Copyright fees (invoices & checks)

We already know our resident actor Ima has been very busy. She is a member of Actors' Equity and received multiple W-2s this year for her work in theatre and films. She was also a part time singer in the group The Blue Jazzbos. She had even found the time to do some modeling, and she had finally finished her book, one of those kiss-and-tell books about her life in show business. Luckily she downloaded our Excel® spreadsheet found on www.art-staxinfo.com for performers and loaded it on her notebook computer at the beginning of the tax year, and carefully tracked her expenses all year!

We will now review Ima's 1040 income tax return in detail—and remember you can download the current year's version from our website—www.artstaxinfo.com.

We'll review some of Ima's employment (W-2) income. In Chapter 1 we saw her W-2 from the Goodwrench Theatre in Philadelphia for her work in *Godspell*. We find out the Goodwrench is barely surviving, so it could not offer her any expense reimbursements. This means that Ima can deduct virtually all her costs while staying in Philadelphia. These include meals, using the Philadelphia per diem rate of $64 (in 2008 - www.gsa.gov), actual hotel accommodations, clothes cleaning, and telephone calls home. She can also deduct any professional costs associated with the show, wardrobe (if unsuited for street wear), scripts, etc.

Ima also had a small W-2 for some residual income from a TV production she was in the prior year.

Ima's next gig was a great job in California: a small part in a movie starring Mel Funn. Mel's production company, Springtime for Kaminsky, Inc., employed her. She was paid $40K on a W-2 for this work. Since the company paid all her transportation and living expenses she would have no deductions for those. (Both Actors' Equity and SAG operate "Accountable Plans" as far as expense reimbursements are concerned, which means that Ima's reimbursements will not usually appear on her W-2.) To prepare for her role she rented DVDs of all of Mr. Fun's movies and purchased a book about his life. She bought a new DVD player that together with these expenses would all be deductible as research on her Form 2106 (employee business expense). The DVD player will be depreciated over five years, or she could use the Section 179 election and write it all off this year. She may choose to allocate some of the DVD cost as personal expenses and write off only a percentage of the player. To do further research into the Mr. Funn's career Ima used her Internet service, making part of her Internet service deductible. All the expense associated with this job will be deducted on her 2106 Form.

All of Ima's W-2 forms will be aggregated and reported on line 7 of her 1040 form.

On the strength of some of the connections Ima made in California during the above-mentioned gig she made a second trip to California. Ima wanted to be certain the trip would be 100% deductible, so she set up appointments in advance and consulted *Variety* (a tax deductable expense) to see what open auditions and productions would be taking place during her stay. She needed to ensure that she had enough daily activity to show

the IRS that the trip was primarily for business. During her six-day stay in California Ima set up lunch appointments almost every day with various industry types who had job potential for her. She arranged in advance an appointment with folks in Mel Fun's production company regarding other potential film assignments. While in California Ima stayed with a friend at no cost to her, consequently there will be no deduction for hotel. She was able to take the $64 Los Angeles per diem rate for meals. Ima will be able to deduct her travel, taxi (or rental car), etc., as business related, and her meals with the industry types as business entertainment deductions. Ima dutifully wrote the "who, what, and where" of each meal in her electronic organizer which she later printed out to retain a hard copy for her permanent record. Indeed, she made notes in her organizer regarding all her business activity while in LA. By doing her homework and planning her trip in advance she had made it far more likely that an IRS agent would consider the trip a legitimate business deduction. What if Ima did not have a friend in LA to stay with—would she be able to deduct her hotel and non-entertainment meals while there? Absolutely yes! This trip will also be deducted on her Form 2106 because the expenses are related to her (potential) W-2 employment income.

As a result of this second visit to California Ima got a small part in a movie playing a famous woman aviator of the 1940s. To prepare for the role she searched the Internet and located an individual who owned a plane similar to the one this famous flyer would have flown. She offered to pay the plane's owner to take her flying and help give her a feel for the plane. This individual did not charge her, but she did have to travel some distance to meet with him. Because this research was for a particular role and had a clear, well-defined purpose all the costs associated with this trip will be fully deductible. Ima will need to have some evidence of the trip, such as a letter from the plane's owner or perhaps a photograph of her with the plane.

During the summer Ima landed some summer stock work on Cape Cod. The theatre offers no monetary reimbursement, but provides the players a place to live while there. Ima would have expenses for meals and incidentals, but obviously not for lodging. Ima uses the IRS per diem rates for all her meals and incidentals throughout the year. The daily rate for Martha's Vineyard on Cape Cod, MA (a designated high cost locality), is $64 a day for 2008. Of course, her mileage driving to the Cape, including the ferry, and auto use while there would be deductible on her Form 2106.

In late summer Ima had a chance to audition for a musical being staged in London's West End. She flew to London for the audition, and then decided

to stay on for several weeks for a vacation. Her agent had arranged for her to meet with other theatre and film folk while there. She and her accountant decided that she had spent about 30% of her time on clearly defined business-related activities. These activities included appointments with agents, casting directors, and other actors. She had kept business cards and made notes in her schedule book regarding each meeting so that she had records backing up the business purpose. To gauge what the British theatre scene was like she attended some performances. The IRS might balk at these theatre ticket expenses, but Ima figures it is worth a try. She kept all the ticket stubs and noted the business reason in her diary. Because the trip was outside the US and more than 25% of the trip was personal, Ima will prorate the trip's costs, taking only 30% as a business expense. As this would be potential W-2 income these deductions are found on her Form 2106.

Next Ima goes on a tour singing with The Blue Jazzbos. This activity will be reported on its own Schedule C on her 1040. It was a short southern tour with no expenses reimbursed. She had considered setting up an LLC with her bandmates but it seemed too complicated for such a small tour. It was decided that she would declare all the income from the tour on her tax return and then pay her band as sidemen as a deduction. This will be her largest expense and she will need to make sure she obtains their names, addresses and social security numbers as she will need to have her accountant issue them 1099s at year end (this expense will be found as part of line 4 of her Schedule C).

Ima also decided to purchase a new sound system and microphone, as the one she had been using was no longer adequate and she was not sure if the clubs would have PA systems.

The income from the tour will be reported on Ima's schedule C because it is self-employment income. The depreciation for the sound system and microphone will be written off over five years and deducted on her Schedule C, as will all her travel expenses. To help her work up a Peggy Lee medley for the tour, Ima purchases a new box set of CDs by Ms. Lee; this will become another expense on her Schedule C. Ima also took a few lessons, which are tax deductible, from a noted New York singer in regards to matters of stage presence. The leader of the Jazzbos wanted the band members to get new formal wear for the tour. As you know, for clothing to be deductible it has to be:

1. Required to keep your job;
2. Not suitable for wear when not working

Ima bought an evening gown expressly for this tour. This is not a clear-cut deduction, but the IRS has allowed the deduction of formal wear for musicians. If Ima can deduct the clothing, she can also deduct the cleaning of the gown.

The band members will also have some income from selling copies of their self-produced CD. Copies of the CD that Ima purchases to sell will become a "cost of goods sold" on her Schedule C.

Back in New York, Ima did a series of small modeling assignments. These were all paid as contract income and other than some mileage expenses traveling between jobs she did not have any direct expenses. For simplicity, and because the modeling income was relatively low, Ima's tax preparer chose to include this income as part of her "Jazzbos" Schedule C.

Because Ima is fairly well known in NYC she had a unique opportunity to endorse a well-known local brand of pizza during the year. The small pizzeria chain starred Ima in its local cable TV ad. In addition to her pay, she received free pizza for a year. At the end of the year the pizzeria chain estimated that Ima had received about $550 worth of pizza. Ima declared the $550 value of the pizza as self-employment income on her modeling Schedule C.

Ima received her first $13K advance royalty income from her book in January. This income will be reported on a separate Schedule C. She had allocated some expenses for her home office, computer, printer, office supplies, Internet use, etc. She added the expense of a writing class she had taken at Columbia University earlier in the year while she was finishing her book. For the Columbia class Ima has the choice of using the Lifetime Learning credit or taking the expense as a deduction on her Schedule C form. Her accountant will calculate it both ways to see which yields the most tax benefit. She included some research expense, as she had purchased and read some other famous Hollywood and theatre memoirs. In May, as she was finishing her book, she flew out to California to visit with a colleague to check on the accuracy of some incidents she had used. She was in LA for two days interviewing her friend. The entire costs of this trip would be deductible against her book income.

In response to some bootleg videos showing up on YouTube, Ima decided that she wanted to set up a personal website, where she could post her resume, pictures, sound and video clips of her singing with The Blue Jazzbos, and perhaps even some video clips from her acting. The costs of setting up the website, registering her domain name and hosting the site will all be deductible. The IRS stipulates that website development be written off (amor-

tized) over three years. So all the costs of setting up and designing the site will be added up (capitalized) and expensed over three years.

In the fall Ima decided to purchase some video equipment to experiment with filmmaking and allow her to shoot her own promotional videos. Because it is directly related to her career, the cost of the equipment will be deductible. She did not have the cash to purchase the equipment outright, so she charged it on her credit card and is paying a little off each month. The full cost of the equipment will be deductible in the current year and will be depreciated over five years.

Near the end of the year, an audition opportunity in Chicago came up. Ima arrived in Chicago on Monday evening and had her audition on Tuesday morning. She waited in town to hear back from the director on Wednesday. On Wednesday afternoon she received a callback, and met with the director again on Thursday morning. After the callback, she decided to stay on and visit with a friend for a few days; she returned to NYC on Sunday. She can clearly show that a preponderance of time was spent in directly related business activities. Therefore 100% of her airline travel expenses to Chicago would be deductible. Her other expenses, such as hotel, meals and incidentals, would be fully deductible through Thursday (the day the business part of the trip ended). The meals and lodging expenses while she was visiting her friend would not be deductible. FIY: If the scales tip the other way and the trip begins to be more personal than business, none of the travel expense is deductible. These expenses would be found on her Form 2106.

Ima is considering moving to California and calls her accountant to ask him or her if the move would be deductible. She finds out that she has two main criteria to meet. The first concerns distance, the second relates to time. Here are the details from IRS Publication 521:

1. Your move will meet the distance test if your new main job location is at least 50 miles farther from your former home than your old main job location was from your former home. For example, if your old job was 3 miles from your former home, your new job must be at least 53 miles from that former home.

2. If you are an employee, you must work full time for at least 39 weeks during the first 12 months after you arrive in the general area of your new job location. For this time test, count only your full-time work as an employee; do not count any work you do as a self-employed person. You do not have to work for the same employer for the 39 weeks. You do not have to work 39 weeks in a row. However, you must work full time within the same general

> commuting area. Full-time employment depends on what is usual
> for your type of work in your area.

The moving deduction can be a difficult issue for folks in the arts such as Ima. Employment and income are often not consistent, thus making it hard to meet the 39-week rule. The key phrase to focus on is: *employment depends on what is usual for your type of work in your area.* Ima will have to be ready to argue that her employment and work circumstances were typical for her acting, singing and modeling jobs.

If she thinks she will have a tax-deductible move she will be saving receipts for the following costs according to the IRS Publication 521:

1. Moving your household goods and personal effects (including in-transit storage expenses), and

2. Traveling (including lodging but not meals) to your new home.

Actors, Directors, & other Performing Artists

Continuing Education

Coaching & Lessons	
Dance Training	
Music - Arrangements	
Tapes, CDs & Recordings	
Training	
Rents - Rehearsal Hall	
Tickets - Performance Audit/Research	
Voice Training	
Other: _____	

Promotional Expenses

Audition Tapes, Videos & DVDs	
Business Cards	
Film & Processing	
Mailing Supplies - Envelopes, etc.	
Photos - Professional	
Website Development & Hosting	
Resume' and Portfolio Expenses	
Other: _____	

Supplies & Other Expenses

Alterations/Repairs (costumes)	
Cleaning (costumes/wardrobe)	
Costumes - Wardrobe (special business)	
Dues - Union & Professional	
Gifts - Business ($25 maximum per person per year)	
Insurance - Equipment	
Interest - Business Loans	
Makeup - Cosmetics (special business)	
Manicure - (special for hand inserts)	
Meals - Business (100% of cost)	
Photocopy - Scripts, etc.	
Postage & Office Supplies	
Props, Stunt Supplies	
Publications - Trade	
Rents - Office, Storage, etc.	
Rents - Equipment, Costumes, etc.	
Repairs - Equipment	
Secretarial & Bookkeeping	
Commissions - Agent/Manager	
Other: _____	

Auto Travel (in miles)

Auditions	
Business Meetings	
Continuing Education	
Job Seeking	
Out-Of-Town Business Trips	
Purchasing Job Supplies & Materials	
Professional Society Meetings	
Parking Fees & Tolls	
Other: _____	

Travel - Out of Town

Airfare	
Car Rental	
Parking	
Taxi, Train, Bus & Subway	
Lodging (do not combine with meals)	
Apartment Rent (jobs lasting less than 1 year)	
Meals (do not combine with lodging)	
Laundry and Porter	
Bridge & Highway Tolls	
Telephone Calls (including home)	
Other: _____	

Telephone Costs

Cellular Calls	
FAX Transmissions	
Online Services	
Paging Service	
Pay Phone	
Toll Calls	
Other: _____	

Equipment Purchases

Answering Machine	
Personal Digital Assistants (PDAs)	
Audio Systems	
Musical Instruments	
Pager and Recorder	
Camera & Video Equipment	
Speaker Systems	
Computers, Software & Printers	
Office Furniture	
Other: _____	

```
Meals Detail Form 2106 - Line 5

     Philadelphia 14 days x $64          896.00          896.00
     LA 6 days x $64                     384.00          384.00
     Cape Cod 14 days x $64              896.00          896.00
     London $941 x 30%                   282.00          282.00
     Chicago Meals 3 days x $64          192.00          192.00
     Other professional meals           411.00          411.00
                                      ─────────        ─────────
                                      3,061.00         3,061.00
                                      ═════════        ═════════

Travel Detail Form 2106 - Line 3

     Hotel - Philadelphia             1,346.00         1,346.00
     Airline - LA trip                  501.00          501.00
     Taxi/Rental Car - LA               324.00          324.00
     Ferry - Cape Cod                    52.00           52.00
     London - $1949 x 30%               588.00          588.00
     Chicago Audition Airfare           389.00          389.00
     Chicago Hotel                      578.00          578.00
     Chicago Taxi                        88.00           88.00
                                      ─────────        ─────────
                                      3,866.00         3,866.00
                                      ═════════        ═════════
```

List

Form **1040** U.S. Individual Income Tax Return **2008** (99) IRS Use Only - Do not write or staple in this space.

For the year Jan. 1-Dec. 31, 2008, or other tax year beginning ____ , 2008, ending ____ , 20 ____ OMB No. 1545-0074

Label
(See instructions on page 14.)

Use the IRS label. Otherwise, please print or type.

Your first name and initial	Last name	Your social security number
Ima	Starr	111 22 2333
If a joint return, spouse's first name and initial	Last name	Spouse's social security number

Home address (number and street). If you have a P.O. box, see page 14. | Apt. no.
5th Ave | 9

City, town or post office, state, and ZIP code. If you have a foreign address, see page 14.
New York, NY 10019

You must enter ▲ your SSN(s) above. ▲

Checking a box below will not change your tax or refund.

Presidential Election Campaign ▶ Check here if you, or your spouse if filing jointly, want $3 to go to this fund (see page 14) ▶ ☐ You ☐ Spouse

Filing Status

Check only one box.

1 ☒ Single
2 ☐ Married filing jointly (even if only one had income)
3 ☐ Married filing separately. Enter spouse's SSN above and full name here. ▶
4 ☐ Head of household (with qualifying person). If the qualifying person is a child but not your dependent, enter this child's name here. ▶
5 ☐ Qualifying widow(er) with dependent child (see page 16)

Exemptions

6a ☒ Yourself. If someone can claim you as a dependent, **do not** check box 6a
b ☐ Spouse

Boxes checked on 6a and 6b	1

c Dependents:

(1) First name Last name	(2) Dependent's social security number	(3) Dependent's relationship to you	(4) ✓ if qualifying child for child tax credit (see page 17)

No. of children on 6c who:
● lived with you ____
● did not live with you due to divorce or separation (see page 18) ____

If more than four dependents, see page 17.

Dependents on 6c not entered above ____

d Total number of exemptions claimed | Add numbers on lines above ▶ | 1 |

Income

Attach Form(s) W-2 here. Also attach Forms W-2G and 1099-R if tax was withheld.

If you did not get a W-2, see page 21.

Enclose, but do not attach, any payment. Also, please use Form 1040-V.

7	Wages, salaries, tips, etc. Attach Form(s) W-2	7	49,905.		
8a	Taxable interest. Attach Schedule B if required	8a	19.		
b	Tax-exempt interest. **Do not** include on line 8a	8b			
9a	Ordinary dividends. Attach Schedule B if required	9a			
b	Qualified dividends (see page 21)	9b			
10	Taxable refunds, credits, or offsets of state and local income taxes	10			
11	Alimony received	11			
12	Business income or (loss). Attach Schedule C or C-EZ	12	5,359.		
13	Capital gain or (loss). Attach Schedule D if required. If not required, check here ▶ ☐	13			
14	Other gains or (losses). Attach Form 4797	14			
15a	IRA distributions	15a	b Taxable amount	15b	
16a	Pensions and annuities	16a	b Taxable amount	16b	
17	Rental real estate, royalties, partnerships, S corporations, trusts, etc. Attach Schedule E	17			
18	Farm income or (loss). Attach Schedule F	18			
19	Unemployment compensation	19			
20a	Social security benefits	20a	b Taxable amount (see page 26)	20b	
21	Other income. List type and amount (see page 28) Muddy Mudskippers BBQ - Prize Income 1,000.	21	1,000.		
22	Add the amounts in the far right column for lines 7 through 21. This is your **total income** ▶	22	56,283.		

Adjusted Gross Income

23	Educator expenses (see page 28)	23	
24	Certain business expenses of reservists, performing artists, and fee-basis government officials. Attach Form 2106 or 2106-EZ	24	
25	Health savings account deduction. Attach Form 8889	25	
26	Moving expenses. Attach Form 3903	26	
27	One-half of self-employment tax. Attach Schedule SE	27	379.
28	Self-employed SEP, SIMPLE, and qualified plans	28	
29	Self-employed health insurance deduction (see page 29)	29	
30	Penalty on early withdrawal of savings	30	
31a	Alimony paid b Recipient's SSN ▶	31a	
32	IRA deduction (see page 30)	32	
33	Student loan interest deduction (see page 33)	33	
34	Tuition and fees deduction. Attach Form 8917	34	
35	Domestic production activities deduction. Attach Form 8903	35	
36	Add lines 23 through 31a and 32 through 35	36	379.
37	Subtract line 36 from line 22. This is your **adjusted gross income** ▶	37	55,904.

810001
11-10-08

LHA **For Disclosure, Privacy Act, and Paperwork Reduction Act Notice, see page 88.** Form **1040** (2008)

Form 1040 (2008) Ima Starr 111-22-2333 Page 2

Tax and Credits	**38**	Amount from line 37 (adjusted gross income)		**38**	55,904.

39a Check if: ☐ **You** were born before January 2, 1944, ☐ Blind. ☐ **Spouse** was born before January 2, 1944, ☐ Blind. } **Total boxes checked** ► **39a** ☐

b If your spouse itemizes on a separate return or you were a dual-status alien, see page 34 and check here ► **39b** ☐

c Check if standard deduction includes real estate taxes or disaster loss (see page 34) ► **39c** ☐

40 Itemized deductions (from Schedule A) **or** your **standard deduction** (see left margin)	**40**	10,793.
41 Subtract line 40 from line 38	**41**	45,111.
42 If line 38 is over $119,975, or you provided housing to a Midwestern displaced individual, see page 36. Otherwise, multiply $3,500 by the total number of exemptions claimed on line 6d	**42**	3,500.
43 Taxable income. Subtract line 42 from line 41. If line 42 is more than line 41, enter -0-	**43**	41,611.
44 Tax. Check if any tax is from: **a** ☐ Form(s) 8814 **b** ☐ Form 4972	**44**	6,750.
45 Alternative minimum tax. Attach Form 6251	**45**	0.
46 Add lines 44 and 45 ►	**46**	6,750.

Standard Deduction for -
● People who checked any box on line 39a, 39b, or 39c **or** who can be claimed as a dependent.
● All others:
Single or Married filing separately, $5,450
Married filing jointly or Qualifying widow(er), $10,900
Head of household, $8,000

47 Foreign tax credit. Attach Form 1116 if required	**47**	
48 Credit for child and dependent care expenses. Attach Form 2441	**48**	
49 Credit for the elderly or the disabled. Attach Schedule R	**49**	
50 Education credits. Attach Form 8863	**50**	
51 Retirement savings contributions credit. Attach Form 8880	**51**	
52 Child tax credit (see page 42). Attach Form 8901 if required	**52**	
53 Credits from Form: **a** ☐ 8396 **b** ☐ 8839 **c** ☐ 5695	**53**	
54 Other credits from Form: **a** ☐ 3800 **b** ☐ 8801 **c** ☐	**54**	
55 Add lines 47 through 54. These are your total credits	**55**	
56 Subtract line 55 from line 46. If line 55 is more than line 46, enter -0- ►	**56**	6,750.

Other Taxes	**57** Self-employment tax. Attach Schedule SE	**57**	757.
	58 Unreported social security and Medicare tax from Form: **a** ☐ 4137 **b** ☐ 8919	**58**	
	59 Additional tax on IRAs, other qualified retirement plans, etc. Attach Form 5329 if required	**59**	
	60 Additional taxes: **a** ☐ AEIC payments **b** ☐ Household employment taxes. Attach Schedule H	**60**	
	61 Add lines 56 through 60. This is your total tax ►	**61**	7,507.

Payments	**62** Federal income tax withheld from Forms W-2 and 1099	**62**	7,530.	
	63 2008 estimated tax payments and amount applied from 2007 return	**63**		
	64a Earned income credit (EIC)	**64a**		
	b Nontaxable combat pay election ► 64b			
	65 Excess social security and tier 1 RRTA tax withheld (see page 61)	**65**		
	66 Additional child tax credit. Attach Form 8812	**66**		
	67 Amount paid with request for extension to file (see page 61)	**67**		
	68 Credits from Form: **a** ☐ 2439 **b** ☐ 4136 **c** ☐ 8801 **d** ☐ 8885	**68**		
	69 First-time homebuyer credit. Attach Form 5405	**69**		
	70 Recovery rebate credit (see worksheet on pages 62 and 63)	**70**		
	71 Add lines 62 through 70. These are your total payments ►	**71**	7,530.	

If you have a qualifying child, attach Schedule EIC.

Refund	**72** If line 71 is more than line 61, subtract line 61 from line 71. This is the amount you overpaid	**72**	23.
	73a Amount of line 72 you want refunded to you. If Form 8888 is attached, check here ► ☐	**73a**	23.
	b Routing number ☐☐☐ ► **c** Type: ☐ Checking ☐ Savings **d** Account number ☐☐☐		
	74 Amount of line 72 you want applied to your 2009 estimated tax ► **74**		

Direct deposit? See page 63 and fill in 73b, 73c, and 73d, or Form 8888.

Amount You Owe	**75** Amount you owe. Subtract line 71 from line 61. For details on how to pay, see page 65 ►	**75**	
	76 Estimated tax penalty (see page 65)	**76**	

Third Party Designee Do you want to allow another person to discuss this return with the IRS (see page 66)? ☒ **Yes.** Complete the following. ☐ **No**

Designee's name ► **Preparer** Phone no. ► Personal identification number (PIN) ►

Sign Here
Under penalties of perjury, I declare that I have examined this return and accompanying schedules and statements, and to the best of my knowledge and belief, they are true, correct, and complete. Declaration of preparer (other than taxpayer) is based on all information of which preparer has any knowledge.

Joint return? See page 15. Keep a copy for your records.

Your signature | Date | Your occupation **Performer/Writer** | Daytime phone number

Spouse's signature. If a joint return, **both** must sign. | Date | Spouse's occupation

Paid Preparer's Use Only

Preparer's signature ► **Peter Jason Riley, CPA**	Date **12/13/09**	Check if self-employed ☐	Preparer's SSN or PTIN **P00413102**
Firm's name (or yours if self-employed), address, and ZIP code ► **Riley & Associates, P.C.** **P.O. Box 157** **Newburyport, MA 01950-0157**		EIN **04 3577120** Phone no **978-463-9350**	

810002 11-10-08

SCHEDULES A&B (Form 1040) Department of the Treasury Internal Revenue Service (99)	Schedule A - Itemized Deductions (Schedule B is on page 2) ▶ Attach to Form 1040. ▶ See Instructions for Schedules A&B (Form 1040).	OMB No. 1545-0074 **2008** Attachment Sequence No. **07**

Name(s) shown on Form 1040

Ima Starr

Your social security number: 111 22 2333

Medical and Dental Expenses		Caution. Do not include expenses reimbursed or paid by others.			
	1	Medical and dental expenses (see page A-1)	1		
	2	Enter amount from Form 1040, line 38	2		
	3	Multiply line 2 by 7.5% (.075)	3		
	4	Subtract line 3 from line 1. If line 3 is more than line 1, enter -0-		4	
Taxes You Paid (See page A-2.)	5	State and local (check only one box): a [X] Income taxes, or b [] General sales taxes	5	2,854.	
	6	Real estate taxes (see page A-5)	6		
	7	Personal property taxes	7	204.	
	8	Other taxes. List type and amount ▶ _____			
	9	Add lines 5 through 8	8		
			9	3,058.	
Interest You Paid (See page A-5.) **Note.** Personal interest is not deductible.	10	Home mortgage interest and points reported to you on Form 1098	10		
	11	Home mortgage interest not reported to you on Form 1098. If paid to the person from whom you bought the home, see page A-6 and show that person's name, identifying no., and address ▶ _____	11		
	12	Points not reported to you on Form 1098	12		
	13	Qualified mortgage insurance premiums (See page A-6)	13		
	14	Investment interest. Attach Form 4952 if required. (See page A-6.)	14		
	15	Add lines 10 through 14		15	
Gifts to Charity If you made a gift and got a benefit for it, see page A-7.	16	Gifts by cash or check	16	325.	
	17	Other than by cash or check. If any gift of $250 or more, see page A-8. You **must** attach Form 8283 if over $500	17		
	18	Carryover from prior year	18		
	19	Add lines 16 through 18		19	325.
Casualty and Theft Losses	20	Casualty or theft loss(es). Attach Form 4684. (See page A-8.)		20	
Job Expenses and Certain Miscellaneous Deductions (See page A-9.)	21	Unreimbursed employee expenses - job travel, union dues, job education, etc. Attach Form 2106 or 2106-EZ if required. (See page A-9.) ▶From Form 2106-EZ _____ 8,528.	21	8,528.	
	22	Tax preparation fees	22		
	23	Other expenses - investment, safe deposit box, etc. List type and amount ▶ _____	23		
	24	Add lines 21 through 23	24	8,528.	
	25	Enter amount from Form 1040, line 38	25	55,904.	
	26	Multiply line 25 by 2% (.02)	26	1,118.	
	27	Subtract line 26 from line 24. If line 26 is more than line 24, enter -0-		27	7,410.
Other Miscellaneous Deductions	28	Other - from list on page A-10. List type and amount ▶ _____		28	
Total Itemized Deductions	29	Is Form 1040, line 38, over $159,950 (over $79,975 if married filing separately)? [X] **No.** Your deduction is not limited. Add the amounts in the far right column for lines 4 through 28. Also, enter this amount on Form 1040, line 40. [] **Yes.** Your deduction may be limited. See page A-10 for the amount to enter.	29	10,793.	
	30	If you elect to itemize deductions even though they are less than your standard deduction, check here ▶ []			

LHA 819501 11-10-08 **For Paperwork Reduction Act Notice, see Form 1040 instructions.**

Schedule A (Form 1040) 2008

3

56

New Tax Guide

OMB No. 1545-0074 **Page 2**

Name(s) shown on Form 1040. Do not enter name and social security number if shown on page 1.

Your social security number

Ima Starr

111 22 2333

Schedule B - Interest and Ordinary Dividends

Attachment Sequence No. **08**

Part I
Interest

1 List name of payer. If any interest is from a seller-financed mortgage and the buyer used the property as a personal residence, see page B-1 and list this interest first. Also, show that buyer's social security number and address ▶

Amount

Bank of NY 19.

Note. If you received a Form 1099-INT, Form 1099-OID, or substitute statement from a brokerage firm, list the firm's name as the payer and enter the total interest shown on that form.

1

2 Add the amounts on line 1 | 2 | 19.
3 Excludable interest on series EE and I U.S. savings bonds issued after 1989. Attach Form 8815 | 3 |
4 Subtract line 3 from line 2. Enter the result here and on Form 1040, line 8a ▶ | 4 | 19.

Note. If line 4 is over $1,500, you must complete Part III.

Part II
Ordinary Dividends

5 List name of payer ▶

Amount

Note: If you received a Form 1099-DIV or substitute statement from a brokerage firm, list the firm's name as the payer and enter the ordinary dividends shown on that form.

5

6 Add the amounts on line 5. Enter the total here and on Form 1040, line 9a ▶ | 6 |

Note. If line 6 is over $1,500, you must complete Part III.

Part III
Foreign Accounts and Trusts

You must complete this part if you **(a)** had over $1,500 of taxable interest or ordinary dividends; or **(b)** had a foreign account; or **(c)** received a distribution from, or were a grantor of, or a transferor to, a foreign trust.

Yes | **No**

7a At any time during 2008, did you have an interest in or a signature or other authority over a financial account in a foreign country, such as a bank account, securities account, or other financial account? See page B-2 for exceptions and filing requirements for Form TD F 90-22.1 | | X

b If "Yes," enter the name of the foreign country ▶

8 During 2008, did you receive a distribution from, or were you the grantor of, or transferor to, a foreign trust? If "Yes," you may have to file Form 3520. See page B-2 | | X

827501 11-11-08
LHA **For Paperwork Reduction Act Notice, see Form 1040 instructions.** **Schedule B (Form 1040) 2008**

4

SCHEDULE C
(Form 1040)
Department of the Treasury
Internal Revenue Service (99)

Profit or Loss From Business
(Sole Proprietorship)
▶ Partnerships, joint ventures, etc., generally must file Form 1065 or 1065-B.
▶ Attach to Form 1040, 1040NR, or 1041. ▶See Instructions for Schedule C (Form 1040).

OMB No. 1545-0074

2008

Attachment
Sequence No. **09**

Name of proprietor	Social security number (SSN)
Ima Starr	111-22-2333

A	Principal business or profession, including product or service (see page C-3)	B Enter code from pages C-9, 10, & 11
Writer		▶ 711510

C	Business name. If no separate business name, leave blank.	D Employer ID number (EIN), if any
Ima Starr		

E Business address (including suite or room no.) ▶ 5th Ave
City, town or post office, state, and ZIP code New York, NY 10019

F Accounting method: (1) [X] Cash (2) ☐ Accrual (3) ☐ Other (specify) ▶ _____

G Did you "materially participate" in the operation of this business during 2008? If "No," see page C-4 for limit on losses [X] Yes ☐ No

H If you started or acquired this business during 2008, check here ▶ ☐

Part I Income

1	Gross receipts or sales. Caution. See page C-4 and check the box if:			
	● This income was reported to you on Form W-2 and the "Statutory employee" box on that form was checked, or	▶ ☐	1	13,000.
	● You are a member of a qualified joint venture reporting only rental real estate income not subject to self-employment tax. Also see page C-4 for limit on losses.			
2	Returns and allowances	2		
3	Subtract line 2 from line 1	3	13,000.	
4	Cost of goods sold (from line 42 on page 2)	4		
5	Gross profit. Subtract line 4 from line 3	5	13,000.	
6	Other income, including federal and state gasoline or fuel tax credit or refund (see page C-5)	6		
7	Gross income. Add lines 5 and 6	▶ 7	13,000.	

Part II Expenses. Enter expenses for business use of your home only on line 30.

8	Advertising	8		18	Office expense	18	89.
9	Car and truck expenses (see page C-5)	9	513	19	Pension and profit-sharing plans	19	
10	Commissions and fees	10		20	Rent or lease (see page C-6):		
11	Contract labor (see page C-5)	11		a	Vehicles, machinery, and equipment	20a	
12	Depletion	12		b	Other business property	20b	
13	Depreciation and section 179 expense deduction (not included in Part III) (see page C-5)	13	305.	21	Repairs and maintenance	21	
				22	Supplies (not included in Part III)	22	
				23	Taxes and licenses	23	
14	Employee benefit programs (other than on line 19)	14		24	Travel, meals, and entertainment:		
				a	Travel	24a	489.
15	Insurance (other than health)	15		b	Deductible meals and entertainment (see page C-7)	24b	32.
16	Interest:			25	Utilities	25	
a	Mortgage (paid to banks, etc.)	16a		26	Wages (less employment credits)	26	
b	Other	16b		27	Other expenses (from line 48 on page 2)	27	4,816.
17	Legal and professional services	17	100.				

28	Total expenses before expenses for business use of home. Add lines 8 through 27	▶	28	6,344.
29	Tentative profit or (loss). Subtract line 28 from line 7		29	6,656.
30	Expenses for business use of your home. Attach Form 8829		30	2,653.
31	Net profit or (loss). Subtract line 30 from line 29.			
	● If a profit, enter on both Form 1040, line 12, and Schedule SE, line 2, or on Form 1040NR, line 13 (if you checked the box on line 1, see page C-7). Estates and trusts, enter on Form 1041, line 3.	}	31	4,003.
	● If a loss, you must go to line 32.			
32	If you have a loss, check the box that describes your investment in this activity (see page C-8).			
	● If you checked 32a, enter the loss on both Form 1040, line 12, and Schedule SE, line 2, or on Form 1040NR, line 13 (if you checked the box on line 1, see the line 31 instructions on page C-7). Estates and trusts, enter on Form 1041, line 3.	}	32a ☐	All investment is at risk.
	● If you checked 32b, you must attach Form 6198. Your loss may be limited.		32b ☐	Some investment is not at risk.

LHA For Paperwork Reduction Act Notice, see page C-9 of the instructions.

Schedule C (Form 1040) 2008

820001 11-20-08

5

Schedule C (Form 1040) 2008 **IMA STARR** 111-22-2333 Page **2**

Part III	**Cost of Goods Sold** (see page C-8)		

33 Method(s) used to value closing inventory: **a** ☐ Cost **b** ☐ Lower of cost or market **c** ☐ Other (attach explanation)

34 Was there any change in determining quantities, costs, or valuations between opening and closing inventory? If "Yes," attach explanation ... ☐ Yes ☐ No

35	Inventory at beginning of year. If different from last year's closing inventory, attach explanation	**35**	
36	Purchases less cost of items withdrawn for personal use	**36**	
37	Cost of labor. Do not include any amounts paid to yourself	**37**	
38	Materials and supplies	**38**	
39	Other costs	**39**	
40	Add lines 35 through 39	**40**	
41	Inventory at end of year	**41**	
42	**Cost of goods sold.** Subtract line 41 from line 40. Enter the result here and on page 1, line 4	**42**	

Part IV	**Information on Your Vehicle.** Complete this part **only** if you are claiming car or truck expenses on line 9 and are not required to file Form 4562 for this business. See the instructions for line 13 on page C-5 to find out if you must file Form 4562.

43 When did you place your vehicle in service for business purposes? (month, day, year) ▶ / / .

44 Of the total number of miles you drove your vehicle during 2008, enter the number of miles you used your vehicle for:

a Business _____ **b** Commuting _____ **c** Other _____

45 Was your vehicle available for personal use during off-duty hours? .. ☐ Yes ☐ No

46 Do you (or your spouse) have another vehicle available for personal use? ☐ Yes ☐ No

47a Do you have evidence to support your deduction? ... ☐ Yes ☐ No

 b If "Yes," is the evidence written? .. ☐ Yes ☐ No

Part V	**Other Expenses.** List below business expenses not included on lines 8-26 or line 30.		
Education		2,124.	
Research - Books		299.	
Internet		189.	
Cell Phone		204.	
Agent Commission		2,000.	
48	**Total other expenses.** Enter here and on page 1, line 27	**48**	4,816.

820002 11-20-08 Schedule C (Form 1040) 2008

2008 DEPRECIATION AND AMORTIZATION REPORT

Ima Starr

SCHEDULE C - 2

Asset No.	Description	Date Acquired	Method	Life	Line No.	Unadjusted Cost Of Basis	Bus % Excl	Reduction In Basis	Basis For Depreciation	Accumulated Depreciation	Current Sec 179	Current Year Deduction
4	Powerbook and Printer	070108	200DB	5.00	19B	1,523.			1,523.			305.
	Total Sch C Depr. & Amortization					1,523.			1,523.			305.

828102
04-25-08

(D) - Asset disposed

* ITC, Section 179, Salvage, Bonus, Commercial Revitalization Deduction, GO Zone

6.1

SCHEDULE C
(Form 1040)
Department of the Treasury
Internal Revenue Service (99)

Profit or Loss From Business
(Sole Proprietorship)
▶ Partnerships, joint ventures, etc., generally must file Form 1065 or 1065-B.
▶ Attach to Form 1040, 1040NR, or 1041. ▶ See Instructions for Schedule C (Form 1040).

OMB No. 1545-0074

2008

Attachment
Sequence No. **09**

Name of proprietor	Social security number (SSN)
Ima Starr	111-22-2333

A Principal business or profession, including product or service (see page C-3)
Musical Group/Modeling

B Enter code from pages C-9, 10, & 11
▶ 711510

C Business name. If no separate business name, leave blank.
The Blue Jazzbos

D Employer ID number (EIN), if any

E Business address (including suite or room no.) ▶ 5th Ave.
City, town or post office, state, and ZIP code New York, NY 10019

F Accounting method: (1) [X] Cash (2) ☐ Accrual (3) ☐ Other (specify) ▶

G Did you "materially participate" in the operation of this business during 2008? If "No," see page C-4 for limit on losses [X] Yes ☐ No

H If you started or acquired this business during 2008, check here ▶ ☐

Part I Income

1	Gross receipts or sales. **Caution.** See page C-4 and check the box if: • This income was reported to you on Form W-2 and the "Statutory employee" box on that form was checked, or • You are a member of a qualified joint venture reporting only rental real estate income not subject to self-employment tax. Also see page C-4 for limit on losses. ▶ ☐	1	12,620.
2	Returns and allowances	2	
3	Subtract line 2 from line 1	3	12,620.
4	Cost of goods sold (from line 42 on page 2)	4	6,179.
5	**Gross profit.** Subtract line 4 from line 3	5	6,441.
6	Other income, including federal and state gasoline or fuel tax credit or refund (see page C-4) See Statement 1	6	2,445.
7	**Gross income.** Add lines 5 and 6 ▶	7	8,886.

Part II Expenses. Enter expenses for business use of your home **only** on line 30.

8	Advertising	8		18	Office expense	18	
9	Car and truck expenses (see page C-5)	9	1,606	19	Pension and profit-sharing plans	19	
10	Commissions and fees	10		20	Rent or lease (see page C-6):		
11	Contract labor (see page C-5)	11		a	Vehicles, machinery, and equipment	20a	
12	Depletion	12		b	Other business property	20b	
13	Depreciation and section 179 expense deduction (not included in Part III) (see page C-5)	13	754.	21	Repairs and maintenance	21	
				22	Supplies (not included in Part III)	22	204.
				23	Taxes and licenses	23	
14	Employee benefit programs (other than on line 19)	14		24	Travel, meals, and entertainment:		
15	Insurance (other than health)	15		a	Travel	24a	1,944.
16	Interest:			b	Deductible meals and entertainment (see page C-7)	24b	725.
a	Mortgage (paid to banks, etc.)	16a		25	Utilities	25	
b	Other	16b		26	Wages (less employment credits)	26	
17	Legal and professional services	17	100.	27	Other expenses (from line 48 on page 2)	27	2,197.

28	**Total expenses** before expenses for business use of home. Add lines 8 through 27 ▶	28	7,530.
29	Tentative profit or (loss). Subtract line 28 from line 7	29	1,356.
30	Expenses for business use of your home. Attach Form 8829	30	
31	**Net profit or (loss).** Subtract line 30 from line 29. • If a profit, enter on both **Form 1040, line 12,** and **Schedule SE, line 2,** or on **Form 1040NR, line 13** (if you checked the box in line 1, see page C-7). Estates and trusts, enter on **Form 1041, line 3.** • If a loss, you **must** go to line 32.	31	1,356.
32	If you have a loss, check the box that describes your investment in this activity (see page C-8). • If you checked 32a, enter the loss on both **Form 1040, line 12,** and **Schedule SE, line 2,** or on **Form 1040NR, line 13** (if you checked the box on line 1, see the line 31 instructions on page C-7). Estates and trusts, enter on **Form 1041, line 3.** • If you checked 32b, you **must** attach **Form 6198.** Your loss may be limited.	32a ☐ All investment is at risk. 32b ☐ Some investment is not at risk.	

LHA **For Paperwork Reduction Act Notice, see page C-9 of the instructions.**

820001 11-20-08

Schedule C (Form 1040) 2008

7

Schedule C (Form 1040) 2008 IMA STARR 111-22-2333 Page **2**

Part III | Cost of Goods Sold (see page C-8)

33	Method(s) used to value closing inventory: **a** ☐ Cost **b** ☐ Lower of cost or market **c** ☐ Other (attach explanation)		

34 Was there any change in determining quantities, costs, or valuations between opening and closing inventory? If "Yes," attach explanation .. ☐ Yes ☐ No

35	Inventory at beginning of year. If different from last year's closing inventory, attach explanation	35	
36	Purchases less cost of items withdrawn for personal use	36	199.
37	Cost of labor. Do not include any amounts paid to yourself	37	
38	Materials and supplies	38	
39	Other costs See Statement 2	39	5,980.
40	Add lines 35 through 39	40	6,179.
41	Inventory at end of year	41	
42	**Cost of goods sold.** Subtract line 41 from line 40. Enter the result here and on page 1, line 4	42	6,179.

Part IV | Information on Your Vehicle. Complete this part **only** if you are claiming car or truck expenses on line 9 and are not required to file Form 4562 for this business. See the instructions for line 13 on page C-5 to find out if you must file Form 4562.

43 When did you place your vehicle in service for business purposes? (month, day, year) ▶ ___ / ___ / ___ .

44 Of the total number of miles you drove your vehicle during 2008, enter the number of miles you used your vehicle for:

 a Business _____ **b** Commuting _____ **c** Other _____

45 Was your vehicle available for personal use during off-duty hours? ... ☐ Yes ☐ No

46 Do you (or your spouse) have another vehicle available for personal use? ☐ Yes ☐ No

47 **a** Do you have evidence to support your deduction? ... ☐ Yes ☐ No

 b If "Yes," is the evidence written? .. ☐ Yes ☐ No

Part V | Other Expenses. List below business expenses not included on lines 8-26 or line 30.

Formal Wear (stage wear)	304.
Cell Phone	239.
Research - CDs	341.
Promo Photos	305.
Trade Publications - Billboard	299.
Coaching/Education	350.
Amortization	359.

48	**Total other expenses.** Enter here and on page 1, line 27	48	2,197.

820002 11-20-08 Schedule C (Form 1040) 2008

8

2008 DEPRECIATION AND AMORTIZATION REPORT
The Blue Jazzbos

SCHEDULE C-1

Asset No.	Description	Date Acquired	Method	Life	Line No.	Unadjusted Cost Or Basis	Bus % Excl	Reduction In Basis	Basis For Depreciation	Accumulated Depreciation	Current Sec 179	Current Year Deduction
2	PA System	070108	200DB	5.00	19B	1,849.			1,849.			370.
6	Video Equipment	070108	200DB	5.00	19B	1,621.			1,621.			324.
8	iPod	070108	200DB	5.00	19B	299.			299.			60.
11	Website	070108		36M	42	2,150.			2,150.			359.
	Total Sch C Depr. & Amortization					5,919.			5,919.			1,113.
	Current Year Activity											
	Beginning balance					0.		0.	0.	0.		
	Acquisitions					5,919.		0.	5,919.	0.		
	Dispositions					0.		0.	0.	0.		
	Ending balance					5,919.		0.	5,919.	0.		

(D) - Asset disposed * ITC, Section 179, Salvage, Bonus, Commercial Revitalization Deduction, GO Zone

8.1

828102
04-25-08

SCHEDULE SE		OMB No. 1545-0074
(Form 1040)	**Self-Employment Tax**	**2008**
Department of the Treasury Internal Revenue Service (99)	▶ **Attach to Form 1040.** ▶ **See Instructions for Schedule SE (Form 1040).**	Attachment Sequence No. **17**

Name of person with **self-employment** income (as shown on Form 1040) Ima Starr	Social security number of person with **self-employment** income ▶	111 22 2333

Who Must File Schedule SE
You must file Schedule SE if:

- You had net earnings from self-employment from **other than** church employee income (line 4 of Short Schedule SE or line 4c of Long Schedule SE) of $400 or more, **or**
- You had church employee income of $108.28 or more. Income from services you performed as a minister or a member of a religious order **is not** church employee income (see page SE-1).

Note. Even if you had a loss or a small amount of income from self-employment, it may be to your benefit to file Schedule SE and use either "optional method" in Part II of Long Schedule SE (see page SE-4).

Exception. If your only self-employment income was from earnings as a minister, member of a religious order, or Christian Science practitioner **and** you filed Form 4361 and received IRS approval not to be taxed on those earnings, **do not** file Schedule SE. Instead, write "Exempt-Form 4361" on Form 1040, line 57.

May I Use Short Schedule SE or Must I Use Long Schedule SE?

Note. Use this flowchart **only if** you must file Schedule SE. If unsure, see *Who Must File Schedule SE,* above.

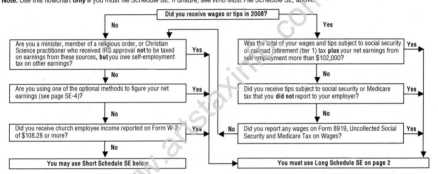

Section A–Short Schedule SE. Caution. Read above to see if you can use Short Schedule SE.

1a	Net farm profit or (loss) from Schedule F, line 36, and farm partnerships, Schedule K-1 (Form 1065), box 14, code A ..	**1a**	
b	If you received social security retirement or disability benefits, enter the amount of Conservation Reserve Program payments included on Schedule F, line 6b, or listed on Schedule K-1 (Form 1065), box 20, code X	**1b**	
2	Net profit or (loss) from Schedule C, line 31; Schedule C-EZ, line 3; Schedule K-1 (Form 1065), box 14, code A (other than farming); and Schedule K-1 (Form 1065-B), box 9, code J1. Ministers and members of religious orders, see pg SE-1 for types of income to report on this line. See pg SE-3 for other income to report Stmt 3	**2**	5,359.
3	Combine lines 1a, 1b, and 2 ...	**3**	5,359.
4	**Net earnings from self-employment.** Multiply line 3 by 92.35% (.9235). If less than $400, **do not** file this schedule; you do not owe self-employment tax ▶	**4**	4,949.
5	**Self-employment tax.** If the amount on line 4 is: • $102,000 or less, multiply line 4 by 15.3% (.153). Enter the result here and on **Form 1040, line 57.** • More than $102,000, multiply line 4 by 2.9% (.029). Then, add $12,648 to the result. Enter the total here and on **Form 1040, line 57**	**5**	757.
6	**Deduction for one-half of self-employment tax.** Multiply line 5 by 50% (.5). Enter the result here and on **Form 1040, line 27** **6** 379.		

LHA **For Paperwork Reduction Act Notice, see Form 1040 instructions.** Schedule SE (Form 1040) 2008

824501
11-11-08

Does not apply

Form **6251**	**Alternative Minimum Tax - Individuals**	OMB No. 1545-0074
Department of the Treasury Internal Revenue Service (99)	▶ Attach to Form 1040 or Form 1040NR.	**2008** Attachment Sequence No. **32**

Name(s) shown on Form 1040 or Form 1040NR	Your social security number
Ima Starr	111 22 2333

Part I Alternative Minimum Taxable Income

1	If filing Schedule A (Form 1040), enter the amount from Form 1040, line 41 (minus any amount on Form 8914, line 2), and go to line 2. Otherwise, enter the amount from Form 1040, line 38 (minus any amount on Form 8914, line 2), and go to line 7. (If less than zero, enter as a negative amount.)	**1**	45,111.
2	Medical and dental. Enter the **smaller** of Schedule A (Form 1040), line 4, **or** 2.5% (.025) of Form 1040, line 38. If zero or less, enter -0-	**2**	
3	Taxes from Schedule A (Form 1040), line 9	**3**	3,058.
4	Enter the home mortgage interest adjustment, if any, from line 6 of the worksheet on page 2 of the instructions	**4**	
5	Miscellaneous deductions from Schedule A (Form 1040), line 27	**5**	7,410.
6	If Form 1040, line 38, is over $159,950 (over $79,975 if married filing separately), enter the amount from line 11 of the **Itemized Deductions Worksheet** on page A-10 of the instructions for Schedule A (Form 1040)	**6**	
7	If claiming the standard deduction, enter any amount from Form 4684, line 18a, as a negative amount	**7**	
8	Tax refund from Form 1040, line 10 or line 21	**8**	
9	Investment interest expense (difference between regular tax and AMT)	**9**	
10	Depletion (difference between regular tax and AMT)	**10**	
11	Net operating loss deduction from Form 1040, line 21. Enter as a positive amount	**11**	
12	Interest from specified private activity bonds exempt from the regular tax	**12**	
13	Qualified small business stock (7% of gain excluded under section 1202)	**13**	
14	Exercise of incentive stock options (excess of AMT income over regular tax income)	**14**	
15	Estates and trusts (amount from Schedule K-1 (Form 1041), box 12, code A)	**15**	
16	Electing large partnerships (amount from Schedule K-1 (Form 1065-B), box 6)	**16**	
17	Disposition of property (difference between AMT and regular tax gain or loss)	**17**	
18	Depreciation on assets placed in service after 1986 (difference between regular tax and AMT) Stmt 4	**18**	350.
19	Passive activities (difference between AMT and regular tax income or loss)	**19**	
20	Loss limitations (difference between AMT and regular tax income or loss)	**20**	
21	Circulation costs (difference between regular tax and AMT)	**21**	
22	Long-term contracts (difference between AMT and regular tax income)	**22**	
23	Mining costs (difference between regular tax and AMT)	**23**	
24	Research and experimental costs (difference between regular tax and AMT)	**24**	
25	Income from certain installment sales before January 1, 1987	**25**	
26	Intangible drilling costs preference	**26**	
27	Other adjustments, including income-based related adjustments	**27**	
28	Alternative tax net operating loss deduction	**28**	
29	**Alternative minimum taxable income.** Combine lines 1 through 28. (If married filing separately and line 29 is more than $214,900, see instructions.)	**29**	55,929.

Part II Alternative Minimum Tax (AMT)

30	Exemption. (If you were under age 24 at the end of 2008, see instructions.)		

IF your filing status is		AND line 29 is not over	THEN enter on line 30		
Single or head of household		$112,500	$46,200		
Married filing jointly or qualifying widow(er)		150,000	69,950		
Married filing separately		75,000	34,975	**30**	46,200.

	If line 29 is **over** the amount shown above for your filing status, see instructions.		
31	Subtract line 30 from line 29. If more than zero, go to line 32. If zero or less, enter -0- here and on lines 34 and 36 and skip the rest of Part II	**31**	9,729.
32	• If you are filing Form 2555 or 2555-EZ, see page 9 of the instructions for the amount to enter. • If you reported capital gain distributions directly on Form 1040, line 13; you reported qualified dividends on Form 1040, line 9b; **or** you had a gain on both lines 15 and 16 of Schedule D (Form 1040) (as refigured for the AMT, if necessary), complete Part III on page 2 and enter the amount from line 55 here. • **All others:** If line 31 is $175,000 or less ($87,500 or less if married filing separately), multiply line 31 by 26% (.26). Otherwise, multiply line 31 by 28% (.28) and subtract $3,500 ($1,750 if married filing separately) from the result.	**32**	2,530.
33	Alternative minimum tax foreign tax credit (see instructions)	**33**	
34	Tentative minimum tax. Subtract line 33 from line 32	**34**	2,530.
35	Tax from Form 1040, line 44 (minus any tax from Form 4972 and any foreign tax credit from Form 1040, line 47). If you used Sch J to figure your tax, the amount from line 44 of Form 1040 must be refigured without using Sch J	**35**	6,750.
36	**AMT.** Subtract line 35 from line 34. If zero or less, enter -0-. Enter here and on Form 1040, line 45	**36**	0.

819481
12-02-08 LHA **For Paperwork Reduction Act Notice, see instructions.** Form **6251** (2008)

Form 6251 (2008) Ima Starr 111-22-2333 Page **2**

| **Part III** | **Tax Computation Using Maximum Capital Gains Rates** |

37 Enter the amount from Form 6251, line 31. If you are filing Form 2555 or 2555-EZ, enter the amount from line 3 of the worksheet in the instructions ... | **37** |

38 Enter the amount from line 6 of the Qualified Dividends and Capital Gain Tax Worksheet in the instructions for Form 1040, line 44, or the amount from line 13 of the Schedule D Tax Worksheet on page D-10 of the instructions for Schedule D (Form 1040), whichever applies (as refigured for the AMT, if necessary) (see the instructions). If you are filing Form 2555 or 2555-EZ, see instructions for the amount to enter ... | **38** |

39 Enter the amount from Schedule D (Form 1040), line 19 (as refigured for the AMT, if necessary) (see instructions). If you are filing Form 2555 or 2555-EZ, see instructions for the amount to enter | **39** |

40 If you did not complete a Schedule D Tax Worksheet for the regular tax or the AMT, enter the amount from line 38. Otherwise, add lines 38 and 39, and enter the **smaller** of that result or the amount from line 10 of the Schedule D Tax Worksheet (as refigured for the AMT, if necessary). If you are filing Form 2555 or 2555-EZ, see instructions for the amount to enter | **40** |

41 Enter the **smaller** of line 37 or line 40 .. | **41** |

42 Subtract line 41 from line 37 ... | **42** |

43 If line 42 is $175,000 or less ($87,500 or less if married filing separately), multiply line 42 by 26% (.26). Otherwise, multiply line 42 by 28% (.28) and subtract $3,500 ($1,750 if married filing separately) from the result .. ▶ | **43** |

44 Enter:
 • $65,100 if married filing jointly or qualifying widow(er),
 • $32,550 if single or married filing separately, or
 • $43,650 if head of household. | **44** |

45 Enter the amount from line 7 of the Qualified Dividends and Capital Gain Tax Worksheet in the instructions for Form 1040, line 44, or the amount from line 14 of the Schedule D Tax Worksheet on page D-10 of the instructions for Schedule D (Form 1040), whichever applies (as figured for the regular tax). If you did not complete either worksheet for the regular tax, enter -0- | **45** |

46 Subtract line 45 from line 44. If zero or less, enter -0- | **46** |

47 Enter the **smaller** of line 37 or line 38 ... | **47** |

48 Enter the **smaller** of line 46 or line 47 ... | **48** |

49 Subtract line 48 from line 47 ... | **49** |

50 Multiply line 49 by 15% (.15) ... ▶ | **50** |

 If line 39 is zero or blank, skip lines 51 and 52 and go to line 53. Otherwise, go to line 51.

51 Subtract line 47 from line 41 ... | **51** |

52 Multiply line 51 by 25% (.25) ... ▶ | **52** |

53 Add lines 43, 50, and 52 ... | **53** |

54 If line 37 is $175,000 or less ($87,500 or less if married filing separately), multiply line 37 by 26% (.26). Otherwise, multiply line 37 by 28% (.28) and subtract $3,500 ($1,750 if married filing separately) from the result .. | **54** |

55 Enter the **smaller** of line 53 or line 54 here and on line 32. If you are filing Form 2555 or 2555-EZ, do not enter this amount on line 32. Instead, enter it on line 4 of the worksheet in the instructions | **55** |

Form **6251** (2008)

11

Form **8829**	**Expenses for Business Use of Your Home**	OMB No. 1545-0074
Department of the Treasury Internal Revenue Service (99)	▶ File only with Schedule C (Form 1040). Use a separate Form 8829 for each home you used for business during the year.	**2008** Attachment Sequence No. **66**

Name(s) of proprietor(s) Ima Starr	Your social security number 111-22-2333

Part I — Part of Your Home Used for Business

1	Area used regularly and exclusively for business, regularly for daycare, or for storage of inventory or product samples	1	177
2	Total area of home	2	1,241
3	Divide line 1 by line 2. Enter the result as a percentage	3	14.2627%
	For daycare facilities not used exclusively for business, go to line 4. All others go to line 7.		
4	Multiply days used for daycare during year by hours used per day — 4 — hr.		
5	Total hours available for use during the year (366 days x 24 hours) — 5 — hr.		
6	Divide line 4 by line 5. Enter the result as a decimal amount — 6		
7	Business percentage. For daycare facilities not used exclusively for business, multiply line 6 by line 3 (enter the result as a percentage). All others, enter the amount from line 3 ▶	7	14.2627%

Part II — Figure Your Allowable Deduction

			(a) Direct expenses	(b) Indirect expenses		
8	Enter the amount from Schedule C, line 29, **plus** any net gain or (loss) derived from the business use of your home and shown on Schedule D or Form 4797. If more than one place of business, see instructions				8	6,656.
	See instructions for columns (a) and (b) before completing lines 9-21.					
9	Casualty losses	9				
10	Deductible mortgage interest	10				
11	Real estate taxes	11				
12	Add lines 9, 10, and 11	12				
13	Multiply line 12, column (b) by line 7		13			
14	Add line 12, column (a) and line 13				14	
15	Subtract line 14 from line 8. If zero or less, enter -0-				15	6,656.
16	Excess mortgage interest	16				
17	Insurance	17		515.		
18	Rent	18		16,500.		
19	Repairs and maintenance	19		399.		
20	Utilities	20		1,189.		
21	Other expenses	21				
22	Add lines 16 through 21	22		18,603.		
23	Multiply line 22, column (b) by line 7		23	2,653.		
24	Carryover of operating expenses from 2007 Form 8829, line 42		24			
25	Add line 22 column (a), line 23, and line 24				25	2,653.
26	Allowable operating expenses. Enter the **smaller** of line 15 or line 25				26	2,653.
27	Limit on excess casualty losses and depreciation. Subtract line 26 from line 15				27	4,003.
28	Excess casualty losses		28			
29	Depreciation of your home from line 41 below		29			
30	Carryover of excess casualty losses and depreciation from 2007 Form 8829, line 43		30			
31	Add lines 28 through 30				31	
32	Allowable excess casualty losses and depreciation. Enter the **smaller** of line 27 or line 31				32	0.
33	Add lines 14, 26, and 32				33	2,653.
34	Casualty loss portion, if any, from lines 14 and 32. Carry amount to **Form 4684**, Section B				34	0.
35	**Allowable expenses for business use of your home.** Subtract line 34 from line 33. Enter here and on Schedule C, line 30. If your home was used for more than one business, see instructions ▶				35	2,653.

Part III — Depreciation of Your Home

36	Enter the **smaller** of your home's adjusted basis or its fair market value	36	
37	Value of land included on line 36	37	
38	Basis of building. Subtract line 37 from line 36	38	
39	Business basis of building. Multiply line 38 by line 7	39	
40	Depreciation percentage	40	%
41	Depreciation allowable. Multiply line 39 by line 40. Enter here and on line 29 above	41	

Part IV — Carryover of Unallowed Expenses to 2009

42	Operating expenses. Subtract line 26 from line 25. If less than zero, enter -0-	42	
43	Excess casualty losses and depreciation. Subtract line 32 from line 31. If less than zero, enter -0-	43	

820301
12-24-08 LHA **For Paperwork Reduction Act Notice, see instructions.** Form **8829** (2008)

Form **4562**	FORM 2106/SBE- 1 **Depreciation and Amortization** (Including Information on Listed Property) ► See separate instructions. ► Attach to your tax return.	OMB No. 1545-0172 **2008**
Department of the Treasury Internal Revenue Service (99)		Attachment Sequence No. **67**

Name(s) shown on return: **Ima Starr**

Business or activity to which this form relates: **Actor**

Identifying number: **111-22-2333**

Part I Election To Expense Certain Property Under Section 179 Note: *If you have any listed property, complete Part V before you complete Part I.*

1	Maximum amount. See the instructions for a higher limit for certain businesses	1	250,000.
2	Total cost of section 179 property placed in service (see instructions)	2	
3	Threshold cost of section 179 property before reduction in limitation	3	800,000.
4	Reduction in limitation. Subtract line 3 from line 2. If zero or less, enter -0-	4	
5	Dollar limitation for tax year. Subtract line 4 from line 1. If zero or less, enter -0-. If married filing separately, see instructions	5	

6	(a) Description of property	(b) Cost (business use only)	(c) Elected cost

7	Listed property. Enter the amount from line 29	7	
8	Total elected cost of section 179 property. Add amounts in column (c), lines 6 and 7	8	
9	Tentative deduction. Enter the **smaller** of line 5 or line 8	9	
10	Carryover of disallowed deduction from line 13 of your 2007 Form 4562	10	
11	Business income limitation. Enter the smaller of business income (not less than zero) or line 5	11	
12	Section 179 expense deduction. Add lines 9 and 10, but do not enter more than line 11	12	
13	Carryover of disallowed deduction to 2009. Add lines 9 and 10, less line 12 ►	13	

Note: *Do not use Part II or Part III below for listed property. Instead, use Part V.*

Part II Special Depreciation Allowance and Other Depreciation (Do not include listed property.)

14	Special depreciation for qualified property (other than listed property) placed in service during the tax year	14	
15	Property subject to section 168(f)(1) election	15	
16	Other depreciation (including ACRS)	16	

Part III MACRS Depreciation (Do not include listed property.) (See instructions.)

Section A

17	MACRS deductions for assets placed in service in tax years beginning before 2008	17	
18	If you are electing to group any assets placed in service during the tax year into one or more general asset accounts, check here ► ☐		

Section B - Assets Placed in Service During 2008 Tax Year Using the General Depreciation System

(a) Classification of property	(b) Month and year placed in service	(c) Basis for depreciation (business/investment use only - see instructions)	(d) Recovery period	(e) Convention	(f) Method	(g) Depreciation deduction
19a 3-year property						
b 5-year property		124.	5 Yrs.	HY	200DB	25.
c 7-year property						
d 10-year property						
e 15-year property						
f 20-year property						
g 25-year property			25 yrs.		S/L	
h Residential rental property	/		27.5 yrs.	MM	S/L	
	/		27.5 yrs.	MM	S/L	
i Nonresidential real property	/		39 yrs.	MM	S/L	
	/			MM	S/L	

Section C - Assets Placed in Service During 2008 Tax Year Using the Alternative Depreciation System

20a Class life					S/L	
b 12-year			12 yrs.		S/L	
c 40-year	/		40 yrs.	MM	S/L	

Part IV Summary (See instructions.)

21	Listed property. Enter amount from line 28	21	
22	**Total.** Add amounts from line 12, lines 14 through 17, lines 19 and 20 in column (g), and line 21. Enter here and on the appropriate lines of your return. Partnerships and S corporations - see instr.	22	25.
23	For assets shown above and placed in service during the current year, enter the portion of the basis attributable to section 263A costs	23	

816251 11-08-08 LHA **For Paperwork Reduction Act Notice, see separate instructions.**

Form **4562** (2008)

14

Form 4562 (2008) **Ima Starr** 111-22-2333 Page **2**

Part V **Listed Property** (Include automobiles, certain other vehicles, cellular telephones, certain computers, and property used for entertainment, recreation, or amusement.)

Note: *For any vehicle for which you are using the standard mileage rate or deducting lease expense, complete* **only** *24a, 24b, columns (a) through (c) of Section A, all of Section B, and Section C if applicable.*

Section A - Depreciation and Other Information (Caution: *See the instructions for limits for passenger automobiles.***)**

24a Do you have evidence to support the business/investment use claimed? ☐ Yes ☐ No **24b** If "Yes," is the evidence written? ☐ Yes ☐ No

(a) Type of property (list vehicles first)	(b) Date placed in service	(c) Business/ investment use percentage	(d) Cost or other basis	(e) Basis for depreciation (business/investment use only)	(f) Recovery period	(g) Method/ Convention	(h) Depreciation deduction	(i) Elected section 179 cost
25 Special depreciation allowance for qualified listed property placed in service during the tax year and used more than 50% in a qualified business use **25**								
26 Property used more than 50% in a qualified business use:								
	: :	%						
	: :	%						
	: :	%						
27 Property used 50% or less in a qualified business use:								
	: :	%				S/L -		
	: :	%				S/L -		
	: :	%				S/L -		
28 Add amounts in column (h), lines 25 through 27. Enter here and on line 21, page 1 **28**								
29 Add amounts in column (i), line 26. Enter here and on line 7, page 1 **29**								

Section B - Information on Use of Vehicles

Complete this section for vehicles used by a sole proprietor, partner, or other "more than 5% owner," or related person.
If you provided vehicles to your employees, first answer the questions in Section C to see if you meet an exception to completing this section for those vehicles.

	(a) Vehicle	(b) Vehicle	(c) Vehicle	(d) Vehicle	(e) Vehicle	(f) Vehicle
30 Total business/investment miles driven during the year (**do not** include commuting miles)						
31 Total commuting miles driven during the year ...						
32 Total other personal (noncommuting) miles driven						
33 Total miles driven during the year. Add lines 30 through 32						
34 Was the vehicle available for personal use during off-duty hours?	Yes No	Yes No	Yes No	Yes No	Yes No	Yes No
35 Was the vehicle used primarily by a more than 5% owner or related person?						
36 Is another vehicle available for personal use?						

Section C - Questions for Employers Who Provide Vehicles for Use by Their Employees

Answer these questions to determine if you meet an exception to completing Section B for vehicles used by employees who **are not** more than 5% owners or related persons.

	Yes	No
37 Do you maintain a written policy statement that prohibits all personal use of vehicles, including commuting, by your employees?		
38 Do you maintain a written policy statement that prohibits personal use of vehicles, except commuting, by your employees? See the instructions for vehicles used by corporate officers, directors, or 1% or more owners		
39 Do you treat all use of vehicles by employees as personal use?		
40 Do you provide more than five vehicles to your employees, obtain information from your employees about the use of the vehicles, and retain the information received?		
41 Do you meet the requirements concerning qualified automobile demonstration use?		

Note: *If your answer to 37, 38, 39, 40, or 41 is "Yes," do not complete Section B for the covered vehicles.*

Part VI | **Amortization**

(a) Description of costs	(b) Date amortization begins	(c) Amortizable amount	(d) Code section	(e) Amortization period or percentage	(f) Amortization for this year
42 Amortization of costs that begins during your 2008 tax year:					
	: :				
	: :				
43 Amortization of costs that began before your 2008 tax year **43**					
44 **Total.** Add amounts in column (f). See the instructions for where to report **44**					

816252 11-08-08 Form **4562** (2008)

Form **4562**		SCHEDULE C-2 **Depreciation and Amortization** (Including Information on Listed Property)	OMB No. 1545-0172 **2008**
Department of the Treasury Internal Revenue Service (99)		▶ **See separate instructions.** ▶ **Attach to your tax return.**	Attachment Sequence No. **67**

Name(s) shown on return	Business or activity to which this form relates	Identifying number
Ima Starr	Ima Starr	111-22-2333

Part I Election To Expense Certain Property Under Section 179 **Note:** *If you have any listed property, complete Part V before you complete Part I.*

1	Maximum amount. See the instructions for a higher limit for certain businesses	1	250,000.
2	Total cost of section 179 property placed in service (see instructions)	2	
3	Threshold cost of section 179 property before reduction in limitation	3	800,000.
4	Reduction in limitation. Subtract line 3 from line 2. If zero or less, enter -0-	4	
5	Dollar limitation for tax year. Subtract line 4 from line 1. If zero or less, enter -0-. If married filing separately, see instructions	5	

6	(a) Description of property	(b) Cost (business use only)	(c) Elected cost

7	Listed property. Enter the amount from line 29	7	
8	Total elected cost of section 179 property. Add amounts in column (c), lines 6 and 7	8	
9	Tentative deduction. Enter the **smaller** of line 5 or line 8	9	
10	Carryover of disallowed deduction from line 13 of your 2007 Form 4562	10	
11	Business income limitation. Enter the smaller of business income (not less than zero) or line 5	11	
12	Section 179 expense deduction. Add lines 9 and 10, but do not enter more than line 11	12	
13	Carryover of disallowed deduction to 2009. Add lines 9 and 10, less line 12 ▶	13	

Note: *Do not use Part II or Part III below for listed property. Instead, use Part V.*

Part II Special Depreciation Allowance and Other Depreciation (Do not include listed property.)

14	Special depreciation for qualified property (other than listed property) placed in service during the tax year	14	
15	Property subject to section 168(f)(1) election	15	
16	Other depreciation (including ACRS)	16	

Part III MACRS Depreciation (Do not include listed property.) (See instructions.)

Section A

17	MACRS deductions for assets placed in service in tax years beginning before 2008	17	
18	If you are electing to group any assets placed in service during the tax year into one or more general asset accounts, check here ▶ ☐		

Section B - Assets Placed in Service During 2008 Tax Year Using the General Depreciation System

	(a) Classification of property	(b) Month and year placed in service	(c) Basis for depreciation (business/investment use only - see instructions)	(d) Recovery period	(e) Convention	(f) Method	(g) Depreciation deduction
19a	3-year property						
b	5-year property		1,523.	5 Yrs.	HY	200DB	305.
c	7-year property						
d	10-year property						
e	15-year property						
f	20-year property						
g	25-year property			25 yrs.		S/L	
h	Residential rental property	/		27.5 yrs.	MM	S/L	
		/		27.5 yrs.	MM	S/L	
i	Nonresidential real property	/		39 yrs.	MM	S/L	
		/			MM	S/L	

Section C - Assets Placed in Service During 2008 Tax Year Using the Alternative Depreciation System

20a	Class life					S/L	
b	12-year			12 yrs.		S/L	
c	40-year	/		40 yrs.	MM	S/L	

Part IV Summary (See instructions.)

21	Listed property. Enter amount from line 28	21	
22	**Total.** Add amounts from line 12, lines 14 through 17, lines 19 and 20 in column (g), and line 21. Enter here and on the appropriate lines of your return. Partnerships and S corporations - see instr.	22	305.
23	For assets shown above and placed in service during the current year, enter the portion of the basis attributable to section 263A costs	23	

816251 11-08-08 LHA **For Paperwork Reduction Act Notice, see separate instructions.**

Form **4562** (2008)

16

Form 4562 (2008) **Ima Starr** 111-22-2333 Page **2**

Part V **Listed Property** (Include automobiles, certain other vehicles, cellular telephones, certain computers, and property used for entertainment, recreation, or amusement.)

Note: *For any vehicle for which you are using the standard mileage rate or deducting lease expense, complete* only *24a, 24b, columns (a) through (c) of Section A, all of Section B, and Section C if applicable.*

Section A - Depreciation and Other Information (Caution: *See the instructions for limits for passenger automobiles.*)

24a Do you have evidence to support the business/investment use claimed? ☐ Yes ☐ No 24b If "Yes," is the evidence written? ☐ Yes ☐ No

(a) Type of property (list vehicles first)	(b) Date placed in service	(c) Business/ investment use percentage	(d) Cost or other basis	(e) Basis for depreciation (business/investment use only)	(f) Recovery period	(g) Method/ Convention	(h) Depreciation deduction	(i) Elected section 179 cost
25 Special depreciation allowance for qualified listed property placed in service during the tax year and used more than 50% in a qualified business use ..							25	
26 Property used more than 50% in a qualified business use:								
	: :	%						
	: :	%						
	: :	%						
27 Property used 50% or less in a qualified business use:								
	010107	8.17 %				S/L -		
	: :	%				S/L -		
	: :	%				S/L -		
28 Add amounts in column (h), lines 25 through 27. Enter here and on line 21, page 1						28		
29 Add amounts in column (i), line 26. Enter here and on line 7, page 1							29	

Section B - Information on Use of Vehicles

Complete this section for vehicles used by a sole proprietor, partner, or other "more than 5% owner," or related person.
If you provided vehicles to your employees, first answer the questions in Section C to see if you meet an exception to completing this section for those vehicles.

	(a) Vehicle	(b) Vehicle	(c) Vehicle	(d) Vehicle	(e) Vehicle	(f) Vehicle
30 Total business/investment miles driven during the year (**do not** include commuting miles)				3 941		
31 Total commuting miles driven during the year ...						
32 Total other personal (noncommuting) miles driven				10,580		
33 Total miles driven during the year. Add lines 30 through 32				11,521		
34 Was the vehicle available for personal use during off-duty hours?	Yes No	Yes No	Yes No	Yes No	Yes No	Yes No
35 Was the vehicle used primarily by a more than 5% owner or related person?						
36 Is another vehicle available for personal use?						

Section C - Questions for Employers Who Provide Vehicles for Use by Their Employees

Answer these questions to determine if you meet an exception to completing Section B for vehicles used by employees who **are not** more than 5% owners or related persons.

	Yes	No
37 Do you maintain a written policy statement that prohibits all personal use of vehicles, including commuting, by your employees?		
38 Do you maintain a written policy statement that prohibits personal use of vehicles, except commuting, by your employees? See the instructions for vehicles used by corporate officers, directors, or 1% or more owners		
39 Do you treat all use of vehicles by employees as personal use?		
40 Do you provide more than five vehicles to your employees, obtain information from your employees about the use of the vehicles, and retain the information received?		
41 Do you meet the requirements concerning qualified automobile demonstration use?		

Note: *If your answer to 37, 38, 39, 40, or 41 is "Yes," do not complete Section B for the covered vehicles.*

Part VI **Amortization**

(a) Description of costs	(b) Date amortization begins	(c) Amortizable amount	(d) Code section	(e) Amortization period or percentage	(f) Amortization for this year
42 Amortization of costs that begins during your 2008 tax year:					
	: :				
	: :				
43 Amortization of costs that began before your 2008 tax year				43	
44 **Total.** Add amounts in column (f). See the instructions for where to report				44	

816252 11-08-08

Form **4562** (2008)

Form **4562**	SCHEDULE C-1 **Depreciation and Amortization** (Including Information on Listed Property) ▶ See separate instructions. ▶ Attach to your tax return.	OMB No. 1545-0172 **2008**
Department of the Treasury Internal Revenue Service (99)		Attachment Sequence No. **67**

Name(s) shown on return	Business or activity to which this form relates	Identifying number
Ima Starr	The Blue Jazzbos	111-22-2333

Part I Election To Expense Certain Property Under Section 179 **Note:** *If you have any listed property, complete Part V before you complete Part I.*

1 Maximum amount. See the instructions for a higher limit for certain businesses	**1**	250,000.
2 Total cost of section 179 property placed in service (see instructions)	**2**	
3 Threshold cost of section 179 property before reduction in limitation	**3**	800,000.
4 Reduction in limitation. Subtract line 3 from line 2. If zero or less, enter -0-	**4**	
5 Dollar limitation for tax year. Subtract line 4 from line 1. If zero or less, enter -0-. If married filing separately, see instructions	**5**	

6	(a) Description of property	(b) Cost (business use only)	(c) Elected cost

7 Listed property. Enter the amount from line 29	**7**		
8 Total elected cost of section 179 property. Add amounts in column (c), lines 6 and 7		**8**	
9 Tentative deduction. Enter the **smaller** of line 5 or line 8		**9**	
10 Carryover of disallowed deduction from line 13 of your 2007 Form 4562		**10**	
11 Business income limitation. Enter the smaller of business income (not less than zero) or line 5		**11**	
12 Section 179 expense deduction. Add lines 9 and 10, but do not enter more than line 11		**12**	
13 Carryover of disallowed deduction to 2009. Add lines 9 and 10, less line 12 ▶	**13**		

Note: *Do not use Part II or Part III below for listed property. Instead, use Part V.*

Part II Special Depreciation Allowance and Other Depreciation (Do not include listed property.)

14 Special depreciation for qualified property (other than listed property) placed in service during the tax year	**14**	
15 Property subject to section 168(f)(1) election	**15**	
16 Other depreciation (including ACRS)	**16**	

Part III MACRS Depreciation (Do not include listed property.) (See instructions.)

Section A

17 MACRS deductions for assets placed in service in tax years beginning before 2008	**17**	
18 If you are electing to group any assets placed in service during the tax year into one or more general asset accounts, check here ▶ ☐		

Section B - Assets Placed in Service During 2008 Tax Year Using the General Depreciation System

(a) Classification of property	(b) Month and year placed in service	(c) Basis for depreciation (business/investment use only - see instructions)	(d) Recovery period	(e) Convention	(f) Method	(g) Depreciation deduction
19a 3-year property						
b 5-year property		3,769.	5 Yrs.	HY	200DB	754.
c 7-year property						
d 10-year property						
e 15-year property						
f 20-year property						
g 25-year property			25 yrs.		S/L	
h Residential rental property	/		27.5 yrs.	MM	S/L	
	/		27.5 yrs.	MM	S/L	
i Nonresidential real property	/		39 yrs.	MM	S/L	
	/			MM	S/L	

Section C - Assets Placed in Service During 2008 Tax Year Using the Alternative Depreciation System

20a Class life					S/L	
b 12-year			12 yrs.		S/L	
c 40-year	/		40 yrs.	MM	S/L	

Part IV Summary (See instructions.)

21 Listed property. Enter amount from line 28	**21**	
22 **Total.** Add amounts from line 12, lines 14 through 17, lines 19 and 20 in column (g), and line 21. Enter here and on the appropriate lines of your return. Partnerships and S corporations - see instr.	**22**	754.
23 For assets shown above and placed in service during the current year, enter the portion of the basis attributable to section 263A costs	**23**	

816251 11-08-08 LHA **For Paperwork Reduction Act Notice, see separate instructions.**

Form **4562** (2008)

Form 4562 (2008) **Ima Starr** 111-22-2333 Page **2**

Part V	Listed Property (Include automobiles, certain other vehicles, cellular telephones, certain computers, and property used for entertainment, recreation, or amusement.)

Note: *For any vehicle for which you are using the standard mileage rate or deducting lease expense, complete only 24a, 24b, columns (a) through (c) of Section A, all of Section B, and Section C if applicable.*

Section A - Depreciation and Other Information (Caution: *See the instructions for limits for passenger automobiles.***)**

24a Do you have evidence to support the business/investment use claimed? ☐ Yes ☐ No **24b** If "Yes," is the evidence written? ☐ Yes ☐ No

(a) Type of property (list vehicles first)	(b) Date placed in service	(c) Business/ investment use percentage	(d) Cost or other basis	(e) Basis for depreciation (business/investment use only)	(f) Recovery period	(g) Method/ Convention	(h) Depreciation deduction	(i) Elected section 179 cost
25 Special depreciation allowance for qualified listed property placed in service during the tax year and used more than 50% in a qualified business use .. **25**								
26 Property used more than 50% in a qualified business use:								
	: :	%						
	: :	%						
	: :	%						
27 Property used 50% or less in a qualified business use:								
	010107	25.57 %				S/L -		
	: :	%				S/L -		
	: :	%				S/L -		
28 Add amounts in column (h), lines 25 through 27. Enter here and on line 21, page 1 **28**								
29 Add amounts in column (i), line 26. Enter here and on line 7, page 1								**29**

Section B - Information on Use of Vehicles

Complete this section for vehicles used by a sole proprietor, partner, or other "more than 5% owner," or related person. If you provided vehicles to your employees, first answer the questions in Section C to see if you meet an exception to completing this section for those vehicles.

		(a) Vehicle		(b) Vehicle		(c) Vehicle		(d) Vehicle 2		(e) Vehicle		(f) Vehicle	
30	Total business/investment miles driven during the year (**do not** include commuting miles)							2,946					
31	Total commuting miles driven during the year ...												
32	Total other personal (noncommuting) miles driven ..							8,575					
33	Total miles driven during the year. Add lines 30 through 32							11,521					
34	Was the vehicle available for personal use during off-duty hours?	Yes	No	Yes	No	Yes	No	Yes	No	Yes	No	Yes	No
35	Was the vehicle used primarily by a more than 5% owner or related person?												
36	Is another vehicle available for personal use?												

Section C - Questions for Employers Who Provide Vehicles for Use by Their Employees

Answer these questions to determine if you meet an exception to completing Section B for vehicles used by employees who **are not** more than 5% owners or related persons.

		Yes	No
37	Do you maintain a written policy statement that prohibits all personal use of vehicles, including commuting, by your employees? ..		
38	Do you maintain a written policy statement that prohibits personal use of vehicles, except commuting, by your employees? See the instructions for vehicles used by corporate officers, directors, or 1% or more owners		
39	Do you treat all use of vehicles by employees as personal use? ..		
40	Do you provide more than five vehicles to your employees, obtain information from your employees about the use of the vehicles, and retain the information received? ..		
41	Do you meet the requirements concerning qualified automobile demonstration use?		

Note: *If your answer to 37, 38, 39, 40, or 41 is "Yes," do not complete Section B for the covered vehicles.*

Part VI	**Amortization**

(a) Description of costs	(b) Date amortization begins	(c) Amortizable amount	(d) Code section	(e) Amortization period or percentage	(f) Amortization for this year
42 Amortization of costs that begins during your 2008 tax year:					
Website	070108	2,150.		36M	359.
43 Amortization of costs that began before your 2008 tax year **43**					
44 Total. Add amounts in column (f). See the instructions for where to report **44**					359.

816252 11-08-08 Form **4562** (2008)

Form **2106-EZ**	**Unreimbursed Employee Business Expenses**	OMB No. 1545-0074
Department of the Treasury Internal Revenue Service (99)	▶ Attach to Form 1040 or Form 1040NR.	**2008** Attachment Sequence No. **129A**

Your name	Occupation in which you incurred expenses	Social security number
Ima Starr	Actor	111-22-2333

You May Use This Form Only if All of the Following Apply.

- You are an employee deducting ordinary and necessary expenses attributable to your job. An ordinary expense is one that is common and accepted in your field of trade, business, or profession. A necessary expense is one that is helpful and appropriate for your business. An expense does not have to be required to be considered necessary.
- You **do not** get reimbursed by your employer for any expenses (amounts your employer included in box 1 of your Form W-2 are not considered reimbursements for this purpose).
- If you are claiming vehicle expense, you are using the standard mileage rate for 2008.

Caution: *You can use the standard mileage rate for 2008 **only if: (a)** you owned the vehicle and used the standard mileage rate for the first year you placed the vehicle in service, **or (b)** you leased the vehicle and used the standard mileage rate for the portion of the lease period after 1997.*

Part I	**Figure Your Expenses**		
1	Vehicle expense using the standard mileage rate. Complete Part II and then go to line 1a below.		
a	Multiply business miles driven **before** July 1, 2008, by 50.5¢ (.505)	**1a** 490	
b	Multiply business miles driven **after** June 30, 2008, by 58.5¢ (.585)	**1b** 568	
c	Add lines 1a and 1b ...	**1c**	1,058
2	Parking fees, tolls, and transportation, including train, bus, etc., that **did not** involve overnight travel or commuting to and from work ..	**2**	306
3	Travel expense while away from home overnight, including lodging, airplane, car rental, etc. **Do not** include meals and entertainment ...	**3**	3,866
4	Business expenses not included on lines 1c through 3. **Do not** include meals and entertainment **Statement 5**	**4**	1,767
5	Meals and entertainment expenses: $ _____ 3,061. x 50% (.50). (Employees subject to Department of Transportation (DOT) hours of service limits: Multiply meal expenses incurred while away from home on business by 80% (.80) instead of 50%. For details, see instructions.)	**5**	1,531
6	**Total expenses.** Add lines 1c through 5. Enter here and on **Schedule A (Form 1040), line 21** (or on **Schedule A (Form 1040NR, line 9)**). (Armed Forces reservists, fee-basis state or local government officials, qualified performing artists, and individuals with disabilities: See the instructions for special rules on where to enter this amount.)	**6**	8,528

Part II	**Information on Your Vehicle.** Complete this part **only** if you are claiming vehicle expense on line 1.

7 When did you place your vehicle in service for business use? (month, day, year) ▶ 01 / 01 / 07

8 Of the total number of miles you drove your vehicle during 2008, enter the number of miles you used your vehicle for:

 a Business _____ 1,941 **b** Commuting (see instructions) _____ **c** Other _____ 9,580

9 Was your vehicle available for personal use during off-duty hours? ☐ Yes ☐ No

10 Do you (or your spouse) have another vehicle available for personal use? ☐ Yes ☐ No

11a Do you have evidence to support your deduction? .. ☒ Yes ☐ No

 b If "Yes," is the evidence written? ... ☒ Yes ☐ No

LHA **For Paperwork Reduction Act Notice, see instructions.** Form **2106-EZ** (2008)

812011
11-11-08

2008 DEPRECIATION AND AMORTIZATION REPORT

Actor

FORM 2106/SBE- 1

Asset No.	Description	Date Acquired	Method	Life	Line No.	Unadjusted Cost Or Basis	Bus % Excl	Reduction In Basis	Basis For Depreciation	Accumulated Depreciation	Current Sec 179	Current Year Deduction
1	DVD Player	070108	200DB	5.00	19B	124.			124.			25.
	Total 2106/SBE Depr. & Amortization					124.			124.			25.

(D) - Asset disposed

20.1

* ITC, Section 179, Salvage, Bonus, Commercial Revitalization Deduction, GO Zone

828102
04-25-08

Ima Starr 111-22-2333

Schedule C	Other Income	Statement	1

Description	Amount
Product Endorsment	550.
Modeling	1,895.
Total to Schedule C, line 6	2,445.

Schedule C	Other Costs of Goods Sold	Statement	2

Description	Amount
Sidemen (1099's issued)	5,980.
Total to Schedule C, line 39	5,980.

Schedule SE	Non-Farm Income	Statement	3

Description	Amount
Musical Group/Modeling	1,356.
Writer	4,003.
Total to Schedule SE, line 2	5,359.

Form 6251	Depreciation on Assets Placed in Service After 1986	Statement	4

Description	Amount
PA System	134.
Video Equipment	117.
iPod	22.
Powerbook and Printer	77.
Total to Form 6251, line 18	350.

Ima Starr 111-22-2333

| Form 2106-EZ | Other Business Expenses | Statement 5 |

Actor

Description	Amount
Script Costs	108.
Wardrobe Cleaning	89.
Telephone	108.
Research DVDs	151.
Internet Service	234.
Performance Audit (London tickets)	385.
Cell Phone	189.
Union Dues	148.
Trade Publications - Daily Variety	330.
Depreciation	25.
Total to Form 2106-EZ, Part I, line 4	1,767.

4.

For Musicians and Singers

In this chapter I will look in detail at the activities of our good friend Sonny Phunky and the kind of income and deductions he had for the year.

To begin, we'll walk through some of the expense items for musicians and singers specifically. I will note in parentheses the type of record keeping the IRS would require:

1. Union dues and professional societies (invoices & checks)

2. Professional fees for agents, attorneys & accountants (invoices & checks)

3. Professional registries – both printed and on the Internet (invoices, credit card receipt & checks)

4. Master classes, education and coaching lessons (invoices & checks)

5. Stage makeup – This does not include street makeup, or what you use going to auditions, but does include makeup for showcases. The IRS can be very aggressive on makeup, so write the name of the gig the makeup was used for on the back of the receipt (invoices, credit card receipt & checks).

6. Hair care – This must be a particular style for a specific gig, not general, looking-for-work upkeep (sales receipts, credit card receipt & checks).

7. Photographs and resumes – including videos, CDs, CD-ROMs, DVDs and digital image transfers for use on the Internet or your personal Website (sales receipts, credit card receipt & checks).

8. Stationery and postage (sales receipts & checks)

9. Music books, musical scores, sheet music, batteries, tapes, CDs, etc – these fall under the heading of supplies and may need to be allocated between employment income and contract income (invoices, credit card receipt & checks).

10. Telephone and cellular phone – actual business calls on your home phone are deductible, but the IRS does not allow the allocation of the base monthly rate. You can deduct only the actual long distance charges. The same rule is true with your cellular phone service. If you get a second phone line strictly for business then it can be considered 100% deductible (bills & checks).

11. Internet service – for research purposes, business e-mail and e-mail while on the road. Be sure to allocate some of the costs for personal use (bills, invoice & credit card receipt).

12. Stage clothes – This is professional uniforms, not conventional street wear! The rule says if you can wear it on the street, you can't deduct it. Remember that if the uniform is deductible then the cleaning is as well. A special rule allows musicians to deduct purchase of formal wear (invoices, credit card receipt & checks).

13. Viewing concerts, performances and films (live and via DVD, video and cable) – I often call this expense line item "research"; others refer to it as "performance audit." Whatever you call it, make sure to allocate some of this expense to personal use. After all you must sometimes take part in these activities for personal enjoyment, it can't be all business. I often quote to clients the old Wall Street saying, "the pigs get fat and the hogs get slaughtered." This is the type of deduction that you must not get piggy with. While the IRS typically hates this deduction, it does clearly acknowledge its validity in its audit guidelines. In an audit you would need to explain specifically what the professional value was (ticket stubs, receipts & diary entries).

14. Promotional tickets – Only your ticket is deductible, not your date's, unless your date is your agent, a band member, producer or some other professional colleague (ticket stubs, receipts & diary entries).

15. Rehearsal hall or club rental - (invoices & checks)

16. Accompanist, arranger, sideman, sound or lighting person, personal assistant, etc. – This person must have a defined business purpose. For instance, if your personal assistant is paying your personal bills or engaged in non-business activities, their salary will not be deductible. Also if any of these folks are contractors and they receive more than $600 in a calendar year you must issue them a form 1099-MISC (invoices & checks).

17. Office rent – you must be able to prove you need an outside office (bills, invoices & checks).

18. Repair of equipment - Computers, musical instruments, sound & video equipment (bills, invoices, credit card receipt & checks)

19. Tax preparation, bookkeeping & accounting fees (bills, invoices & checks)

20. Demo tapes, videos, DVDs & commercial prints – Used in promotional activities (bills, invoices & checks)

21. Trade advertisements (invoices, credit card receipt & checks)

22. Trade papers and professional magazines (invoices, credit card receipt & checks)

23. Backstage tips – Note: you cannot give these folks gifts (checks & diary entry)

24. Insurance – Including riders on your home insurance policy to cover home studio or other business activities (bills, invoices & checks)

25. Copyright fees (invoices & checks)

26. Equipment Purchases – Sound equipment, instruments, etc. (bills, invoices, credit card receipt & checks)

Now, let's see what kind of year our bass player Sonny Phunky had. Luckily for his Certified Public Accountant he downloaded our Excel® spreadsheet for musicians found at www.artstaxinfo.com and loaded it on his computer at the beginning of the tax year, and carefully tracked his expenses all year!

We will now review Sonny's 1040 income tax return in detail – and remember you can download the current year version from our website – www.artstaxinfo.com.

You'll recall that Sonny was hired to play on a national tour with the Butterball Kings rock band. Let's look at some of the expenses that Sonny incurred during this time. Sonny lives in Maine so he had to travel to New York City, where the band rehearsed prior to beginning their tour. Sonny rehearsed with the Butterball Kings for three weeks in New York City. Sonny was paid a per diem that was higher then the IRS approved rate (as you will remember from Chapter 1 when we analyzed Sonny's W-2 from his work with the Butterball Kings.) The excess $1,071 was reported as taxable wages in box 1 on Sonny's W-2. In other words, Sonny has to pay taxes on the excess per diem paid to him above the amount that the IRS allows. Fortunately

Sonny had the receipts to support the additional deduction, so he was able to write off living expenses to offset the extra $1,071 that was reported as W-2 income (reported on Form 2106). Sonny had depreciation expenses for the new chartreuse-colored bass he purchased specifically for this gig. During the NYC rehearsal period, Sonny had expenses for supplies, such as new strings, cords and music books. He purchased a variety of CDs in order to learn some of the music the band played and he had a local repair shop overhaul his bass amplifier so that it was in good working order for the tour. Sonny used all these above expenses as deductions against the W-2 on Form 2106.

In anticipation of the money he was going to earn on his gig with the Butterball Kings he splurged almost $10,000 on a rare 1956 Fender® Precision® electric bass guitar. His accountant felt that the rare antique instrument might not be deductible until Sonny told him that he had used it on several studio dates and gigs during the year. The fact that this guitar was used in his profession (as opposed to being primarily a collectable piece) will probably make the purchase deductible. His tax advisor told Sonny to get some pictures of him using the guitar in the studio and on stage, in case he was audited. Because Sonny used the guitar on jobs that were mainly contract income, his accountant depreciated the guitar over seven years as a write-off on Sonny's Schedule C.

During the summer Sonny landed a gig playing for a popular show band in Atlantic City. The band did not offer any monetary reimbursement but gave the players a place to live there. In this case, Sonny had expenses for meals and incidentals, but obviously not for lodging. Sonny is a terrible record keeper and uses the IRS per diem rates for all his meals and incidentals throughout the year. The daily rate for Atlantic City is $54 a day for 2008. Of course, his mileage driving to New Jersey and auto use while there were deductible.

In July Sonny went to the NAMM (National Association of Music Merchandisers) trade show. A luthier who he knows asked him to appear in his exhibition booth to endorse and demonstrate a new bass guitar he had designed. The luthier could not pay cash to Sonny for the appearance, so he gave him one of his handmade basses worth an estimated $2,000. The trip did give Sonny a chance to see new products at the show, hand his card and CD out to recordings studios and generally network with other industry and music types. He attended the show for the entire three days he was away from home. Sonny could clearly show a business purpose and was able

to deduct the entire trip. He will declare the $2,000 value of the bass as self-employment income on his Schedule C.

When Sonny is not away from home on gigs he has a standing weekend job at a local bar in Rockridge, Maine. His band, The Over the Hill Gang is an impromptu one made up of whoever is available that night. The club owner pays Sonny and Sonny in turn pays the band. The club owner issued Sonny a 1099-MISC at the end of the year that included all the funds he had paid Sonny over the year for his band. Sonny then went through his records to obtain a list of all the sidemen he had paid $600 or more to in the year. He ended up issuing five 1099-MISC forms to these musicians. To issue a 1099-MISC, Sonny needed the musician's full name, address and social security number. Sonny's accountant had alerted him to this requirement, so Sonny had all his musicians fill out the federal form W-9 to ensure he would be sure to have all this information at year-end. His accountant gave Sonny a pile of W-9 Forms to keep in his guitar case. Of course all the sidemen he had paid during the year were deductions against his income on his Schedule C form, even those that made less than $600.

Sonny had one particularly good combination of his The Over the Hill Gang during the year, which he was able to assemble to make a CD to sell at the gigs and help promote his own playing. He spent $1,850 recording the CD at a local recording studio. It cost him an additional $1,000 to have 500 copies of the CD pressed and covers printed. Offering it at gigs and through the mail, Sonny figured that it would take him two years to sell all 500 copies of the CD. He did not plan on manufacturing any more copies of the disk, which means that the useful life of the recording is two years. Sonny's accountant will divide the recording costs of $1,850 by 24 (months) and write them (amortize) over two years. The costs of the disks themselves will be expensed as sold on Sonny's Schedule C as "cost of goods sold." Each CD cost $2 to manufacture, so Sonny will expense $2 on his tax return for each CD he sells (or gives away as promotion). Unsold CDs will become inventory. In 2008 Sonny sold 195 CDs at $10 each. This activity is part of Sonny's Schedule C and is found on line 4 & Part III. Sonny may even have to collect state sales tax on a sale, depending on the regulations of the state Sonny is selling in.

The CD started to cause some buzz in the music world and band was offered a short showcase tour. Sonny and the band decided to set up an LLC for the band. They named the LLC "The Lido Shuffle" after one of their favorite songs. They had an attorney set up an LLC entity for them and Sonny's

accountant got a federal tax ID number online (www.irs.gov). Sonny's portion of the band's income from the tour was $9,420 (gross income less touring expenses). The band filed a Federal 1065 Partnership tax return for the LLC and each band member got a form K-1 for their portion of the net band income. Sonny had some out-of-pocket expenses related to the tour that he was able to take against this income on Schedule E, with the expenses detailed on Statement SBE.

A friend of Sonny's recommended that he spend some time out in LA to "see what was going on." Sonny flew out to LA and spent a week hearing music and visiting with some musician buddies he had in California. He had a tax-deductible lunch with a studio owner where he discussed the possibility of getting some studio gigs. He even sat in at some clubs, so he got a chance to play. Unfortunately for Sonny there was little deductible about the trip, he had no income from it and it had no defined, specific business purpose, thus no travel deductions!

Sonny lucked into a gig at the famed Ponderosa Stomp (www.ponderosastomp.com) in New Orleans. He flew there for four days of work (rehearsal and performance) and decided to stay on for two extra days to "hang out" and go to Jazz Fest. Because the primary reason for the trip was business he will be able to write off the full cost of the flight. He will be able to deduct meals, lodging and incidentals only for the four days he was employed doing the session work. The extra days will be considered vacation. If the ratio between vacation and workdays was reversed, Sonny would not be able to write off any of the cost of his flight down to New Orleans because the trip would shift from being primarily business to personal. The income and expense from this gig are on his Schedule C.

Sonny thought a personal website where he could post his resume, pictures, mp3s from the new CD by The Over the Hill Gang and perhaps some video clips from performances would be great. He also wanted to promote his teaching. The costs of setting up the website, registering the domain name and hosting the site will all be deductible. The IRS stipulates that website development be written off (amortized) over three years. So all Sonny's costs of designing and setting up the site will be added up (capitalized) and expensed over three years.

When Sonny met with his accountant at year-end to do some tax planning and check on his estimated tax payments for the year, he had more income than he had expected. His accountant asked if there were some expenses that he could accelerate into the current year; a way he would get the

tax benefit of the deductions in the current year. Sonny decided to purchase a new, smaller bass guitar amplifier before December 31st. By purchasing the amp before year-end he was able to use the section 179 election and write the new amplifier off 100% in the current year. He can do this even if he charges the amp on his credit card and pays it off in the next year as long as the amp is "in use" before December 31st. Sonny will also have to take a year-end inventory of all the unsold CDs so his accountant can correctly calculate his cost of goods sold.

When he is not on the road Sonny has a room set up in his house that he uses exclusively to give bass guitar lessons. Sonny has about ten regular students. He uses Form 8829 to take a home office deduction for his music room. He can also deduct the books, instructional videos and supplies that he uses in his teaching.

Musicians and Singers

Continuing Education

Coaching & Lessons Expense	
Dance Training	
Music - Arrangements	
Tapes, CDs & Recordings	
Training	
Rents - Rehearsal Hall	
Tickets - Performance Audit/Research	
Voice Training	
Other: _____	

Promotional Expenses

Audition Tapes, Videos CDs & DVDs	
Business Cards	
Film & Processing	
Website Development & Hosting	
Mailing Supplies - Envelopes, etc.	
Photos - Professional	
Resume' and Portfolio Expenses	
Other: _____	

Supplies & Other Expenses

Uniforms and Formal wear	
Cleaning (uniforms/formal)	
Recording Studio Costs	
Dues - Union & Professional	
Gifts - Business ($25 maximum per person per year)	
Insurance - Equipment	
Interest - Business Loans	
Strings, picks, cords, reeds, etc.	
Instruments and Musical Supplies	
Meals - Business (enter 100% of cost)	
Photocopy - Music, etc.	
Postage & Office Supplies	
Sheet Music	
Publications - Trade	
Rents - Office, Storage, etc.	
Rents - Equipment, etc.	
Repairs - Instruments and Equipment	
Secretarial & Bookkeeping	
Commissions - Agent/Manager	
Other: _____	

Auto Travel (in miles)

Auditions	
Business Meetings	
Continuing Education	
Job Seeking	
Out-Of-Town Business Trips	
Purchasing Job Supplies & Materials	
Professional Society Meetings	
Parking Fees & Tolls	
Other: _____	

Travel - Out of Town

Airfare

Car Rental

Parking

Apartment Rent (jobs lasting less than 1 year)

Taxi, Train, Bus & Subway

Lodging (do not combine with meals)

Meals (do not combine with lodging)

Laundry and Porter

Bridge & Highway Tolls

Telephone Calls (including home)

Other: _____

Telephone Costs

Cellular Calls

FAX Transmissions

Online Services

Paging Service

Pay Phone

Toll Calls

Other: _____

Equipment Purchases

Answering Machine

Personal Digital Assistants (PDAs)

Audio Systems & Amplifiers

Musical Instruments

Pager and Recorder

Software

Speaker Systems

Computer & Printer

Tools & other music supplies

Other: _____

Schedule C - Meals Detail - Line 24B

Atlantic City 14 days x $54	756.00	756.00
New Orleans 4 days x $59	236.00	236.00
NAMM show 3 days x $54	162.00	162.00
Other professional meals	704.00	704.00
	1,858.00	1,858.00

Travel Schedule C Detail - Line 24A

New Orleans - Air	604.00	604.00
New Orleans hotel - 4 days	842.00	842.00
NAMM Show - hotel 3 days	487.00	487.00
	1,933.00	1,933.00

Meals Detail Form 2106 - Line 5

NYC 21 days x $64	2,604.00	2,604.00
	2,604.00	2,604.00

Meals Detail K-1 - Schedule E

36 days x $44	1,584.00	1,584.00
	1,584.00	1,584.00

Travel Detail Form 2109 - Line 3

NYC - 21 days * $399 actual $	8,379.00	8,379.00
	8,379.00	8,379.00

List

| Form **1040** | U.S. Individual Income Tax Return | **2008** | (99) | IRS Use Only - Do not write or staple in this space. |

| | | For the year Jan. 1-Dec. 31, 2008, or other tax year beginning | , 2008, ending | , 20 | | OMB No. 1545-0074 |

Label (See instructions on page 14.)

Use the IRS label. Otherwise, please print or type.

L A B E L H E R E

Your first name and initial: **Sonny** Last name: **Phunky**

Your social security number: **222 33 4444**

If a joint return, spouse's first name and initial Last name

Spouse's social security number

Home address (number and street). If you have a P.O. box, see page 14. **RR 1** Apt. no.

You must enter ▲ your SSN(s) above. ▲

City, town or post office, state, and ZIP code. If you have a foreign address, see page 14. **Rockridge, ME 03905**

Checking a box below will not change your tax or refund.

Presidential Election Campaign ▶ Check here if you, or your spouse if filing jointly, want $3 to go to this fund (see page 14) ▶ ☐ You ☐ Spouse

Filing Status

Check only one box.

1 ☒ Single
2 ☐ Married filing jointly (even if only one had income)
3 ☐ Married filing separately. Enter spouse's SSN above and full name here. ▶
4 ☐ Head of household (with qualifying person). If the qualifying person is a child but not your dependent, enter this child's name here. ▶
5 ☐ Qualifying widow(er) with dependent child (see page 16)

Exemptions

6a ☒ Yourself. If someone can claim you as a dependent, **do not** check box 6a
b ☐ Spouse
c Dependents:

(1) First name Last name	(2) Dependent's social security number	(3) Dependent's relationship to you	(4) ✓ if qualifying child for child tax credit (see page 17)

If more than four dependents, see page 17.

Boxes checked on 6a and 6b: **1**

No. of children on 6c who:
● lived with you
● did not live with you due to divorce or separation (see page 18)
Dependents on 6c not entered above
Add numbers on lines above ▶ **1**

d Total number of exemptions claimed ...

Income

Attach Form(s) W-2 here. Also attach Forms W-2G and 1099-R if tax was withheld.

If you did not get a W-2, see page 21.

Enclose, but do not attach, any payment. Also, please use Form 1040-V.

7 Wages, salaries, tips, etc. Attach Form(s) W-2 | 7 | **31,071.**
8a Taxable interest. Attach Schedule B if required | 8a | **9.**
b Tax-exempt interest. **Do not** include on line 8a | 8b |
9a Ordinary dividends. Attach Schedule B if required | 9a |
b Qualified dividends (see page 21) | 9b |
10 Taxable refunds, credits, or offsets of state and local income taxes | 10 |
11 Alimony received ... | 11 |
12 Business income or (loss). Attach Schedule C or C-EZ | 12 | **1,006.**
13 Capital gain or (loss). Attach Schedule D if required. If not required, check here ▶ ☐ | 13 |
14 Other gains or (losses). Attach Form 4797 | 14 |
15a IRA distributions | 15a | b Taxable amount | 15b |
16a Pensions and annuities | 16a | b Taxable amount | 16b |
17 Rental real estate, royalties, partnerships, S corporations, trusts, etc. Attach Schedule E | 17 | **7,364.**
18 Farm income or (loss). Attach Schedule F | 18 |
19 Unemployment compensation ... | 19 |
20a Social security benefits | 20a | b Taxable amount (see page 26) | 20b |
21 Other income. List type and amount (see page 28) _____ | 21 |
22 Add the amounts in the far right column for lines 7 through 21. This is your **total income** ▶ | 22 | **39,450.**

Adjusted Gross Income

23 Educator expenses (see page 28) | 23 |
24 Certain business expenses of reservists, performing artists, and fee-basis government officials. Attach Form 2106 or 2106-EZ | 24 |
25 Health savings account deduction. Attach Form 8889 | 25 |
26 Moving expenses. Attach Form 3903 | 26 |
27 One-half of self-employment tax. Attach Schedule SE | 27 | **592.**
28 Self-employed SEP, SIMPLE, and qualified plans | 28 |
29 Self-employed health insurance deduction (see page 29) | 29 |
30 Penalty on early withdrawal of savings | 30 |
31a Alimony paid b Recipient's SSN ▶ | 31a |
32 IRA deduction (see page 30) | 32 |
33 Student loan interest deduction (see page 33) | 33 |
34 Tuition and fees deduction. Attach Form 8917 | 34 |
35 Domestic production activities deduction. Attach Form 8903 | 35 |
36 Add lines 23 through 31a and 32 through 35 | 36 | **592.**
37 Subtract line 36 from line 22. This is your **adjusted gross income** ▶ | 37 | **38,858.**

810001 11-10-08

LHA For Disclosure, Privacy Act, and Paperwork Reduction Act Notice, see page 88.

Form **1040** (2008)

Form 1040 (2008)	Sonny Phunky		222-33-4444			Page **2**

Tax and Credits	38	Amount from line 37 (adjusted gross income)			38	38,858.

Standard Deduction for -

● People who checked any box on line 39a, 39b, or 39c **or** who can be claimed as a dependent.

● All others:

Single or Married filing separately, $5,450

Married filing jointly or Qualifying widow(er), $10,900

Head of household, $8,000

39a	Check if:	☐ **You** were born before January 2, 1944, ☐ Blind. ☐ **Spouse** was born before January 2, 1944, ☐ Blind.	**Total boxes checked** ▶ 39a		
b	If your spouse itemizes on a separate return or you were a dual-status alien, see page 34 and check here ▶ 39b				
c	Check if standard deduction includes real estate taxes or disaster loss (see page 34) ▶ 39c				
40	**Itemized deductions** (from Schedule A) **or** your **standard deduction** (see left margin)		40	15,010.	
41	Subtract line 40 from line 38		41	23,848.	
42	If line 38 is over $119,975, or you provided housing to a Midwestern displaced individual, see page 36. Otherwise, multiply $3,500 by the total number of exemptions claimed on line 6d		42	3,500.	
43	**Taxable income.** Subtract line 42 from line 41. If line 42 is more than line 41, enter -0-		43	20,348.	
44	**Tax.** Check if any tax is from: a ☐ Form(s) 8814 b ☐ Form 4972		44	2,648.	
45	**Alternative minimum tax.** Attach Form 6251		45	0.	
46	Add lines 44 and 45 ▶		46	2,648.	

47	Foreign tax credit. Attach Form 1116 if required	47			
48	Credit for child and dependent care expenses. Attach Form 2441	48			
49	Credit for the elderly or the disabled. Attach Schedule R	49			
50	Education credits. Attach Form 8863	50			
51	Retirement savings contributions credit. Attach Form 8880	51			
52	Child tax credit (see page 42). Attach Form 8901 if required	52			
53	Credits from: a ☐ 8396 b ☐ 8839 c ☐ 5695	53			
54	Other credits from Form: a ☐ 3800 b ☐ 8801 c ☐	54			
55	Add lines 47 through 54. These are your **total credits**		55		
56	Subtract line 55 from line 46. If line 55 is more than line 46, enter -0- ▶		56	2,648.	

Other Taxes	57	Self-employment tax. Attach Schedule SE		57	1,183.
	58	Unreported social security and Medicare tax from Form: a ☐ 4137 b ☐ 8919		58	
	59	Additional tax on IRAs, other qualified retirement plans, etc. Attach Form 5329 if required		59	
	60	Additional taxes: a ☐ AEIC payments b ☐ Household employment taxes. Attach Schedule H		60	
	61	Add lines 56 through 60. This is your **total tax** ▶		61	3,831.

Payments	62	Federal income tax withheld from Forms W-2 and 1099	62	3,462.		

If you have a qualifying child, attach Schedule EIC.

63	2008 estimated tax payments and amount applied from 2007 return	63			
64a	**Earned income credit (EIC)**	64a			
b	Nontaxable combat pay election ▶	64b			
65	Excess social security and tier 1 RRTA tax withheld (see page 61)	65			
66	Additional child tax credit. Attach Form 8812	66			
67	Amount paid with request for extension to file (see page 61)	67			
68	Credits from Form: a ☐ 2439 b ☐ 4136 c ☐ 8801 d ☐ 8885	68			
69	First-time homebuyer credit. Attach Form 5405	69			
70	Recovery rebate credit (see worksheet on pages 62 and 63)	70			
71	Add lines 62 through 70. These are your **total payments** ▶		71	3,462.	

Refund	72	If line 71 is more than line 61, subtract line 61 from line 71. This is the amount you **overpaid**		72	

Direct deposit? See page 63 and fill in 73b, 73c, and 73d, or Form 8888.

73a	Amount of line 72 you want **refunded to you.** If Form 8888 is attached, check here ▶ ☐		73a		
b	Routing number ▶ c Type: ☐ Checking ☐ Savings d Account number ▶				
74	Amount of line 72 you want **applied to your 2009 estimated tax** ▶	74			

Amount You Owe	75	**Amount you owe.** Subtract line 71 from line 61. For details on how to pay, see page 65 ▶		75	369.
	76	Estimated tax penalty (see page 65)	76		

Third Party Designee	Do you want to allow another person to discuss this return with the IRS (see page 66)?	☒ **Yes.** Complete the following.	☐ **No**

Designee's name ▶ **Preparer** Phone no. ▶ Personal identification number (PIN) ▶

Sign Here

Under penalties of perjury, I declare that I have examined this return and accompanying schedules and statements, and to the best of my knowledge and belief, they are true, correct, and complete. Declaration of preparer (other than taxpayer) is based on all information of which preparer has any knowledge.

Joint return? See page 15. Keep a copy for your records.

Your signature	Date	Your occupation	Daytime phone number
		Musician	
Spouse's signature. If a joint return, **both** must sign.	Date	Spouse's occupation	

Paid Preparer's Use Only	Preparer's signature ▶ Peter Jason Riley, CPA	Date 12/13/09	Check if self-employed ☐	Preparer's SSN or PTIN P00413102

810002 11-10-08

Firm's name (or yours if self-employed), address, and ZIP code ▶ Riley & Associates, P.C. P.O. Box 157 Newburyport, MA 01950-0157

EIN 04:3577120 Phone no. 978-463-9350

SCHEDULES A&B (Form 1040)	Schedule A - Itemized Deductions	OMB No. 1545-0074

SCHEDULES A&B
(Form 1040)
Department of the Treasury
Internal Revenue Service (99)

Schedule A - Itemized Deductions
(Schedule B is on page 2)
▶ Attach to Form 1040. ▶ See Instructions for Schedules A&B (Form 1040).

OMB No. 1545-0074

2008

Attachment
Sequence No. **07**

Name(s) shown on Form 1040

Sonny Phunky

Your social security number

222 33 4444

Medical and Dental Expenses		Caution. Do not include expenses reimbursed or paid by others.		
	1	Medical and dental expenses (see page A-1)	1	
	2	Enter amount from Form 1040, line 38 [2]		
	3	Multiply line 2 by 7.5% (.075)	3	
	4	Subtract line 3 from line 1. If line 3 is more than line 1, enter -0-	4	
Taxes You Paid (See page A-2.)	5	State and local (check only one box):	5	2,171.
		a [X] Income taxes, or		
		b [] General sales taxes		
	6	Real estate taxes (see page A-5)	6	1,598.
	7	Personal property taxes	7	147.
	8	Other taxes. List type and amount ▶ _____ _____	8	
	9	Add lines 5 through 8	9	3,916.
Interest You Paid (See page A-5.)	10	Home mortgage interest and points reported to you on Form 1098 Stmt 1	10	5,399.
	11	Home mortgage interest not reported to you on Form 1098. If paid to the person from whom you bought the home, see page A-6 and show that person's name, identifying no., and address ▶ _____	11	
Note. Personal interest is not deductible.	12	Points not reported to you on Form 1098	12	
	13	Qualified mortgage insurance premiums (See page A-6)	13	
	14	Investment interest. Attach Form 4952 if required. (See page A-6.)	14	
	15	Add lines 10 through 14	15	5,399.
Gifts to Charity	16	Gifts by cash or check	16	250.
If you made a gift and got a benefit for it, see page A-7.	17	Other than by cash or check. If any gift of $250 or more, see page A-8. You must attach Form 8283 if over $500	17	
	18	Carryover from prior year	18	
	19	Add lines 16 through 18	19	250.
Casualty and Theft Losses	20	Casualty or theft loss(es). Attach Form 4684. (See page A-8.)	20	
Job Expenses and Certain Miscellaneous Deductions (See page A-9.)	21	Unreimbursed employee expenses - job travel, union dues, job education, etc. Attach Form 2106 or 2106-EZ if required. (See page A-9.) ▶From Form 2106 _____ 6,222.	21	6,222.
	22	Tax preparation fees	22	
	23	Other expenses - investment, safe deposit box, etc. List type and amount ▶ _____ _____	23	
	24	Add lines 21 through 23	24	6,222.
	25	Enter amount from Form 1040, line 38 [25] 38,858.		
	26	Multiply line 25 by 2% (.02)	26	777.
	27	Subtract line 26 from line 24. If line 26 is more than line 24, enter -0-	27	5,445.
Other Miscellaneous Deductions	28	Other - from list on page A-10. List type and amount ▶ _____ _____	28	
Total Itemized Deductions	29	Is Form 1040, line 38, over $159,950 (over $79,975 if married filing separately)? [X] No. Your deduction is not limited. Add the amounts in the far right column for lines 4 through 28. Also, enter this amount on Form 1040, line 40. ▶	29	15,010.
		[] Yes. Your deduction may be limited. See page A-10 for the amount to enter. ▶		
	30	If you elect to itemize deductions even though they are less than your standard deduction, check here ▶ []		

LHA 819501 11-10-08 **For Paperwork Reduction Act Notice, see Form 1040 instructions.**

Schedule A (Form 1040) 2008

Schedules A&B (Form 1040) 2008 OMB No. 1545-0074 Page **2**

Name(s) shown on Form 1040. Do not enter name and social security number if shown on page 1. Your social security number

Sonny Phunky 222 33 4444

Schedule B - Interest and Ordinary Dividends

Attachment Sequence No. **08**

Part I **Interest**		Amount
1 List name of payer. If any interest is from a seller-financed mortgage and the buyer used the property as a personal residence, see page B-1 and list this interest first. Also, show that buyer's social security number and address ▶ _____		**9.**
Bank of America		

Note. If you received a Form 1099-INT, Form 1099-OID, or substitute statement from a brokerage firm, list the firm's name as the payer and enter the total interest shown on that form.

2 Add the amounts on line 1	**2**	**9.**
3 Excludable interest on series EE and I U.S. savings bonds issued after 1989. Attach Form 8815	**3**	
4 Subtract line 3 from line 2. Enter the result here and on Form 1040, line 8a ▶	**4**	**9.**

Note. If line 4 is over $1,500, you must complete Part III.

Part II **Ordinary Dividends**		Amount
5 List name of payer ▶	**5**	

Note: If you received a Form 1099-DIV or substitute statement from a brokerage firm, list the firm's name as the payer and enter the ordinary dividends shown on that form.

6 Add the amounts on line 5. Enter the total here and on Form 1040, line 9a ▶	**6**	

Note. If line 6 is over $1,500, you must complete Part III.

Part III Foreign Accounts and Trusts

You must complete this part if you **(a)** had over $1,500 of taxable interest or ordinary dividends; or **(b)** had a foreign account; or **(c)** received a distribution from, or were a grantor of, or a transferor to, a foreign trust.

	Yes	No
7a At any time during 2008, did you have an interest in or a signature or other authority over a financial account in a foreign country, such as a bank account, securities account, or other financial account? See page B-2 for exceptions and filing requirements for Form TD F 90-22.1		X
b If "Yes," enter the name of the foreign country ▶		
8 During 2008, did you receive a distribution from, or were you the grantor of, or transferor to, a foreign trust? If "Yes," you may have to file Form 3520. See page B-2		X

827501 11-11-08

LHA **For Paperwork Reduction Act Notice, see Form 1040 instructions.** Schedule B (Form 1040) 2008

5

SCHEDULE C (Form 1040)	**Profit or Loss From Business** (Sole Proprietorship)	OMB No. 1545-0074 **2008**

Department of the Treasury
Internal Revenue Service (99)

▶ Partnerships, joint ventures, etc., generally must file Form 1065 or 1065-B.
▶ Attach to Form 1040, 1040NR, or 1041.　▶See Instructions for Schedule C (Form 1040).

Attachment Sequence No. **09**

Name of proprietor

Social security number (SSN)

Sonny Phunky

222-33-4444

A　Principal business or profession, including product or service (see page C-3)

B Enter code from pages C-9, 10, & 11 ▶ 711510

Musician/Teacher

C　Business name. If no separate business name, leave blank.

D Employer ID number (EIN), if any

Sonny Phunky

E　Business address (including suite or room no.) ▶ RR 1
　City, town or post office, state, and ZIP code　Rockridge, ME 03905

F　Accounting method:　(1) [X] Cash　(2) ☐ Accrual　(3) ☐ Other (specify) ▶

G　Did you "materially participate" in the operation of this business during 2008? If "No," see page C-4 for limit on losses [X] Yes ☐ No

H　If you started or acquired this business during 2008, check here ▶ ☐

Part I　Income

1	Gross receipts or sales. **Caution.** See page C-4 and check the box if: • This income was reported to you on Form W-2 and the "Statutory employee" box on that form was checked, or • You are a member of a qualified joint venture reporting only rental real estate income not subject to self-employment tax. Also see page C-4 for limit on losses. ▶ ☐	1	16,845.
2	Returns and allowances	2	
3	Subtract line 2 from line 1	3	16,845.
4	Cost of goods sold (from line 42 on page 2)	4	4,955.
5	**Gross profit.** Subtract line 4 from line 3	5	11,890.
6	Other income, including federal and state gasoline or fuel tax credit or refund (see page C-4) See Statement 2	6	4,191.
7	**Gross income.** Add lines 5 and 6 ▶	7	16,081.

Part II　Expenses. Enter expenses for business use of your home **only** on line 30.

8	Advertising	8	341.	18	Office expense	18	104.
9	Car and truck expenses (see page C-5)	9	2,241.	19	Pension and profit-sharing plans	19	
10	Commissions and fees	10		20	Rent or lease (see page C-6):		
11	Contract labor (see page C-5)	11		a	Vehicles, machinery, and equipment	20a	
12	Depletion	12		b	Other business property	20b	
13	Depreciation and section 179 expense deduction (not included in Part III) (see page C-5)	13	2,228.	21	Repairs and maintenance	21	104.
				22	Supplies (not included in Part III)	22	474.
				23	Taxes and licenses	23	
14	Employee benefit programs (other than on line 19)	14		24	Travel, meals, and entertainment:		
				a	Travel	24a	1,933.
15	Insurance (other than health)	15		b	Deductible meals and entertainment (see page C-7)	24b	929.
16	Interest:			25	Utilities	25	
a	Mortgage (paid to banks, etc.)	16a		26	Wages (less employment credits)	26	
b	Other	16b		27	Other expenses (from line 48 on page 2)	27	3,821.
17	Legal and professional services	17	250.				

28	**Total expenses** before expenses for business use of home. Add lines 8 through 27 ▶	28	12,425.
29	Tentative profit or (loss). Subtract line 28 from line 7	29	3,656.
30	Expenses for business use of your home. Attach **Form 8829**	30	2,650.
31	**Net profit or (loss).** Subtract line 30 from line 29. • If a profit, enter on both **Form 1040, line 12,** and **Schedule SE, line 2,** or on **Form 1040NR, line 13** (if you checked the box on line 1, see page C-7). Estates and trusts, enter on **Form 1041, line 3.** • If a loss, you **must** go to line 32.	31	1,006.
32	If you have a loss, check the box that describes your investment in this activity (see page C-8). • If you checked 32a, enter the loss on both **Form 1040, line 12,** and **Schedule SE, line 2,** or on **Form 1040NR, line 13** (if you checked the box on line 1, see the line 31 instructions on page C-7). Estates and trusts, enter on **Form 1041, line 3.** • If you checked 32b, you **must** attach **Form 6198.** Your loss may be limited.	32a ☐ All investment is at risk. 32b ☐ Some investment is not at risk.	

LHA　For Paperwork Reduction Act Notice, see page C-9 of the instructions.

Schedule C (Form 1040) 2008

820001 11-20-08

6

Schedule C (Form 1040) 2008 SONNY PHUNKY 222-33-4444 Page 2

Part III Cost of Goods Sold (see page C-8)

33	Method(s) used to value closing inventory:	a ☐ Cost b ☐ Lower of cost or market c ☐ Other (attach explanation)	

34 Was there any change in determining quantities, costs, or valuations between opening and closing inventory? If "Yes," attach explanation .. ☐ Yes ☐ No

35	Inventory at beginning of year. If different from last year's closing inventory, attach explanation	35	
36	Purchases less cost of items withdrawn for personal use	36	1,000.
37	Cost of labor. Do not include any amounts paid to yourself	37	
38	Materials and supplies	38	
39	Other costs See Statement 4	39	4,565.
40	Add lines 35 through 39	40	5,565.
41	Inventory at end of year	41	610.
42	**Cost of goods sold.** Subtract line 41 from line 40. Enter the result here and on page 1, line 4	42	4,955.

Part IV Information on Your Vehicle. Complete this part **only** if you are claiming car or truck expenses on line 9 and are not required to file Form 4562 for this business. See the instructions for line 13 on page C-5 to find out if you must file Form 4562.

43 When did you place your vehicle in service for business purposes? (month, day, year) ▶ ___ / ___ / ___

44 Of the total number of miles you drove your vehicle during 2008, enter the number of miles you used your vehicle for:

a Business _____ b Commuting _____ c Other _____

45 Was your vehicle available for personal use during off-duty hours? ... ☐ Yes ☐ No

46 Do you (or your spouse) have another vehicle available for personal use? .. ☐ Yes ☐ No

47 a Do you have evidence to support your deduction? ... ☐ Yes ☐ No

 b If "Yes," is the evidence written? ... ☐ Yes ☐ No

Part V Other Expenses. List below business expenses not included on lines 8-26 or line 30.

See Statement 3	3,821.	
48 **Total other expenses.** Enter here and on page 1, line 27	48	3,821.

820002 11-20-08

Schedule C (Form 1040) 2008

2008 DEPRECIATION AND AMORTIZATION REPORT
Sonny Phunky

SCHEDULE C - 1

Asset No.	Description	Date Acquired	Method	Life	Line No.	Unadjusted Cost Of Basis	Bus % Excl	Reduction In Basis	Basis For Depreciation	Accumulated Depreciation	Current Sec 179	Current Year Deduction
3	Fender⊘Precision⊘ electric bass guitar	070108	200DB	7.00	19C	10,000.			10,000.			1,429.
6	CD Production costs	070108		24M	42	1,850.			1,850.			463.
8	Website	080908		36M	42	2,841.			2,841.			395.
10	Gallien-Krueger Backline 600	091508	200DB	5.00	19B	799.		799.	0.		799.	799.
	Total Sch C Depr. & Amortization					15,490.		799.	14,691.		799.	3,086.
	Current Year Activity											
	Beginning balance					0.		0.	0.	0.		
	Acquisitions					15,490.		799.	14,691.	0.		14,691.
	Dispositions					0.		0.	0.	0.		
	Ending balance					15,490.		799.	14,691.	0.		14,691.

* ITC, Section 179, Salvage, Bonus, Commercial Revitalization Deduction, GO Zone

(D) - Asset disposed

7.1

828102
04-25-08

Schedule E (Form 1040) 2008 Attachment Sequence No. **13** Page **2**

Name(s) shown on return. Do not enter name and social security number if shown on page 1.

Sonny Phunky

Your social security number

222-33-4444

| Part II | Income or Loss From Partnerships and S Corporations |

Note. If you report a loss from an at-risk activity for which **any** amount is **not** at risk, you **must** check column **(e)** on line 28 and attach **Form 6198.** See page E-1.

27 Are you reporting any loss not allowed in a prior year due to the at-risk or basis limitations, a prior year unallowed loss from a passive activity (if that loss was not reported on Form 8582), or unreimbursed partnership expenses? [X] Yes ☐ No

If you answered "Yes," see page E-7 before completing this section.

28	**(a)** Name	**(b)** Enter **P** for partnership; **S** for S corporation	**(c)** Check if foreign partnership	**(d)** Employer identification number	**(e)** Check if any amount is not at risk
A	The Lido Shuffle	P		26-0000001	
B	Unreimbursed expenses	P		26-0000001	
C					
D					

	Passive Income and Loss		Nonpassive Income and Loss		
	(f) Passive loss allowed (attach **Form 8582** if required)	**(g)** Passive income from **Schedule K-1**	**(h)** Nonpassive loss from **Schedule K-1**	**(i)** Section 179 expense deduction from **Form 4562**	**(j)** Nonpassive income from **Schedule K-1**
A					9,420.
B			2,056.		
C					
D					
29a	Totals				9,420.
b	Totals		2,056.		

30 Add columns (g) and (j) of line 29a .. 30 | 9,420.
31 Add columns (f), (h), and (i) of line 29b 31 (2,056.)
32 **Total partnership and S corporation income or (loss).** Combine lines 30 and 31. Enter the result here and include in the total on line 41 below 32 | 7,364.

| Part III | Income or Loss From Estates and Trusts |

33	**(a)** Name	**(b)** Employer identification number
A		
B		

	Passive Income and Loss		Nonpassive Income and Loss	
	(c) Passive deduction or loss allowed (attach **Form 8582** if required)	**(d)** Passive income from **Schedule K-1**	**(e)** Deduction or loss from **Schedule K-1**	**(f)** Other income from **Schedule K-1**
A				
B				
34a	Totals			
b	Totals			

35 Add columns (d) and (f) of line 34a .. 35
36 Add columns (c) and (e) of line 34b 36 ()
37 **Total estate and trust income or (loss).** Combine lines 35 and 36. Enter the result here and include in the total on line 41 below 37

| Part IV | Income or Loss From Real Estate Mortgage Investment Conduits (REMICs) - Residual Holder |

38	**(a)** Name	**(b)** Employer identification number	**(c)** Excess inclusion from **Schedules Q,** line 2c	**(d)** Taxable income (net loss) from **Schedules Q,** line 1b	**(e)** Income from **Schedules Q,** line 3b

39 Combine columns (d) and (e) only. Enter the result here and include in the total on line 41 below 39

| Part V | Summary |

40 Net farm rental income or (loss) from **Form 4835.** Also, complete line 42 below ▶ 40
41 **Total income or (loss).** Combine lines 26, 32, 37, 39, and 40. Enter the result here and on Form 1040, line 17, or Form 1040NR, line 18 ▶ 41 | 7,364.
42 **Reconciliation of farming and fishing income.** Enter your **gross** farming and fishing income reported on Form 4835, line 7; Schedule K-1 (Form 1065), box 14, code B; Schedule K-1 (Form 1120S), box 17, code T; and Schedule K-1 (Form 1041), line 14, code F (see page E-8) | 42 | 31,200.
43 **Reconciliation for real estate professionals.** If you were a real estate professional (see page E-2), enter the net income or (loss) you reported anywhere on Form 1040 or Form 1040NR from all rental real estate activities in which you materially participated under the passive activity loss rules | 43

821501
11-10-08

Schedule E (Form 1040) 2008

SCHEDULE E

INCOME FROM PASSTHROUGH STATEMENT, PAGE 1

2008

Name Sonny Phunky

Passthrough The Lido Shuffle

Partnership

ID 26-0000001

SSN/EIN 222-33-4444

Taxpayer

Nonpassive	K-1 Input	Prior Year Unallowed Basis Loss	Disallowed Due to Basis Limitation	Prior Year Unallowed At-Risk Loss	Disallowed Due to At-Risk	Prior Year Passive Loss	Disallowed Passive Loss	Tax Return
SCHEDULE E, PAGE 2								
Ordinary business income (loss)	9,420.							
Rental real estate income (loss)								
Other net rental income (loss)								
Intangible drilling costs/dry hole costs								
Self-charged passive interest expense								
Guaranteed payments								
Section 179 and carryover								
Disallowed section 179 expense								
Net income (loss)	9,420.							9,420.
First passive other								
Second passive other								
Cost depletion								
Percentage depletion								
Depletion carryover								
Disallowed due to 65% limitation								
Unreimbursed expenses (nonpassive)	2,056.							2,056.
Nonpassive other								
Total Schedule E (page 2)	7,364.							7,364.
FORM 4797								
Section 1231 gain (loss)								
Section 179 recapture on disposition								
SCHEDULE D								
Net short-term cap. gain (loss)								
Net long-term cap. gain (loss)								
Section 1256 contracts & straddles								
FORM 4952								
Investment interest expense - Sch. A								
Other net investment income								
ITEMIZED DEDUCTIONS								
Charitable contributions								
Deductions related to portfolio income								
Other								

821551
04-25-08

9

SCHEDULE E

INCOME FROM PASSTHROUGH STATEMENT, PAGE 2

2008

Name Sonny Phunky

Passthrough The Lido Shuffle

Partnership

ID 26-0000001

SSN/EIN 222-33-4444

Taxpayer

Nonpassive	K-1 Input	Prior Year Unallowed Basis Loss	Disallowed Due to Basis Limitation	Prior Year Unallowed At-Risk Loss	Disallowed Due to At-Risk	Prior Year Passive Loss	Disallowed Passive Loss	Tax Return
INTEREST AND DIVIDENDS								
Interest income								
Interest from U.S. bonds								
Ordinary dividends								
Qualified dividends								
Tax-exempt interest income								
FORM 6251								
Depreciation adjustment after 12/31/86								
Adjusted gain or loss								
Beneficiary's AMT adjustment								
Depletion (other than oil)								
Other								
MISCELLANEOUS								
Self-employment earnings (loss)/Wages	9,420.							9,420.
Gross farming & fishing inc	31,200.							31,200.
Royalties								
Royalty expenses/depletion								
Undistributed capital gains credit								
Backup withholding								
Credit for estimated tax								
Cancellation of debt								
Medical insurance - 1040								
Dependent care benefits								
Retirement plans								
Qualified production activities income								
Passthrough adjustment to Form 1040								
Penalty on early withdrawal of savings								
NOL								
Other taxes/recapture of credits								
Credits								
Casualty and theft loss								

10

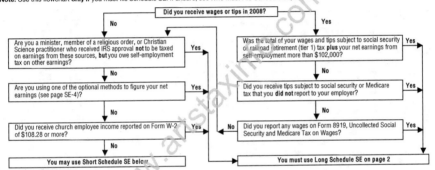

SCHEDULE SE **(Form 1040)** Department of the Treasury Internal Revenue Service (99)	**Self-Employment Tax** ▶ **Attach to Form 1040.** ▶ **See Instructions for Schedule SE (Form 1040).**	OMB No. 1545-0074 **2008** Attachment Sequence No. **17**

Name of person with **self-employment** income (as shown on Form 1040)

Sonny Phunky

Social security number of person with **self-employment** income ▶ 222 : 33 : 4444

Who Must File Schedule SE

You must file Schedule SE if:

- You had net earnings from self-employment from **other than** church employee income (line 4 of Short Schedule SE or line 4c of Long Schedule SE) of $400 or more, **or**
- You had church employee income of $108.28 or more. Income from services you performed as a minister or a member of a religious order **is not** church employee income (see page SE-1).

Note. Even if you had a loss or a small amount of income from self-employment, it may be to your benefit to file Schedule SE and use either "optional method" in Part II of Long Schedule SE (see page SE-4).

Exception. If your only self-employment income was from earnings as a minister, member of a religious order, or Christian Science practitioner **and** you filed Form 4361 and received IRS approval not to be taxed on those earnings, **do not** file Schedule SE. Instead, write "Exempt-Form 4361" on Form 1040, line 57.

May I Use Short Schedule SE or Must I Use Long Schedule SE?

Note. Use this flowchart **only if** you must file Schedule SE. If unsure, see *Who Must File Schedule SE, above.*

Section A-Short Schedule SE. Caution. Read above to see if you can use Short Schedule SE.

1a	Net farm profit or (loss) from Schedule F, line 36, and farm partnerships, Schedule K-1 (Form 1065), box 14, code A ..	**1a**	
b	If you received social security retirement or disability benefits, enter the amount of Conservation Reserve Program payments included on Schedule F, line 6b, or listed on Schedule K-1 (Form 1065), box 20, code X	**1b**	
2	Net profit or (loss) from Schedule C, line 31; Schedule C-EZ, line 3; Schedule K-1 (Form 1065), box 14, code A (other than farming); and Schedule K-1 (Form 1065-B), box 9, code J1. Ministers and members of religious orders, see pg SE-1 for types of income to report on this line. See pg SE-3 for other income to report **Stmt 5**	**2**	8,370.
3	Combine lines 1a, 1b, and 2 ..	**3**	8,370.
4	**Net earnings from self-employment.** Multiply line 3 by 92.35% (.9235). If less than $400, **do not** file this schedule; you do not owe self-employment tax ▶	**4**	7,730.
5	**Self-employment tax.** If the amount on line 4 is: • $102,000 or less, multiply line 4 by 15.3% (.153). Enter the result here and on **Form 1040, line 57.** • More than $102,000, multiply line 4 by 2.9% (.029). Then, add $12,648 to the result. Enter the total here and on **Form 1040, line 57** ..	**5**	1,183.
6	**Deduction for one-half of self-employment tax.** Multiply line 5 by 50% (.5). Enter the result here and on **Form 1040, line 27**	**6** 592.	

LHA **For Paperwork Reduction Act Notice, see Form 1040 instructions.**

Schedule SE (Form 1040) 2008

824501
11-11-08

11

Does not apply

Form **6251**	**Alternative Minimum Tax - Individuals**	OMB No. 1545-0074 **2008**

Department of the Treasury
Internal Revenue Service (99)

▶ **Attach to Form 1040 or Form 1040NR.**

Attachment
Sequence No. **32**

Name(s) shown on Form 1040 or Form 1040NR

Sonny Phunky

Your social security number

222 33 4444

Part I	**Alternative Minimum Taxable Income**		
1	If filing Schedule A (Form 1040), enter the amount from Form 1040, line 41 (minus any amount on Form 8914, line 2), and go to line 2. Otherwise, enter the amount from Form 1040, line 38 (minus any amount on Form 8914, line 2), and go to line 7. (If less than zero, enter as a negative amount.)	1	23,848.
2	Medical and dental. Enter the **smaller** of Schedule A (Form 1040), line 4, **or** 2.5% (.025) of Form 1040, line 38. If zero or less, enter -0-	2	
3	Taxes from Schedule A (Form 1040), line 9	3	3,916.
4	Enter the home mortgage interest adjustment, if any, from line 6 of the worksheet on page 2 of the instructions	4	
5	Miscellaneous deductions from Schedule A (Form 1040), line 27	5	5,445.
6	If Form 1040, line 38, is over $159,950 (over $79,975 if married filing separately), enter the amount from line 11 of the **Itemized Deductions Worksheet** on page A-10 of the instructions for Schedule A (Form 1040)	6	
7	If claiming the standard deduction, enter any amount from Form 4684, line 18a, as a negative amount	7	
8	Tax refund from Form 1040, line 10 or line 21	8	
9	Investment interest expense (difference between regular tax and AMT)	9	
10	Depletion (difference between regular tax and AMT)	10	
11	Net operating loss deduction from Form 1040, line 21. Enter as a positive amount	11	
12	Interest from specified private activity bonds exempt from the regular tax	12	
13	Qualified small business stock (7% of gain excluded under section 1202)	13	
14	Exercise of incentive stock options (excess of AMT income over regular tax income)	14	
15	Estates and trusts (amount from Schedule K-1 (Form 1041), box 12, code A)	15	
16	Electing large partnerships (amount from Schedule K-1 (Form 1065-B), box 6)	16	
17	Disposition of property (difference between AMT and regular tax gain or loss)	17	
18	Depreciation on assets placed in service after 1986 (difference between regular tax and AMT) **Stmt 6**	18	472.
19	Passive activities (difference between AMT and regular tax income or loss)	19	
20	Loss limitations (difference between AMT and regular tax income or loss)	20	
21	Circulation costs (difference between regular tax and AMT)	21	
22	Long-term contracts (difference between AMT and regular tax income)	22	
23	Mining costs (difference between regular tax and AMT)	23	
24	Research and experimental costs (difference between regular tax and AMT)	24	
25	Income from certain installment sales before January 1, 1987	25	
26	Intangible drilling costs preference	26	
27	Other adjustments, including income-based related adjustments	27	
28	Alternative tax net operating loss deduction	28	
29	**Alternative minimum taxable income.** Combine lines 1 through 28. (If married filing separately and line 29 is more than $214,900, see instructions)	29	33,681.

Part II	**Alternative Minimum Tax (AMT)**		
30	Exemption. (If you were under age 24 at the end of 2008, see instructions.)		

IF your filing status is	AND line 29 is not over	THEN enter on line 30
Single or head of household	$112,500	$46,200
Married filing jointly or qualifying widow(er)	150,000	69,950
Married filing separately	75,000	34,975

		30	46,200.
	If line 29 is **over** the amount shown above for your filing status, see instructions.		
31	Subtract line 30 from line 29. If more than zero, go to line 32. If zero or less, enter -0- here and on lines 34 and 36 and skip the rest of Part II	31	0.
32	• If you are filing Form 2555 or 2555-EZ, see page 9 of the instructions for the amount to enter. • If you reported capital gain distributions directly on Form 1040, line 13; you reported qualified dividends on Form 1040, line 9b; **or** you had a gain on both lines 15 and 16 of Schedule D (Form 1040) (as refigured for the AMT, if necessary), complete Part III on page 2 and enter the amount from line 55 here. • **All others:** If line 31 is $175,000 or less ($87,500 or less if married filing separately), multiply line 31 by 26% (.26). Otherwise, multiply line 31 by 28% (.28) and subtract $3,500 ($1,750 if married filing separately) from the result.	32	0.
33	Alternative minimum tax foreign tax credit (see instructions)	33	
34	Tentative minimum tax. Subtract line 33 from line 32	34	0.
35	Tax from Form 1040, line 44 (minus any tax from Form 4972 and any foreign tax credit from Form 1040, line 47). If you used Sch J to figure your tax, the amount from line 44 of Form 1040 must be refigured without using Sch J	35	2,648.
36	**AMT.** Subtract line 35 from line 34. If zero or less, enter -0-. Enter here and on Form 1040, line 45	36	0.

819481
12-02-08 LHA **For Paperwork Reduction Act Notice, see instructions.**

Form **6251** (2008)

12

Form 6251 (2008) Sonny Phunky 222-33-4444 Page **2**

Part III | **Tax Computation Using Maximum Capital Gains Rates**

37 Enter the amount from Form 6251, line 31. If you are filing Form 2555 or 2555-EZ, enter the amount from line 3 of the worksheet in the instructions **37**

38 Enter the amount from line 6 of the Qualified Dividends and Capital Gain Tax Worksheet in the instructions for Form 1040, line 44, or the amount from line 13 of the Schedule D Tax Worksheet on page D-10 of the instructions for Schedule D (Form 1040), whichever applies (as refigured for the AMT, if necessary) (see the instructions). If you are filing Form 2555 or 2555-EZ, see instructions for the amount to enter **38**

39 Enter the amount from Schedule D (Form 1040), line 19 (as refigured for the AMT, if necessary) (see instructions). If you are filing Form 2555 or 2555-EZ, see instructions for the amount to enter **39**

40 If you did not complete a Schedule D Tax Worksheet for the regular tax or the AMT, enter the amount from line 38. Otherwise, add lines 38 and 39, and enter the **smaller** of that result or the amount from line 10 of the Schedule D Tax Worksheet (as refigured for the AMT, if necessary). If you are filing Form 2555 or 2555-EZ, see instructions for the amount to enter **40**

41 Enter the **smaller** of line 37 or line 40 **41**

42 Subtract line 41 from line 37 **42**

43 If line 42 is $175,000 or less ($87,500 or less if married filing separately), multiply line 42 by 26% (.26). Otherwise, multiply line 42 by 28% (.28) and subtract $3,500 ($1,750 if married filing separately) from the result ▶ **43**

44 Enter:
 • $65,100 if married filing jointly or qualifying widow(er),
 • $32,550 if single or married filing separately, or } **44**
 • $43,650 if head of household.

45 Enter the amount from line 7 of the Qualified Dividends and Capital Gain Tax Worksheet in the instructions for Form 1040, line 44, or the amount from line 14 of the Schedule D Tax Worksheet on page D-10 of the instructions for Schedule D (Form 1040), whichever applies (as figured for the regular tax). If you did not complete either worksheet for the regular tax, enter -0- **45**

46 Subtract line 45 from line 44. If zero or less, enter -0- **46**

47 Enter the **smaller** of line 37 or line 38 **47**

48 Enter the **smaller** of line 46 or line 47 **48**

49 Subtract line 48 from line 47 **49**

50 Multiply line 49 by 15% (.15) ▶ **50**

If line 39 is zero or blank, skip lines 51 and 52 and go to line 53. Otherwise, go to line 51.

51 Subtract line 47 from line 41 **51**

52 Multiply line 51 by 25% (.25) ▶ **52**

53 Add lines 43, 50, and 52 **53**

54 If line 37 is $175,000 or less ($87,500 or less if married filing separately), multiply line 37 by 26% (.26). Otherwise, multiply line 37 by 28% (.28) and subtract $3,500 ($1,750 if married filing separately) from the result **54**

55 Enter the **smaller** of line 53 or line 54 here and on line 32. If you are filing Form 2555 or 2555-EZ, do not enter this amount on line 32. Instead, enter it on line 4 of the worksheet in the instructions **55**

Form **6251** (2008)

819591
12-02-08

13

Form **8829**	**Expenses for Business Use of Your Home**	OMB No. 1545-0074
Department of the Treasury Internal Revenue Service (99)	▶ File only with Schedule C (Form 1040). Use a separate Form 8829 for each home you used for business during the year.	**2008** Attachment Sequence No. **66**

Name(s) of proprietor(s)	Your social security number
Sonny Phunky	222-33-4444

Part I **Part of Your Home Used for Business**

1	Area used regularly and exclusively for business, regularly for daycare, or for storage of inventory or product samples	1	208
2	Total area of home	2	1,321
3	Divide line 1 by line 2. Enter the result as a percentage	3	15.7456%
	For daycare facilities not used exclusively for business, go to line 4. All others go to line 7.		
4	Multiply days used for daycare during year by hours used per day	4	hr.
5	Total hours available for use during the year (366 days x 24 hours)	5	hr.
6	Divide line 4 by line 5. Enter the result as a decimal amount	6	
7	Business percentage. For daycare facilities not used exclusively for business, multiply line 6 by line 3 (enter the result as a percentage). All others, enter the amount from line 3 ▶	7	15.7456%

Part II **Figure Your Allowable Deduction**

		(a) Direct expenses	(b) Indirect expenses		
8	Enter the amount from Schedule C, line 29, **plus** any net gain or (loss) derived from the business use of your home and shown on Schedule D or Form 4797. If more than one place of business, see instructions			8	3,656.
	See instructions for columns (a) and (b) before completing lines 9-21.				
9	Casualty losses	9			
10	Deductible mortgage interest	10	6,408.		
11	Real estate taxes	11	1,897.		
12	Add lines 9, 10, and 11	12	8,305.		
13	Multiply line 12, column (b) by line 7	13	1,308.		
14	Add line 12, column (a) and line 13			14	1,308.
15	Subtract line 14 from line 8. If zero or less, enter -0-			15	2,348.
16	Excess mortgage interest	16			
17	Insurance	17	478.		
18	Rent	18			
19	Repairs and maintenance	19	199.		
20	Utilities	20	2,977.		
21	Other expenses	21			
22	Add lines 16 through 21	22	3,654.		
23	Multiply line 22, column (b) by line 7	23	575.		
24	Carryover of operating expenses from 2007 Form 8829, line 42	24			
25	Add line 22 column (a), line 23, and line 24			25	575.
26	Allowable operating expenses. Enter the **smaller** of line 15 or line 25			26	575.
27	Limit on excess casualty losses and depreciation. Subtract line 26 from line 15			27	1,773.
28	Excess casualty losses	28			
29	Depreciation of your home from line 41 below	29	767.		
30	Carryover of excess casualty losses and depreciation from 2007 Form 8829, line 43	30			
31	Add lines 28 through 30			31	767.
32	Allowable excess casualty losses and depreciation. Enter the **smaller** of line 27 or line 31			32	767.
33	Add lines 14, 26, and 32			33	2,650.
34	Casualty loss portion, if any, from lines 14 and 32. Carry amount to **Form 4684**, Section B			34	0.
35	**Allowable expenses for business use of your home.** Subtract line 34 from line 33. Enter here and on Schedule C, line 30. If your home was used for more than one business, see instructions ▶			35	2,650.

Part III **Depreciation of Your Home**

36	Enter the **smaller** of your home's adjusted basis or its fair market value	36	225,000.
37	Value of land included on line 36	37	35,000.
38	Basis of building. Subtract line 37 from line 36	38	190,000.
39	Business basis of building. Multiply line 38 by line 7	39	29,925.
40	Depreciation percentage	40	2.5640%
41	Depreciation allowable. Multiply line 39 by line 40. Enter here and on line 29 above	41	767.

Part IV **Carryover of Unallowed Expenses to 2009**

42	Operating expenses. Subtract line 26 from line 25. If less than zero, enter -0-	42	
43	Excess casualty losses and depreciation. Subtract line 32 from line 31. If less than zero, enter -0-	43	

820301 12-24-08 LHA **For Paperwork Reduction Act Notice, see instructions.** Form **8829** (2008)

15

2008 DEPRECIATION AND AMORTIZATION REPORT
Sonny Phunky

FORM 8829- 1

Asset No.	Description	Date Acquired	Method	Life	Unadjusted Cost Or Basis	Bus % Excl	Reduction In Basis	Basis For Depreciation	Accumulated Depreciation	Current Sec 179	Current Year Deduction
23	House	060106	SL	39.0017	190,000.	.8425		190,000.			4,872.
	Less Exclusion				-160075.			-160075.			-4,105.
24	Land	060106	L		35,000.	.8425		35,000.			0.
	Less Exclusion				-29,487.			-29,487.			0.
	Total 8829 Depr. & Amortization				35,438.			35,438.			767.

* ITC, Section 179, Salvage, Bonus, Commercial Revitalization Deduction, GO Zone

(D) - Asset disposed

15.1

8281/02
04-25-08

Form **4562**	FORM 2106/SBE- 1	OMB No. 1545-0172
Department of the Treasury Internal Revenue Service (99)	**Depreciation and Amortization** (Including Information on Listed Property) ▶ See separate instructions. ▶ Attach to your tax return.	**2008** Attachment Sequence No. **67**

Name(s) shown on return	Business or activity to which this form relates	Identifying number
Sonny Phunky	Musician	222-33-4444

Part I Election To Expense Certain Property Under Section 179 **Note:** *If you have any listed property, complete Part V before you complete Part I.*

1 Maximum amount. See the instructions for a higher limit for certain businesses	1	250,000.
2 Total cost of section 179 property placed in service (see instructions)	2	
3 Threshold cost of section 179 property before reduction in limitation	3	800,000.
4 Reduction in limitation. Subtract line 3 from line 2. If zero or less, enter -0-	4	
5 Dollar limitation for tax year. Subtract line 4 from line 1. If zero or less, enter -0-. If married filing separately, see instructions	5	

6	(a) Description of property	(b) Cost (business use only)	(c) Elected cost

7 Listed property. Enter the amount from line 29	7	
8 Total elected cost of section 179 property. Add amounts in column (c), lines 6 and 7	8	
9 Tentative deduction. Enter the **smaller** of line 5 or line 8	9	
10 Carryover of disallowed deduction from line 13 of your 2007 Form 4562	10	
11 Business income limitation. Enter the smaller of business income (not less than zero) or line 5	11	
12 Section 179 expense deduction. Add lines 9 and 10, but do not enter more than line 11	12	0.
13 Carryover of disallowed deduction to 2009. Add lines 9 and 10, less line 12 ▶	13	

Note: *Do not use Part II or Part III below for listed property. Instead, use Part V.*

Part II Special Depreciation Allowance and Other Depreciation (Do not include listed property.)

14 Special depreciation for qualified property (other than listed property) placed in service during the tax year	14	
15 Property subject to section 168(f)(1) election	15	
16 Other depreciation (including ACRS)	16	

Part III MACRS Depreciation (Do not include listed property.) (See instructions.)

Section A

17 MACRS deductions for assets placed in service in tax years beginning before 2008	17	257.
18 If you are electing to group any assets placed in service during the tax year into one or more general asset accounts, check here ▶ ☐		

Section B - Assets Placed in Service During 2008 Tax Year Using the General Depreciation System

(a) Classification of property	(b) Month and year placed in service	(c) Basis for depreciation (business/investment use only - see instructions)	(d) Recovery period	(e) Convention	(f) Method	(g) Depreciation deduction
19a 3-year property						
b 5-year property		299.	5 Yrs.	HY	200DB	60.
c 7-year property		2,925.	7 Yrs.	HY	200DB	418.
d 10-year property						
e 15-year property						
f 20-year property						
g 25-year property			25 yrs.		S/L	
h Residential rental property	/		27.5 yrs.	MM	S/L	
	/		27.5 yrs.	MM	S/L	
i Nonresidential real property	/		39 yrs.	MM	S/L	
				MM	S/L	

Section C - Assets Placed in Service During 2008 Tax Year Using the Alternative Depreciation System

20a Class life					S/L	
b 12-year			12 yrs.		S/L	
c 40-year	/		40 yrs.	MM	S/L	

Part IV Summary (See instructions.)

21 Listed property. Enter amount from line 28	21	
22 **Total.** Add amounts from line 12, lines 14 through 17, lines 19 and 20 in column (g), and line 21. Enter here and on the appropriate lines of your return. Partnerships and S corporations · see instr.	22	735.
23 For assets shown above and placed in service during the current year, enter the portion of the basis attributable to section 263A costs	23	

816251 11-08-08 LHA **For Paperwork Reduction Act Notice, see separate instructions.** Form **4562** (2008)

17

Form 4562 (2008) **Sonny Phunky** 222-33-4444 Page **2**

Part V **Listed Property** (Include automobiles, certain other vehicles, cellular telephones, certain computers, and property used for entertainment, recreation, or amusement.)

Note: *For any vehicle for which you are using the standard mileage rate or deducting lease expense, complete only 24a, 24b, columns (a) through (c) of Section A, all of Section B, and Section C if applicable.*

Section A - Depreciation and Other Information (Caution: *See the instructions for limits for passenger automobiles.*)

24a Do you have evidence to support the business/investment use claimed? [] Yes [] No **24b** If "Yes," is the evidence written? [] Yes [] No

(a) Type of property (list vehicles first)	(b) Date placed in service	(c) Business/ investment use percentage	(d) Cost or other basis	(e) Basis for depreciation (business/investment use only)	(f) Recovery period	(g) Method/ Convention	(h) Depreciation deduction	(i) Elected section 179 cost
25 Special depreciation allowance for qualified listed property placed in service during the tax year and used more than 50% in a qualified business use					**25**			
26 Property used more than 50% in a qualified business use:								
	: :	%						
	: :	%						
	: :	%						
27 Property used 50% or less in a qualified business use:								
	: :	%			S/L -			
	: :	%			S/L -			
	: :	%			S/L -			

28 Add amounts in column (h), lines 25 through 27. Enter here and on line 21, page 1 **28**

29 Add amounts in column (i), line 26. Enter here and on line 7, page 1 **29**

Section B - Information on Use of Vehicles

Complete this section for vehicles used by a sole proprietor, partner, or other "more than 5% owner," or related person.
If you provided vehicles to your employees, first answer the questions in Section C to see if you meet an exception to completing this section for those vehicles.

	(a) Vehicle	(b) Vehicle	(c) Vehicle	(d) Vehicle	(e) Vehicle	(f) Vehicle
30 Total business/investment miles driven during the year (**do not** include commuting miles)						
31 Total commuting miles driven during the year ...						
32 Total other personal (noncommuting) miles driven						
33 Total miles driven during the year. Add lines 30 through 32						
34 Was the vehicle available for personal use during off-duty hours?	Yes No	Yes No	Yes No	Yes No	Yes No	Yes No
35 Was the vehicle used primarily by a more than 5% owner or related person?						
36 Is another vehicle available for personal use?						

Section C - Questions for Employers Who Provide Vehicles for Use by Their Employees

Answer these questions to determine if you meet an exception to completing Section B for vehicles used by employees who **are not** more than 5% owners or related persons.

	Yes	No
37 Do you maintain a written policy statement that prohibits all personal use of vehicles, including commuting, by your employees?		
38 Do you maintain a written policy statement that prohibits personal use of vehicles, except commuting, by your employees? See the instructions for vehicles used by corporate officers, directors, or 1% or more owners		
39 Do you treat all use of vehicles by employees as personal use?		
40 Do you provide more than five vehicles to your employees, obtain information from your employees about the use of the vehicles, and retain the information received?		
41 Do you meet the requirements concerning qualified automobile demonstration use?		

Note: *If your answer to 37, 38, 39, 40, or 41 is "Yes," do not complete Section B for the covered vehicles.*

Part VI **Amortization**

(a) Description of costs	(b) Date amortization begins	(c) Amortizable amount	(d) Code section	(e) Amortization period or percentage	(f) Amortization for this year
42 Amortization of costs that begins during your 2008 tax year:					
	: :				
	: :				
43 Amortization of costs that began before your 2008 tax year			**43**		
44 **Total.** Add amounts in column (f). See the instructions for where to report			**44**		

816252 11-08-08 Form **4562** (2008)

Form **4562**	SCHEDULE C-1 **Depreciation and Amortization** (Including Information on Listed Property) ▶ See separate instructions. ▶ Attach to your tax return.	OMB No. 1545-0172 **2008** Attachment Sequence No. **67**
Department of the Treasury Internal Revenue Service (99)		

Name(s) shown on return	Business or activity to which this form relates	Identifying number
Sonny Phunky	Sonny Phunky	222-33-4444

Part I Election To Expense Certain Property Under Section 179 **Note:** *If you have any listed property, complete Part V before you complete Part I.*

1	Maximum amount. See the instructions for a higher limit for certain businesses	1 250,000.
2	Total cost of section 179 property placed in service (see instructions)	2
3	Threshold cost of section 179 property before reduction in limitation	3 800,000.
4	Reduction in limitation. Subtract line 3 from line 2. If zero or less, enter -0-	4
5	Dollar limitation for tax year. Subtract line 4 from line 1. If zero or less, enter -0-. If married filing separately, see instructions	5

6	(a) Description of property	(b) Cost (business use only)	(c) Elected cost

7	Listed property. Enter the amount from line 29 ...	7
8	Total elected cost of section 179 property. Add amounts in column (c), lines 6 and 7	8
9	Tentative deduction. Enter the **smaller** of line 5 or line 8	9
10	Carryover of disallowed deduction from line 13 of your 2007 Form 4562	10
11	Business income limitation. Enter the smaller of business income (not less than zero) or line 5	11
12	Section 179 expense deduction. Add lines 9 and 10, but do not enter more than line 11	12 799.
13	Carryover of disallowed deduction to 2009. Add lines 9 and 10, less line 12 ▶	13

Note: *Do not use Part II or Part III below for listed property. Instead, use Part V.*

Part II Special Depreciation Allowance and Other Depreciation (Do not include listed property.)

14	Special depreciation for qualified property (other than listed property) placed in service during the tax year	14
15	Property subject to section 168(f)(1) election	15
16	Other depreciation (including ACRS)	16

Part III MACRS Depreciation (Do not include listed property.) (See instructions.)

Section A

17	MACRS deductions for assets placed in service in tax years beginning before 2008	17
18	If you are electing to group any assets placed in service during the tax year into one or more general asset accounts, check here ▶	

Section B - Assets Placed in Service During 2008 Tax Year Using the General Depreciation System

(a) Classification of property	(b) Month and year placed in service	(c) Basis for depreciation (business/investment use only - see instructions)	(d) Recovery period	(e) Convention	(f) Method	(g) Depreciation deduction
19a 3-year property						
b 5-year property						
c 7-year property		10,000.	7 Yrs.	HY	200DB	1,429.
d 10-year property						
e 15-year property						
f 20-year property						
g 25-year property			25 yrs.		S/L	
h Residential rental property	/		27.5 yrs.	MM	S/L	
	/		27.5 yrs.	MM	S/L	
i Nonresidential real property	/		39 yrs.	MM	S/L	
	/			MM	S/L	

Section C - Assets Placed in Service During 2008 Tax Year Using the Alternative Depreciation System

20a Class life					S/L	
b 12-year			12 yrs.		S/L	
c 40-year	/		40 yrs.	MM	S/L	

Part IV Summary (See instructions.)

21	Listed property. Enter amount from line 28	21
22	**Total.** Add amounts from line 12, lines 14 through 17, lines 19 and 20 in column (g), and line 21. Enter here and on the appropriate lines of your return. Partnerships and S corporations - see instr.	22 2,228.
23	For assets shown above and placed in service during the current year, enter the portion of the basis attributable to section 263A costs	23

816251 11-08-08 LHA **For Paperwork Reduction Act Notice, see separate instructions.** Form **4562** (2008)

Form 4562 (2008) **Sonny Phunky** 222-33-4444 Page **2**

Part V	Listed Property (Include automobiles, certain other vehicles, cellular telephones, certain computers, and property used for entertainment, recreation, or amusement.)

Note: *For any vehicle for which you are using the standard mileage rate or deducting lease expense, complete* only *24a, 24b, columns (a) through (c) of Section A, all of Section B, and Section C if applicable.*

Section A - Depreciation and Other Information (Caution: *See the instructions for limits for passenger automobiles.*)

24a Do you have evidence to support the business/investment use claimed? ☐ **Yes** ☐ **No** **24b** If "Yes," is the evidence written? ☐ **Yes** ☐ **No**

(a) Type of property (list vehicles first)	(b) Date placed in service	(c) Business/ investment use percentage	(d) Cost or other basis	(e) Basis for depreciation (business/investment use only)	(f) Recovery period	(g) Method/ Convention	(h) Depreciation deduction	(i) Elected section 179 cost
25 Special depreciation allowance for qualified listed property placed in service during the tax year and used more than 50% in a qualified business use **25**								
26 Property used more than 50% in a qualified business use:								
		%						
		%						
		%						
27 Property used 50% or less in a qualified business use:								
	010107	24.59 %				S/L -		
		%				S/L -		
		%				S/L -		
28 Add amounts in column (h), lines 25 through 27. Enter here and on line 21, page 1 **28**								
29 Add amounts in column (i), line 26. Enter here and on line 7, page 1							**29**	

Section B - Information on Use of Vehicles

Complete this section for vehicles used by a sole proprietor, partner, or other "more than 5% owner," or related person.
If you provided vehicles to your employees, first answer the questions in Section C to see if you meet an exception to completing this section for those vehicles.

	(a) Vehicle	(b) Vehicle	(c) Vehicle	(d) Vehicle 3	(e) Vehicle	(f) Vehicle
30 Total business/investment miles driven during the year (**do not** include commuting miles)				3,920		
31 Total commuting miles driven during the year ...						
32 Total other personal (noncommuting) miles driven...........................				12,021		
33 Total miles driven during the year. Add lines 30 through 32				15,941		
34 Was the vehicle available for personal use during off-duty hours?	Yes No	Yes No	Yes No	Yes No	Yes No	Yes No
35 Was the vehicle used primarily by a more than 5% owner or related person?						
36 Is another vehicle available for personal use? ..						

Section C - Questions for Employers Who Provide Vehicles for Use by Their Employees

Answer these questions to determine if you meet an exception to completing Section B for vehicles used by employees who **are not** more than 5% owners or related persons.

	Yes	No
37 Do you maintain a written policy statement that prohibits all personal use of vehicles, including commuting, by your employees?		
38 Do you maintain a written policy statement that prohibits personal use of vehicles, except commuting, by your employees? See the instructions for vehicles used by corporate officers, directors, or 1% or more owners		
39 Do you treat all use of vehicles by employees as personal use?		
40 Do you provide more than five vehicles to your employees, obtain information from your employees about the use of the vehicles, and retain the information received?		
41 Do you meet the requirements concerning qualified automobile demonstration use?		

Note: *If your answer to 37, 38, 39, 40, or 41 is "Yes," do not complete Section B for the covered vehicles.*

Part VI	**Amortization**

(a) Description of costs	(b) Date amortization begins	(c) Amortizable amount	(d) Code section	(e) Amortization period or percentage	(f) Amortization for this year
42 Amortization of costs that begins during your 2008 tax year:					
CD Production costs	070108	1,850.		24M	463.
Website	080908	2,841.		36M	395.
43 Amortization of costs that began before your 2008 tax year ...				**43**	
44 Total. Add amounts in column (f). See the instructions for where to report				**44**	858.

816252 11-08-08 Form **4562** (2008)

Form **2106**	**Employee Business Expenses**		OMB No. 1545-0074

Form **2106**				
Department of the Treasury Internal Revenue Service (99)	▶ See separate instructions. ▶ Attach to Form 1040 or Form 1040NR.		**2008** Attachment Sequence No. **129**	

Your name	Occupation in which you incurred expenses	Social security number
Sonny Phunky	Musician	222 33 4444

Part I	**Employee Business Expenses and Reimbursements**

		Column A Other Than Meals and Entertainment	**Column B** Meals and Entertainment
Step 1	**Enter Your Expenses**		
1	Vehicle expense from line 22c or line 29. (Rural mail carriers: See instructions.) ... **1**	1,146.	
2	Parking fees, tolls, and transportation, including train, bus, etc., that **did not** involve overnight travel or commuting to and from work **2**		
3	Travel expense while away from home overnight, including lodging, airplane, car rental, etc. **Do not** include meals and entertainment **3**	8,379.	
4	Business expenses not included on lines 1 through 3. **Do not** include meals and entertainment See Statement 8 **4**	2,052.	
5	Meals and entertainment expenses (see instructions) **5**		2,604.
6	**Total expenses.** In Column A, add lines 1 through 4 and enter the result. In Column B, enter the amount from line 5 **6**	11,577.	2,604.

Note: *If you were not reimbursed for any expenses in Step 1, skip line 7 and enter the amount from line 6 on line 8.*

Step 2	**Enter Reimbursements Received From Your Employer for Expenses Listed in Step 1**		
7	Enter reimbursements received from your employer that were **not** reported to you in box 1 of Form W-2. Include any reimbursements reported under code "L" in box 12 of your Form W-2 (see instructions) **7**	5,985.	1,344.

Step 3	**Figure Expenses To Deduct on Schedule A (Form 1040 or Form 1040NR)**		
8	Subtract line 7 from line 6. If zero or less, enter -0-. However, if line 7 is greater than line 6 in Column A, report the excess as income on Form 1040, line 7 (or on Form 1040NR, line 8) **8**	5,592.	1,260.
	Note: *If both columns of line 8 are zero, you cannot deduct employee business expenses. Stop here and attach Form 2106 to your return.*		
9	In Column A, enter the amount from line 8. In Column B, multiply line 8 by 50% (.50). (Employees subject to Department of Transportation (DOT) hours of service limits: Multiply meal expenses incurred while away from home on business by 80% (.80) instead of 50%. For details, see instructions.) **9**	5,592.	630.
10	Add the amounts on line 9 of both columns and enter the total here. **Also, enter the total on Schedule A (Form 1040), line 21** (or on **Schedule A (Form 1040NR), line 9**). (Reservists, qualified performing artists, fee-basis state or local government officials, and individuals with disabilities: See the instructions for special rules on where to enter the total.)▶ **10**		6,222.

LHA **For Paperwork Reduction Act Notice, see instructions.** Form **2106** (2008)

812001
11-08-08

Form 2106 (2008) Sonny Phunky 222-33-4444 Page **2**

Part II	Vehicle Expenses				

Section A - General Information (You must complete this section if you are claiming vehicle expenses.)

			(a) Vehicle 1	**(b)** Vehicle
11	Enter the date the vehicle was placed in service	11	01/01/07	
12	Total miles the vehicle was driven during 2008	12	15,941 miles	miles
13	Business miles included on line 12	13	2,104 miles	miles
14	Percent of business use. Divide line 13 by line 12	14	13.20 %	%
15	Average daily roundtrip commuting distance	15	miles	miles
16	Commuting miles included on line 12	16	miles	miles
17	Other miles. Add lines 13 and 16 and subtract the total from line 12	17	13,837 miles	miles

18	Was your vehicle available for personal use during off-duty hours?	☐ Yes	☐ No
19	Do you (or your spouse) have another vehicle available for personal use?	☐ Yes	☐ No
20	Do you have evidence to support your deduction?	☒ Yes	☐ No
21	If "Yes," is the evidence written?	☒ Yes	☐ No

Section B - Standard Mileage Rate (See the instructions for Part II to find out whether to complete this section or Section C.)

22a	Multiply business miles driven **before** July 1, 2008, by 50.5¢ (.505)	22a	531.
b	Multiply business miles driven **after** June 30, 2008, by 58.5¢ (.585)	22b	615.
c	Add lines 22a and 22b. Enter the result here and on line 1	22c	1,146.

Section C - Actual Expenses

			(a) Vehicle	**(b)** Vehicle
23	Gasoline, oil, repairs, vehicle insurance, etc.	23		
24a	Vehicle rentals	24a		
b	Inclusion amount (see instructions)	24b		
c	Subtract line 24b from line 24a	24c		
25	Value of employer-provided vehicle (applies only if 100% of annual lease value was included on Form W-2–see instructions)	25		
26	Add lines 23, 24c, and 25	26		
27	Multiply line 26 by the percentage on ln 14	27		
28	Depreciation (see instructions)	28		
29	Add lines 27 and 28. Enter total here and on line 1	29		

Section D - Depreciation of Vehicles (Use this section only if you owned the vehicle and are completing Section C for the vehicle.)

			(a) Vehicle	**(b)** Vehicle
30	Enter cost or other basis (see instructions)	30		
31	Enter section 179 deduction and special allowance (see instructions)	31		
32	Multiply line 30 by line 14 (see instructions if you claimed the section 179 deduction or special allowance)	32		
33	Enter depreciation method and percentage (see instructions)	33		
34	Multiply line 32 by the percentage on line 33 (see instructions)	34		
35	Add lines 31 and 34	35		
36	Enter the applicable limit explained in the line 36 instructions	36		
37	Multiply line 36 by the percentage on ln 14	37		
38	Enter the **smaller** of line 35 or line 37. If you skipped lines 36 and 37, enter the amount from line 35. Also enter this amount on line 28 above	38		

Form **2106** (2008)

Statement SBE
Supplemental Business Expenses

2008

Your name	Social security number	Business in which expenses were incurred
Sonny Phunky	222 33 4444	Musician

Part I　　Business Expenses and Reimbursements

STEP 1　　Enter Your Expenses		Column A Other Than Meals and Entertainment	Column B Meals and Entertainment
1　Vehicle expense from line 22c or line 29	1	546.	
2　Parking fees, tolls, and transportation, including train, bus, etc., that **did not** involve overnight travel	2	153.	
3　Travel expense while away from home overnight, including lodging, airplane, car rental, etc. **Do not** include meals and entertainment	3	412.	
4　Business expenses not included on lines 1 through 3. **Do not** include meals and entertainment　　　**See Statement 9**	4	333.	
5　Meals and entertainment expenses	5		1,584.
6　**Total expenses.** In Column A, add lines 1 through 4 and enter the result. In Column B, enter the amount from line 5	6	1,444.	1,584.

NOTE:　If you were not reimbursed for any expenses in Step 1, skip line 7 and enter the amount from line 6 on line 8.

STEP 2　Reimbursements for Expenses Listed In STEP 1

7　Enter amounts that were **not** reported to you in box 1 of Form W-2. Include any amount reported under code "L" in box 12 of your Form W-2	7		360.

STEP 3　Figure Expenses Subject to the Limitation

8　Subtract line 7 from line 6	8	1,444.	1,224.
9　In Column A, enter the amount from line 8. In Column B, multiply the amount on line 8 by 50% (.50). (If zero or less, enter -0-) (If subject to the Department of Transportation (DOT) hours-of-service limits, Multiply by 80% (.80) instead of 50%)	9	1,444.	612.
10　Add the amounts on line 9 of both columns and enter the total here. These are your supplemental business expenses ▶	10		2,056.

812021
07-23-08

23

Statement SBE (2008) **Sonny Phunky** 222-33-4444 Page **2**

Part II | Vehicle Expenses

Section A. - General Information

			(a) Vehicle 2	(b) Vehicle
11	Enter the date vehicle was placed in service	11	07/01/07	
12	Total miles vehicle was driven during 2008	12	15,941 miles	miles
13	Business miles included on line 12	13	1,000 miles	miles
14	Percent of business use. Divide line 13 by line 12	14	6.27 %	%
15	Average daily roundtrip commuting distance	15	miles	miles
16	Commuting miles included on line 12	16	miles	miles
17	Other miles. Add lines 13 and 16 and subtract the total from line 12	17	14,941 miles	miles
18	Was your vehicle available for personal use during off-duty hours?		☐ Yes ☐ No	
19	Do you (or your spouse) have another vehicle available for personal use?		☐ Yes ☐ No	
20	Do you have evidence to support your deduction?		☒ Yes ☐ No	
21	If "Yes," is the evidence written?		☒ Yes ☐ No	

Section B. - Standard Mileage Rate (See the instructions for Part II to find out whether to complete this section or Section C.)

22a	Multiply business miles driven **before** July 1, 2008, by 50.5¢ (.505)	22a	253.	
b	Multiply business miles drive **after** June 30, 2008, by 58.5¢ (.585)	22b	293.	
c	Add lines 22a and 22b. Enter the result here and on line 1		22c	546.

Section C. - Actual Expenses

			(a) Vehicle	(b) Vehicle
23	Gasoline, oil, repairs, vehicle insurance, etc.	23		
24a	Vehicle rentals	24a		
b	Inclusion amount	24b		
c	Subtract line 24b from line 24a	24c		
25	Value of employer-provided vehicle (applies only if 100% of annual lease value was included on Form W-2)	25		
26	Add lines 23, 24c, and 25	26		
27	Multiply line 26 by the percentage on line 14	27		
28	Depreciation. Enter amount from line 38 below	28		
29	Add lines 27 and 28. Enter total here and on line 1	29		

Section D. - Depreciation of Vehicles (Use this section only if you owned the vehicle and are completing Section C for the vehicle.)

			(a) Vehicle	(b) Vehicle
30	Enter cost or other basis	30		
31	Enter section 179 deduction and special allowance	31		
32	Multiply line 30 by line 14 (see Form 2106 instructions if you claimed the section 179 deduction or special allowance)	32		
33	Enter depreciation method and percentage	33		
34	Multiply line 32 by the percentage on line 33	34		
35	Add lines 31 and 34	35		
36	Enter the limitation amount	36		
37	Multiply line 36 by the percentage on line 14	37		
38	Enter the **smaller** of line 35 or line 37. If you skipped lines 36 and 37, enter the amount from line 35. Also enter this amount on line 28 above	38		

812022
07-23-08

Allocation of Form 2106/Statement SBE Business Expenses

Musician
Sonny Phunky

222-33-4444

| Description | Schedule A/ Form 2106 | Other Business Entities/Statement SBE | | | | | Total to Business Entity |
		Vehicle Expenses	Parking Fees, tolls and transportation	Travel Expenses	Business Expenses	Meals & Entertainment Expenses	
The Lido Shuffle							
Other Business Expenses			153.	412.	333.	612.	1,510.
Car and truck expenses		546.					546.
Total vehicle exp.		546.					546.
Grand Total							2,056.

24.1

803521
04-25-08

2008 DEPRECIATION AND AMORTIZATION REPORT
Musician

FORM 2106/SBE- 1

Asset No.	Description	Date Acquired	Method	Life	Line No.	Unadjusted Cost Of Basis	Bus % Excl	Reduction In Basis	Basis For Depreciation	Accumulated Depreciation	Current Sec 179	Current Year Deduction
1	Fender Bass (chartreuse)	070108	200DB	7.00	19C	2,925.			2,925.			418.
2	iPod	070108	200DB	5.00	19B	299.			299.			60.
4	Ampeg Bass Amp	070105	200DB	5.00	17	1,650.			1,650.	1,007.		257.
	Total 2106/SBE Depr. & Amortization					4,874.			4,874.	1,007.		735.
	Current Year Activity											
	Beginning balance					1,650.		0.	1,650.	1,007.		
	Acquisitions					3,224.		0.	3,224.	0.		
	Dispositions					0.		0.	0.	0.		
	Ending balance					4,874.		0.	4,874.	1,007.		

(D) - Asset disposed

* ITC, Section 179, Salvage, Bonus, Commercial Revitalization Deduction, GO Zone

24.2

828102
04-25-08

Sonny Phunky 222-33-44

Schedule A	Mortgage Interest and Points Reported on Form 1098	Statement

Description	Amount
From Form 8829 - Deductible home mortgage interest	5,39
Total to Schedule A, line 10	5,39

Schedule C	Other Income	Statement

Description	Amount
Endorsment Income (promotional bass guitar)	2,00
Sales of CDs	1,95
Royalties	24
Total to Schedule C, line 6	4,19

Schedule C	Other Expenses	Statement

Description	Amount
Cell Phone	27
Internet Service	40
Music Downloads (iTunes)	30
Performance Audit (show tickets)	40
Research	30
Trade Publications - Billboard	29
Online A&R (Taxi)	30
CD Baby & Online Fees	7
Instructional DVDs	8
Sheet Music	16
Promo Photos	28
Printing (business cards)	4
Amortization	85
Total to Schedule C, line 48	3,82

Sonny Phunky 222-33-4444

Schedule C	Other Costs of Goods Sold	Statement 4

Description	Amount
Sidemen (1099's issued)	3,640.
1099 reported income NOT recieved until 2008	925.
Total to Schedule C, line 39	4,565.

Schedule SE	Non-Farm Income	Statement 5

Description	Amount
Musician/Teacher	1,006.
The Lido Shuffle	7,364.
Total to Schedule SE, line 2	8,370.

Form 6251	Depreciation on Assets Placed in Service After 1986	Statement 6

Description	Amount
Fender⊘Precision⊘electric bass guitar	472.
Total to Form 6251, line 18	472.

Form 4562	Part I - Business Income	Statement 7

Income Type	Amount
Wages	31,071.
Schedule C	1,006.
Partnerships	7,364.
Section 179 expense	799.
Total business income used in Form 4562, line 11	40,240.

Sonny Phunky 222-33-4444

Form 2106/SBE	Other Business Expenses	Statement 8

Musician

Description	Amount
Research CDs	621.
Music Downloads (iTunes)	197.
Repairs	399.
Professional Fees	100.
Depreciation	735.
Total to Form 2106/SBE, Part I, line 4	2,052.

Form 2106/SBE	Other Business Expenses	Statement 9

Musician

Description	Amount
Supplies	294.
Cell Phone	39.
Total to Form 2106/SBE, Part I, line 4	333.

5.

For Visual Artists

In this chapter I will look in detail at the activities of our good friend Liz Brushstroke and the kind of income and deductions she had for the year.

First let's walk through some of the expense items for visual artists specifically. I will note in parentheses the type of record keeping the IRS would require:

1. Union dues, professional societies & organizations (invoices & checks)

2. Professional fees for agents, attorneys & accountants (invoices & checks)

3. Artist registries (both printed and on the Internet) (bills, invoice, credit card receipt or check)

4. Master classes, education and seminars (bills, invoice, credit card receipt or check)

5. Personal photographs and resumes – including videos, CDs, CD-ROMs, DVDs and digital image transfers for use on the Internet or your personal Website (bills, invoices, credit card receipt or checks)

6. Slides of artwork – including all photographers fees, developing, slide copies and digital image transfers to CDs (invoices & checks)

7. Costs of printmaking – having giclee or other types of printing done (bills, invoices, checks or credit card receipt)

8. Stationery and postage (sales receipts, credit card receipt & checks)

9. Printing of brochures (invoices & checks)

10. Art books – these may need to be allocated between employment income and contract income (sales receipts, credit card receipt & checks).

11. Telephone and cellular phone – actual business calls on your home phone are deductible, but the IRS does not allow the allocation of the base monthly rate. You can deduct only the actual long distance charges. The same rule is true with your cellular phone service. If you get a second phone line strictly for business, then it can be considered 100% deductible (bills & checks).

12. Internet service – for research purposes, business e-mail and e-mail while traveling. Be sure to allocate some of the costs for personal use (bills, invoices & credit card receipt).

13. Visiting galleries and museums to view artwork – I often call this expense line item "research;" others refer to it as "auditing." Whatever you call it, make sure to allocate some of this expense to personal use. After all you must sometimes take part in these activities for personal enjoyment, it can't be all business. I quote to clients the old Wall Street saying, "the pigs get fat and the hogs get slaughtered." This is the type of deduction that you must not get piggy with. While the IRS typically hates this deduction, you can easily argue that the visual artist must engage in these viewings for educational reasons and to keep abreast of trends and dynamics within their profession. In an audit you would need to explain what the specific professional value was (museum admission stubs, business cards from the gallery & diary entries).

14. Gallery rents or memberships - (invoices & checks)

15. Studio rent – you must be able to prove you need an outside studio, and note: you cannot maintain a tax deductible home studio if you rent outside space (bills, invoices & checks).

16. Repair of equipment - Computers, presses, sculpting tools & equipment, photography equipment, etc. (bills, invoices & checks)

17. Tax preparation, bookkeeping & accounting fees (bills, invoices & checks)

18. Entry fees into juried show (copy of entry and checks)

19. Advertisement and listing in arts publications (bills, invoices, credit card receipt or checks)

20. Professional magazines (bills, invoices, credit card receipt or checks)

21. Insurance – This can include riders on your home policy that relate directly to your home studio (bills, invoices & checks).

22. Copyright fees (invoices & checks)

23. Equipment purchases – Tools, presses, camera equipment, welders, computers, printers, etc. (bills, invoices, credit card receipt or checks)

24. Framing & displaying Costs – You can only deduct for the costs of artwork you actually sold; other costs related to unsold work become inventory at year-end (bills, invoices, credit card receipt or checks).

25. Supplies – Like the framing costs listed above, keep in mind that you can only deduct for the costs of artwork you actually sold; other costs related to unsold work become inventory at year-end (bills, invoices, credit card receipt or checks).

26. Studio supplies and fixtures (bills, invoices, credit card receipt or checks)

Now, let's see what kind of year our artist Liz had.

Luckily for her tax preparer Liz downloaded our Excel® spreadsheet found on www.artstaxinfo.com for visual artists and loaded it on her notebook computer at the beginning of the tax year and carefully tracked her expenses all year!

We will now review Liz's 1040 income tax return in detail—and remember you can download the current year version from our website – www.artstaxinfo.com.

Liz's primary income is from her teaching position at the Independent Art Institute. This income is reported on her W-2 and is found in box 7 of her 1040.

During the winter she had a one-artist show of her work at the Dublin gallery. She had to arrange for shipping her artwork to Ireland. She planned to go over to Ireland for the show opening, as the artist's presence generally increases sales, and the gallery owner had arranged for her to give a talk on her artwork while she was there. Liz wanted to make sure the trip would be 100% deductible, so she discussed the trip with her accountant in advance.

Her trip was going to last eight days; as it was outside the continental US, she learned that any personal and/or vacation time would have to be limited to no more than 25%. Liz realized she would need to arrange some other business activity beyond the gallery exhibit and talk. Using the Internet she checked with some of the schools in Dublin to see if they were offering a class or seminar that she could attend. She signed up for a seminar being given by a famous Irish art historian on the history of Irish art. She also arranged a studio visit with an Irish landscape painter she admired, and she pre-arranged appointments with some gallery owners that owned galleries in Europe, to see what opportunities might be available beyond Ireland. These other business activities helped Liz make the entire trip deductible and still have some time for tourist activity. She could deduct her flight, the shipping of the artwork to Ireland and back, the 50% allowed for meals, all her hotel costs during the business portion of the trip, her auto rental there, laundry, phone calls home, etc. She will also deduct the costs of the artwork sold, including framing costs as a "cost of goods sold" on her Schedule C. She did not want to be bothered to keep receipts of meals so she decided to use the Internal Revenue Service approved foreign per diem rates (OCONUS) published by the Department of Defense (find link at www.artstaxinfo.com). The rate for Dublin in 2008 is $142 for meals and $35 for incidentals. Liz was sad to sell one of her personal favorite paintings; "Sunlight on the Brook," of course the income from the art she sold will be self-employment income on her Schedule C.

Here we must pause to discuss the issue of inventory. Inventory is often problematic for many artists; I often get blank stares when I ask the question at tax time. The inquiry concerns the artist's cost at year end of the artwork that has not yet been sold: this is the artist's inventory.

Not to get too technical, but the calculation of inventory is primary in arriving at "cost of goods sold." In other words, my direct materials deduction for tax purposes is (1) the direct *cost* of all material used in the production of finished art work; materials, framing, printing, etc. *less* (2) the finished artwork held at the end of the year (ending inventory).

Some artists (being cash-based taxpayers) can ignore this process altogether because the direct product costs are relatively minor (a potter comes to mind), but for most fine artists, photographers, etc. the cost of framing alone can be sizable enough to require addressing ending inventory.

On the tax return the calculation looks something like this (Schedule C, Part III):

Beginning Inventory (beginning of year – from all prior years)	$5,000
Materials purchased during the current year	$3,000
Printing done during the current year	$2,000
Framing done during the current year	$6,000
Total inventory available for sale in the current year	$16,000
Ending Inventory (end of year)	-$5,500
Cost of Goods Sold	$10,500

In this example Liz started the year with $5K of value (stretchers, printing, materials costs, framing, prints, etc) in "unsold" art work from prior years. During the year she purchased $3K of materials, had $2K of printing costs and spent $6K in framing so that during the year she spent $11K producing new finished art work. The $11K added to the $5K beginning number to yield $16K of direct costs in finished art for the year. Finally at year end she had $5,500 (in cost) of unsold art work, this was her ending inventory. According to this example Liz had deductable, direct cost of art work sold during the year of $10,500. You will see on Liz's Schedule C line 4 and Part III how this worked out on her 1040 income tax return.

In the spring Liz attended an annual conference of a national women's art organization in Phoenix, Arizona. As an officer in the local chapter of this organization, Liz was expected to be there. The trip gave her a chance to network with fellow artists, an opportunity to see new products that art supply dealers displayed, and show her portfolio to some gallery owners. The organization held educational events for the participants every day and an afternoon of gallery tours. Liz was at the conference for the entire three days she was away from home. She made sure that she brought home the convention schedule and related literature and noted which events she attended and when. Liz clearly showed a business purpose and she will be able to deduct the entire trip.

A friend of Liz's recommended that she spend some time in New York City to "see what was happening" in the art scene there. Liz flew to the city and spent a week visiting galleries and museums, staying with artist friends she had in New York. She even did some studio visits with other artists. While she may be able to claim some business entertainment expense for lunch with a gallery owner and she perhaps is able to deduct the costs of attending the museums, unfortunately for Liz there will probably be little to deduct on

this trip. She had no income from it, and as far as the IRS is concerned it had no well-defined, specific business purpose, thus few deductions!

Liz was invited to be the juror for a local art show. A small art non-profit decided to have its own juried art show in order to attract more artists from around the region. Liz received a small stipend from the organization. Other than some car mileage, she probably didn't have other expenses connected with this activity.

After her opening in Dublin, Liz decided that she wanted to set up a personal website where she could post her resume, art images, artist statement, etc. If she were going to expand into Europe it would be very helpful to have a website for gallery owners to be able to visit and see her latest work. The costs of setting up the website, registering the domain name and hosting the site will all be deductible. She will be able to deduct the costs of having photos taken and transferred to digital images or possibly scanned for use on the site. The IRS stipulates that website development is written off (amortized) over three years. So all the costs of designing and setting up the site will be added up (capitalized) and expensed over 3 years.

The look of her new website pleased Liz so much that she decided to have business cards, stationery and a brochure designed and printed to capitalize on and promote it. To let folks know the website was up and running she did a postcard mailing. All the costs of printing and postage were fully deductible on Liz's Schedule C. Any brochures remaining unsent (if material) at year-end may have to be added to her year-end inventory.

Near the end of the year Liz was in a group show at the New York City gallery. As flying was not as time effective as it once had been, she decided to drive to NYC where she attended the opening. She spent the following day at the gallery and in the evening had dinner with the gallery owner to discuss possibilities of future shows. The next day she drove back home. Her entire trip will be deductible, including mileage, tolls, parking, hotel and meals (50%), etc. Sales of artwork in NYC are subject to sales tax, but since the gallery is the entity actually selling Liz's work, they would have the responsibility for handling this tax.

During the year, Liz entered her work into several juried art shows throughout the country. The entry fees, photographer, costs of developing and sending slides and shipping artwork would all be deductible business expenses on her schedule C. To provide evidence of her ongoing effort to market and sell artwork, Liz saves photocopies of all her entries. These could be very important if Liz is hit with a "hobby loss" audit we discussed in Chapter 2.

Liz set up a large room in her home as a studio that she exclusively uses to make art. She takes a home office deduction for the studio on Form 8829. This form allows her to take a portion of all her general home expenses as a deduction against her art income. If she makes alterations to the room specifically for the art production she can take those expenses 100%. This year Liz installed an air venting system to help extract the paint fumes from the studio when she is working. She also upgraded her electrical system. Liz's accountant will depreciate both of these items.

When she met with her accountant at year-end to do some tax planning and check on her estimated tax payments for the year she had more income than she had anticipated. Her accountant asked if there were some expenses that she could accelerate into the current year; a way she would get the tax benefit of the deductions in the current year. Liz needed more places to store artwork and wanted some new flat files. She also needed a new digital camera to take pictures of subjects she wanted to paint in her studio as well as to take pictures of her artwork. She decided to purchase the new files and the camera before December 31. By purchasing these before year-end she was able to use the Section 179 election and write them off 100% in the current year. She can do this, even if she charges the files and/or camera on her credit card and pays it off in the next year, as long as the files are "in use" before December 31.

Painters, Photographers, & Other Visual Artists

Continuing Education

Private Lessons	
Master Classes & Apprenticeships	
Schools & Conferences	
Tickets to Special Exhibits	
Gallery Visits & Talks	
Museum Memberships	
Other: _____	

Promotional Expenses

Portfolio Costs	
Business Cards & Resume	
Website Development & Hosting	

Postage & Shipping	
Slide and Photographer Fees	
Printing of Show Announcement Cards	
Shows & Exhibits	
Printing Costs	
Other: _____	

Supplies & Other Expenses

Gallery Membership & Dues	
Brushes & Cleaning Supplies	
Paint, Film, Papers, etc.	
Dues - Union & Professional	
Gifts - Business ($25 maximum per person per year)	
Chemicals for Film Processing	
Museum Dues and Memberships	
Canvas and Stretchers	
Framing Costs	
Meals - Business (enter 100% of cost)	
Slide & Film Processing	
Stationary & Office Supplies	
Rent - Studio & Gallery Space	
Art Magazines and Books	
Legal & Accounting Fees	
Rents & Repairs of Equipment	
Sculpture Supplies & Hardware	
Food & Wine - Gallery Openings	
Modeling Fees & Props	
Commissions - Agent/Manager	
Other: _____	

Auto Travel (in miles)

Museum & Gallery Visits	
Client & Business Meetings	
Continuing Education	
Gallery Interviews (Potential Shows)	
Out-Of-Town Business Trips	

Purchasing Art Supplies & Materials
Professional Society Meetings
Parking Fees & Tolls
Other: _____

Travel - Out of Town

Airfare & Auto Rental
Van Rental for Moving of Artwork
Parking
Taxi, Train, Bus & Subway
Lodging (do not combine with meals)
Meals (enter 100% of expense)
Laundry, Maid & Porter
Tolls
Telephone Calls (including home)
Other: _____

Telephone Costs

Paging Service
Internet & Online Services
Pay Phone & Toll Calls
Cellular Phone
Other: _____

Equipment Purchases

Phone & Answering Machine
Computer, Peripherals, & Software
Press, easel, and Paint Box
Darkroom Equipment
Camera (Digital & Traditional) & Lenses
Safety Equipment & Fixtures
Kiln & Foundry
Framing Apparatus
Power & Hand Tools
Sculpting Tools & Equipment
Other: _____

Schdule C - Meals Detail - Line 24B

Ireland 8 days x $142	1,136.00	1,136.00
Ireland 8 days x $35	280.00	280.00
Phoenix 3 days x $59	177.00	177.00
Lunch NYC	42.00	42.00
NYC 2 days x $64	128.00	128.00
Other professional meals	401.00	401.00
	2,164.00	2,164.00

Schedule C Travel Detail - Line 24A

Ireland - Airline	1,108.00	1,108.00
Ireland - Hotel 8 days x 304	2,432.00	2,432.00
Ireland - Transportation	844.00	844.00
Phoenix - Airline	348.00	348.00
Phoenix - Hotel 3 days	423.00	423.00
	5,155.00	5,155.00

000901
04-25-08

| Form **1040** | U.S. Individual Income Tax Return | **2008** | (99) | IRS Use Only - Do not write or staple in this space. | |

For the year Jan. 1-Dec. 31, 2008, or other tax year beginning _____ , 2008, ending _____ , 20 ____ | OMB No. 1545-0074

Label (See instructions on page 14.)

Use the IRS label. Otherwise, please print or type.

Your first name and initial: **Liz**
Last name: **Brushstroke**
Your social security number: **333 44 5555**

If a joint return, spouse's first name and initial | Last name | Spouse's social security number

Home address (number and street). If you have a P.O. box, see page 14. **Commonwealth Ave** | Apt. no. | You **must** enter ▲ your SSN(s) above. ▲

City, town or post office, state, and ZIP code. If you have a foreign address, see page 14. **Boston, MA 02467** | Checking a box below will not change your tax or refund.

Presidential Election Campaign ▶ Check here if you, or your spouse if filing jointly, want $3 to go to this fund (see page 14) ▶ ☐ **You** ☐ **Spouse**

Filing Status

Check only one box.

1 ☒ Single
2 ☐ Married filing jointly (even if only one had income)
3 ☐ Married filing separately. Enter spouse's SSN above and full name here. ▶
4 ☐ Head of household (with qualifying person). If the qualifying person is a child but not your dependent, enter this child's name here. ▶
5 ☐ Qualifying widow(er) with dependent child (see page 16)

Exemptions

6a ☒ Yourself. If someone can claim you as a dependent, **do not** check box 6a | Boxes checked on 6a and 6b: **1**
b ☐ Spouse
| No. of children on 6c who:

c Dependents:
| (1) First name Last name | (2) Dependent's social security number | (3) Dependent's relationship to you | (4) ✓ if qualifying child for child tax credit (see page 17) |
| ● lived with you
● did not live with you due to divorce or separation (see page 18)

If more than four dependents, see page 17.

Dependents on 6c not entered above

d Total number of exemptions claimed | Add numbers on lines above ▶ **1**

Income

Attach Form(s) W-2 here. Also attach Forms W-2G and 1099-R if tax was withheld.

If you did not get a W-2, see page 21.

Enclose, but do not attach, any payment. Also, please use Form 1040-V.

7	Wages, salaries, tips, etc. Attach Form(s) W-2	7	**53,211.**	
8a	Taxable interest. Attach Schedule B if required	8a		
b	Tax-exempt interest. **Do not** include on line 8a	8b		
9a	Ordinary dividends. Attach Schedule B if required	9a		
b	Qualified dividends (see page 21)	9b		
10	Taxable refunds, credits, or offsets of state and local income taxes	10		
11	Alimony received	11		
12	Business income or (loss). Attach Schedule C or C-EZ	12	**907.**	
13	Capital gain or (loss). Attach Schedule D if required. If not required, check here ▶ ☐	13		
14	Other gains or (losses). Attach Form 4797	14		
15a	IRA distributions 15a	b Taxable amount	15b	
16a	Pensions and annuities 16a	b Taxable amount	16b	
17	Rental real estate, royalties, partnerships, S corporations, trusts, etc. Attach Schedule E	17		
18	Farm income or (loss). Attach Schedule F	18		
19	Unemployment compensation	19		
20a	Social security benefits 20a	b Taxable amount (see page 26)	20b	
21	Other income. List type and amount (see page 28) _____	21		
22	Add the amounts in the far right column for lines 7 through 21. This is your **total income** ▶	22	**54,118.**	

Adjusted Gross Income

23	Educator expenses (see page 28)	23	
24	Certain business expenses of reservists, performing artists, and fee-basis government officials. Attach Form 2106 or 2106-EZ	24	
25	Health savings account deduction. Attach Form 8889	25	
26	Moving expenses. Attach Form 3903	26	
27	One-half of self-employment tax. Attach Schedule SE	27	**64.**
28	Self-employed SEP, SIMPLE, and qualified plans	28	
29	Self-employed health insurance deduction (see page 29)	29	
30	Penalty on early withdrawal of savings	30	
31a	Alimony paid b Recipient's SSN ▶	31a	
32	IRA deduction (see page 30)	32	
33	Student loan interest deduction (see page 33)	33	
34	Tuition and fees deduction. Attach Form 8917	34	
35	Domestic production activities deduction. Attach Form 8903	35	
36	Add lines 23 through 31a and 32 through 35	36	**64.**
37	Subtract line 36 from line 22. This is your **adjusted gross income** ▶	37	**54,054.**

810001 11-10-08

LHA For Disclosure, Privacy Act, and Paperwork Reduction Act Notice, see page 88.

Form **1040** (2008)

Form 1040 (2008)	Liz Brushstroke		333-44-5555		Page **2**

Tax and Credits	38	Amount from line 37 (adjusted gross income)		38	54,054.

Standard Deduction for -

● People who checked any box on line 39a, 39b, or 39c **or** who can be claimed as a dependent.

● All others:

Single or Married filing separately, $5,450

Married filing jointly or Qualifying widow(er), $10,900

Head of household, $8,000

	39a	Check if:	You were born before January 1, 1944, ☐	Blind. ☐	Total boxes			
			Spouse was born before January 1, 1944, ☐	Blind. ☐	checked ▶ 39a			
	b	If your spouse itemizes on a separate return or you were a dual-status alien, see page 34 and check here ▶ 39b ☐						
	c	Check if standard deduction includes real estate taxes or disaster loss (see page 34) ▶ 39c ☐						
	40	Itemized deductions (from Schedule A) **or** your standard deduction (see left margin) Stmt 1					40	5,450.
	41	Subtract line 40 from line 38					41	48,604.
	42	If line 38 is over $119,975, or you provided housing to a Midwestern displaced individual, see page 36. Otherwise, multiply $3,500 by the total number of exemptions claimed on line 6d					42	3,500.
	43	Taxable income. Subtract line 42 from line 41. If line 42 is more than line 41, enter -0-					43	45,104.
	44	Tax. Check if any tax is from: a ☐ Form(s) 8814 b ☐ Form 4972					44	7,625.
	45	Alternative minimum tax. Attach Form 6251					45	0.
	46	Add lines 44 and 45 ▶					46	7,625.
	47	Foreign tax credit. Attach Form 1116 if required		47				
	48	Credit for child and dependent care expenses. Attach Form 2441		48				
	49	Credit for the elderly or the disabled. Attach Schedule R		49				
	50	Education credits. Attach Form 8863		50				
	51	Retirement savings contributions credit. Attach Form 8880		51				
	52	Child tax credit (see page 42). Attach Form 8901 if required		52				
	53	Credits from Form: a ☐ 8396 b ☐ 8839 c ☐ 5695		53				
	54	Other credits from Form: a ☐ 3800 b ☐ 8801 c ☐		54				
	55	Add lines 47 through 54. These are your total credits					55	
	56	Subtract line 55 from line 46. If line 55 is more than line 46, enter -0- ▶					56	7,625.
Other Taxes	57	Self-employment tax. Attach Schedule SE					57	128.
	58	Unreported social security and Medicare tax from Form: a ☐ 4137 b ☐ 8919					58	
	59	Additional tax on IRAs, other qualified retirement plans, etc. Attach Form 5329 if required					59	
	60	Additional taxes: a ☐ AEIC payments b ☐ Household employment taxes. Attach Schedule H					60	
	61	Add lines 56 through 60. This is your total tax ▶					61	7,753.
Payments	62	Federal income tax withheld from Forms W-2 and 1099		62	7,144.			
	63	2008 estimated tax payments and amount applied from 2007 return		63				
If you have a qualifying child, attach Schedule EIC.	64a	Earned income credit (EIC)		64a				
	b	Nontaxable combat pay election ▶	64b					
	65	Excess social security and tier 1 RRTA tax withheld (see page 61)		65				
	66	Additional child tax credit. Attach Form 8812		66				
	67	Amount paid with request for extension to file (see page 61)		67				
	68	Credits from Form: a ☐ 2439 b ☐ 4136 c ☐ 8801 d ☐ 8885		68				
	69	First-time homebuyer credit. Attach Form 5405		69				
	70	Recovery rebate credit (see worksheet on pages 62 and 63)		70				
	71	Add lines 62 through 70. These are your total payments ▶					71	7,144.
Refund Direct deposit? See page 63 and fill in 73b, 73c, and 73d, or Form 8888.	72	If line 71 is more than line 61, subtract line 61 from line 71. This is the amount you overpaid					72	
	73a	Amount of line 72 you want refunded to you. If Form 8888 is attached, check here ▶ ☐					73a	
	b	Routing number	c Type: ☐ Checking ☐ Savings	d Account number				
	74	Amount of line 72 you want applied to your 2009 estimated tax ▶		74				
Amount You Owe	75	Amount you owe. Subtract line 71 from line 61. For details on how to pay, see page 65 ▶					75	609.
	76	Estimated tax penalty (see page 65)		76				

Third Party Designee	Do you want to allow another person to discuss this return with the IRS (see page 66)? ☒ Yes. Complete the following. ☐ No		
	Designee's name ▶ Preparer	Phone no. ▶	Personal identification number (PIN) ▶

Sign Here
Joint return? See page 15. Keep a copy for your records.

Under penalties of perjury, I declare that I have examined this return and accompanying schedules and statements, and to the best of my knowledge and belief, they are true, correct, and complete. Declaration of preparer (other than taxpayer) is based on all information of which preparer has any knowledge.

Your signature	Date	Your occupation Artist/Teacher	Daytime phone number
Spouse's signature. If a joint return, **both** must sign.	Date	Spouse's occupation	

Paid Preparer's Use Only	Preparer's signature ▶ Peter Jason Riley, CPA	Date 12/13/09	Check if self-employed ☐	Preparer's SSN or PTIN P00413102
810002 11-10-08	Firm's name (or yours if self-employed), address, and ZIP code ▶	Riley & Associates, P.C. P.O. Box 157 Newburyport, MA 01950-0157	EIN 04-3577120	Phone no. 978-463-9350

SCHEDULE C
(Form 1040)
Department of the Treasury
Internal Revenue Service (99)

Profit or Loss From Business
(Sole Proprietorship)
► Partnerships, joint ventures, etc., generally must file Form 1065 or 1065-B.
► Attach to Form 1040, 1040NR, or 1041. ►See Instructions for Schedule C (Form 1040).

OMB No. 1545-0074

2008

Attachment
Sequence No. **09**

Name of proprietor: **Liz Brushstroke**

Social security number (SSN): **333-44-5555**

A Principal business or profession, including product or service (see page C-3)
Visual Arts

B Enter code from pages C-9, 10, & 11 ► **711510**

C Business name. If no separate business name, leave blank.
Liz Brushstroke Art Studio

D Employer ID number (EIN), if any

E Business address (including suite or room no.) ► **Commonwealth Ave.**
City, town or post office, state, and ZIP code ► **Boston, MA 02467**

F Accounting method: (1) [X] Cash (2) [] Accrual (3) [] Other (specify) ► _____

G Did you "materially participate" in the operation of this business during 2008? If "No," see page C-4 for limit on losses ... [X] Yes [] No

H If you started or acquired this business during 2008, check here ► []

Part I Income

1	Gross receipts or sales. **Caution.** See page C-4 and check the box if: ● This income was reported to you on Form W-2 and the "Statutory employee" box on that form was checked, or ● You are a member of a qualified joint venture reporting only rental real estate income not subject to self-employment tax. Also see page C-4 for limit on losses. ► []	**1** 29,540.
2	Returns and allowances	**2**
3	Subtract line 2 from line 1	**3** 29,540.
4	Cost of goods sold (from line 42 on page 2)	**4** 10,500.
5	Gross profit. Subtract line 4 from line 3	**5** 19,040.
6	Other income, including federal and state gasoline or fuel tax credit or refund (see page C-4) **See Statement 2**	**6** 100.
7	**Gross income.** Add lines 5 and 6 ►	**7** 19,140.

Part II Expenses. Enter expenses for business use of your home **only** on line 30.

8	Advertising	**8**	18	Office expense	**18**	104.
9	Car and truck expenses (see page C-5)	**9** 2,335.	19	Pension and profit-sharing plans	**19**	
10	Commissions and fees	**10**	20	Rent or lease (see page C-6):		
11	Contract labor (see page C-5)	**11**	a	Vehicles, machinery, and equipment	**20a**	
12	Depletion	**12**	b	Other business property	**20b**	
13	Depreciation and section 179 expense deduction (not included in Part III) (see page C-5)	**13** 972.	21	Repairs and maintenance	**21**	
			22	Supplies (not included in Part III)	**22**	207.
			23	Taxes and licenses	**23**	
14	Employee benefit programs (other than on line 19)	**14**	24	Travel, meals, and entertainment:		
15	Insurance (other than health)	**15**	a	Travel	**24a**	5,155.
16	Interest:		b	Deductible meals and entertainment (see page C-7)	**24b**	1,082.
a	Mortgage (paid to banks, etc.)	**16a**	25	Utilities	**25**	
b	Other	**16b**	26	Wages (less employment credits)	**26**	
17	Legal and professional services	**17** 250.	27	Other expenses (from line 48 on page 2)	**27**	5,460.

28	**Total expenses** before expenses for business use of home. Add lines 8 through 27 ►	**28**	15,565.
29	Tentative profit or (loss). Subtract line 28 from line 7	**29**	3,575.
30	Expenses for business use of your home. Attach Form 8829	**30**	2,668.
31	**Net profit or (loss).** Subtract line 30 from line 29. ● If a profit, enter on both **Form 1040, line 12,** and **Schedule SE, line 2,** or on **Form 1040NR, line 13** (if you checked the box on line 1, see page C-7). Estates and trusts, enter on **Form 1041, line 3.** ● If a loss, you **must** go to line 32.	**31**	907.
32	If you have a loss, check the box that describes your investment in this activity (see page C-8). ● If you checked 32a, enter the loss on both **Form 1040, line 12,** and **Schedule SE, line 2,** or on **Form 1040NR, line 13** (if you checked the box on line 1, see the line 31 instructions on page C-7). Estates and trusts, enter on **Form 1041, line 3.** ● If you checked 32b, you **must** attach **Form 6198.** Your loss may be limited.	**32a** [] All investment is at risk. **32b** [] Some investment is not at risk.	

LHA For Paperwork Reduction Act Notice, see page C-9 of the instructions.

Schedule C (Form 1040) 2008

820001 11-20-08

5

Schedule C (Form 1040) 2008 LIZ BRUSHSTROKE 333-44-5555 Page 2

Part III | **Cost of Goods Sold** (see page C-8)

33	Method(s) used to value closing inventory:	**a** ☐ Cost	**b** ☐ Lower of cost or market	**c** ☐ Other (attach explanation)

34 Was there any change in determining quantities, costs, or valuations between opening and closing inventory? If "Yes," attach explanation .. ☐ **Yes** ☐ **No**

35	Inventory at beginning of year. If different from last year's closing inventory, attach explanation	35	5,000.
36	Purchases less cost of items withdrawn for personal use	36	3,000.
37	Cost of labor. Do not include any amounts paid to yourself	37	
38	Materials and supplies	38	
39	Other costs See Statement 4	39	8,000.
40	Add lines 35 through 39	40	16,000.
41	Inventory at end of year	41	5,500.
42	**Cost of goods sold.** Subtract line 41 from line 40. Enter the result here and on page 1, line 4	42	10,500.

Part IV | **Information on Your Vehicle.** Complete this part **only** if you are claiming car or truck expenses on line 9 and are not required to file Form 4562 for this business. See the instructions for line 13 on page C-5 to find out if you must file Form 4562.

43 When did you place your vehicle in service for business purposes? (month, day, year) ▶ ____ / ____ / ____

44 Of the total number of miles you drove your vehicle during 2008, enter the number of miles you used your vehicle for:

 a Business _____ **b** Commuting _____ **c** Other _____

45 Was your vehicle available for personal use during off-duty hours? .. ☐ **Yes** ☐ **No**

46 Do you (or your spouse) have another vehicle available for personal use? ☐ **Yes** ☐ **No**

47 **a** Do you have evidence to support your deduction? .. ☐ **Yes** ☐ **No**

 b If "Yes," is the evidence written? ... ☐ **Yes** ☐ **No**

Part V | **Other Expenses.** List below business expenses not included on lines 8-26 or line 30.

See Statement 3	5,460.

48	**Total other expenses.** Enter here and on page 1, line 27	48	5,460.

820002 11-20-08 Schedule C (Form 1040) 2008

2008 DEPRECIATION AND AMORTIZATION REPORT
Liz Brushstroke Art Studio

SCHEDULE C - 1

Asset No.	Description	Date Acquired	Method	Life	Line No.	Unadjusted Cost Of Basis	Bus % Excl	Reduction In Basis	Basis For Depreciation	Accumulated Depreciation	Current Sec 179	Current Year Deduction
1	Website Costs	070108		36M	42	1,945.			1,945.			324.
2	Flat Files	122808	200DB	7.00	19C	1,650.			1,650.			59.
4	Digital Camera	122708	200DB	5.00	19B	399.		399.	0.		399.	399.
6	Notebook Computer	070106	200DB	5.00	17	1,644.			1,644.	855.		316.
8	Studio Vent & Installation	070108	200DB	7.00	19C	1,844.			1,844.			198.
	Total Sch C Depr. & Amortization					7,482.		399.	7,083.	855.	399.	1,296.
	Current Year Activity											
	Beginning balance					1,644.			1,644.	855.		
	Acquisitions					5,838.		399.	5,439.	0.		
	Dispositions					0.		0.	0.	0.		
	Ending balance					7,482.		399.	7,083.	855.		

(D) - Asset disposed

* ITC; Section 179, Salvage, Bonus, Commercial Revitalization Deduction, GO Zone

6.1

SCHEDULE SE		OMB No. 1545-0074

SCHEDULE SE
(Form 1040)
Department of the Treasury
Internal Revenue Service (99)

Self-Employment Tax

► **Attach to Form 1040.** ► **See Instructions for Schedule SE (Form 1040).**

2008
Attachment
Sequence No. **17**

Name of person with **self-employment** income (as shown on Form 1040)	Social security number of person with **self-employment** income►
Liz Brushstroke	333 44 5555

Who Must File Schedule SE

You must file Schedule SE if:

- You had net earnings from self-employment from **other than** church employee income (line 4 of Short Schedule SE or line 4c of Long Schedule SE) of $400 or more, **or**
- You had church employee income of $108.28 or more. Income from services you performed as a minister or a member of a religious order **is not** church employee income (see page SE-1).

Note. Even if you had a loss or a small amount of income from self-employment, it may be to your benefit to file Schedule SE and use either "optional method" in Part II of Long Schedule SE (see page SE-4).

Exception. If your only self-employment income was from earnings as a minister, member of a religious order, or Christian Science practitioner **and** you filed Form 4361 and received IRS approval not to be taxed on those earnings, **do not** file Schedule SE. Instead, write "Exempt-Form 4361" on Form 1040, line 57.

May I Use Short Schedule SE or Must I Use Long Schedule SE?

Note. Use this flowchart **only if** you must file Schedule SE. If unsure, see *Who Must File Schedule SE,* above.

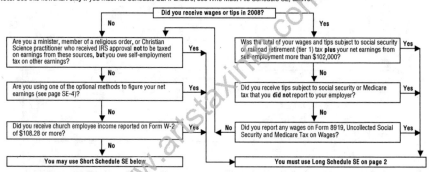

Section A-Short Schedule SE. Caution. Read above to see if you can use Short Schedule SE.

1a Net farm profit or (loss) from Schedule F, line 36, and farm partnerships, Schedule K-1 (Form 1065), box 14, code A ..	**1a**		
b If you received social security retirement or disability benefits, enter the amount of Conservation Reserve Program payments included on Schedule F, line 6b, or listed on Schedule K-1 (Form 1065), box 20, code X	**1b**		
2 Net profit or (loss) from Schedule C, line 31; Schedule C-EZ, line 3; Schedule K-1 (Form 1065), box 14, code A (other than farming); and Schedule K-1 (Form 1065-B), box 9, code J1. Ministers and members of religious orders, see pg SE-1 for types of income to report on this line. See pg SE-3 for other income to report Stmt 5	**2**		907.
3 Combine lines 1a, 1b, and 2 ..	**3**		907.
4 **Net earnings from self-employment.** Multiply line 3 by 92.35% (.9235). If less than $400, **do not** file this schedule; you do not owe self-employment tax ..►	**4**		838.
5 Self-employment tax. If the amount on line 4 is:			
• $102,000 or less, multiply line 4 by 15.3% (.153). Enter the result here and on **Form 1040, line 57.**			
• More than $102,000, multiply line 4 by 2.9% (.029). Then, add $12,648 to the result. Enter the total here and on **Form 1040, line 57** ..	**5**		128.
6 **Deduction for one-half of self-employment tax.** Multiply line 5 by 50% (.5). Enter the result here and on **Form 1040, line 27**	**6**	64.	

LHA **For Paperwork Reduction Act Notice, see Form 1040 instructions.**

Schedule SE (Form 1040) 2008

824501
11-11-08

Does not apply

Form **6251**	**Alternative Minimum Tax - Individuals**	OMB No. 1545-0074
Department of the Treasury Internal Revenue Service (99)	▶ Attach to Form 1040 or Form 1040NR.	**2008** Attachment Sequence No. **32**

Name(s) shown on Form 1040 or Form 1040NR	Your social security number
Liz Brushstroke	333 44 5555

Part I Alternative Minimum Taxable Income

1	If filing Schedule A (Form 1040), enter the amount from Form 1040, line 41 (minus any amount on Form 8914, line 2), and go to line 2. Otherwise, enter the amount from Form 1040, line 38 (minus any amount on Form 8914, line 2), and go to line 7. (If less than zero, enter as a negative amount.) ... **1**	54,054.
2	Medical and dental. Enter the **smaller** of Schedule A (Form 1040), line 4, **or** 2.5% (.025) of Form 1040, line 38. If zero or less, enter -0- **2**	
3	Taxes from Schedule A (Form 1040), line 9 **3**	
4	Enter the home mortgage interest adjustment, if any, from line 6 of the worksheet on page 2 of the instructions **4**	
5	Miscellaneous deductions from Schedule A (Form 1040), line 27 **5**	
6	If Form 1040, line 38, is over $159,950 (over $79,975 if married filing separately), enter the amount from line 11 of the **Itemized Deductions Worksheet** on page A-10 of the instructions for Schedule A (Form 1040) **6**	
7	If claiming the standard deduction, enter any amount from Form 4684, line 18a, as a negative amount **7**	
8	Tax refund from Form 1040, line 10 or line 21 **8**	
9	Investment interest expense (difference between regular tax and AMT) **9**	
10	Depletion (difference between regular tax and AMT) **10**	
11	Net operating loss deduction from Form 1040, line 21. Enter as a positive amount **11**	
12	Interest from specified private activity bonds exempt from the regular tax **12**	
13	Qualified small business stock (7% of gain excluded under section 1202) **13**	
14	Exercise of incentive stock options (excess of AMT income over regular tax income) **14**	
15	Estates and trusts (amount from Schedule K-1 (Form 1041), box 12, code A) **15**	
16	Electing large partnerships (amount from Schedule K-1 (Form 1065-B), box 6) **16**	
17	Disposition of property (difference between AMT and regular tax gain or loss) **17**	
18	Depreciation on assets placed in service after 1986 (difference between regular tax and AMT) Stmt 6 **18**	88.
19	Passive activities (difference between AMT and regular tax income or loss) **19**	
20	Loss limitations (difference between AMT and regular tax income or loss) **20**	
21	Circulation costs (difference between regular tax and AMT) **21**	
22	Long-term contracts (difference between AMT and regular tax income) **22**	
23	Mining costs (difference between regular tax and AMT) **23**	
24	Research and experimental costs (difference between regular tax and AMT) **24**	
25	Income from certain installment sales before January 1, 1987 **25**	
26	Intangible drilling costs preference **26**	
27	Other adjustments, including income-based related adjustments **27**	
28	Alternative tax net operating loss deduction **28**	
29	**Alternative minimum taxable income.** Combine lines 1 through 28. (If married filing separately and line 29 is more than $214,900, see instructions) **29**	54,142.

Part II Alternative Minimum Tax (AMT)

30	Exemption. (If you were under age 24 at the end of 2008, see instructions.)	

IF your filing status is	AND line 29 is not over	THEN enter on line 30
Single or head of household	$112,500	$46,200
Married filing jointly or qualifying widow(er)	150,000	69,950
Married filing separately	75,000	34,975

	If line 29 is **over** the amount shown above for your filing status, see instructions. **30**	46,200.
31	Subtract line 30 from line 29. If more than zero, go to line 32. If zero or less, enter -0- here and on lines 34 and 36 and skip the rest of Part II **31**	7,942.
32	• If you are filing Form 2555 or 2555-EZ, see page 9 of the instructions for the amount to enter. • If you reported capital gain distributions directly on Form 1040, line 13; you reported qualified dividends on Form 1040, line 9b; **or** you had a gain on both lines 15 and 16 of Schedule D (Form 1040) (as refigured for the AMT, if necessary), complete Part III on page 2 and enter the amount from line 55 here. • **All others:** If line 31 is $175,000 or less ($87,500 or less if married filing separately), multiply line 31 by 26% (.26). Otherwise, multiply line 31 by 28% (.28) and subtract $3,500 ($1,750 if married filing separately) from the result. **32**	2,065.
33	Alternative minimum tax foreign tax credit (see instructions) **33**	
34	Tentative minimum tax. Subtract line 33 from line 32 **34**	2,065.
35	Tax from Form 1040, line 44 (minus any tax from Form 4972 and any foreign tax credit from Form 1040, line 47). If you used Sch J to figure your tax, the amount from line 44 of Form 1040 must be refigured without using Sch J **35**	7,625.
36	**AMT.** Subtract line 35 from line 34. If zero or less, enter -0-. Enter here and on Form 1040, line 45 **36**	0.

819481 12-02-08 LHA **For Paperwork Reduction Act Notice, see instructions.** Form **6251** (2008)

8

Form 6251 (2008) Liz Brushstroke 333-44-5555 Page **2**

Part III	Tax Computation Using Maximum Capital Gains Rates		

37 Enter the amount from Form 6251, line 31. If you are filing Form 2555 or 2555-EZ, enter the amount from line 3 of the worksheet in the instructions | **37** | |

38 Enter the amount from line 6 of the Qualified Dividends and Capital Gain Tax Worksheet in the instructions for Form 1040, line 44, or the amount from line 13 of the Schedule D Tax Worksheet on page D-10 of the instructions for Schedule D (Form 1040), whichever applies (as refigured for the AMT, if necessary) (see the instructions). If you are filing Form 2555 or 2555-EZ, see instructions for the amount to enter | **38** | |

39 Enter the amount from Schedule D (Form 1040), line 19 (as refigured for the AMT, if necessary) (see instructions). If you are filing Form 2555 or 2555-EZ, see instructions for the amount to enter | **39** | |

40 If you did not complete a Schedule D Tax Worksheet for the regular tax or the AMT, enter the amount from line 38. Otherwise, add lines 38 and 39, and enter the **smaller** of that result or the amount from line 10 of the Schedule D Tax Worksheet (as refigured for the AMT, if necessary). If you are filing Form 2555 or 2555-EZ, see instructions for the amount to enter | **40** | |

41 Enter the **smaller** of line 37 or line 40 | | **41** |

42 Subtract line 41 from line 37 | | **42** |

43 If line 42 is $175,000 or less ($87,500 or less if married filing separately), multiply line 42 by 26% (.26). Otherwise, multiply line 42 by 28% (.28) and subtract $3,500 ($1,750 if married filing separately) from the result ▶ | | **43** |

44 Enter:
 • $65,100 if married filing jointly or qualifying widow(er),
 • $32,550 if single or married filing separately, or
 • $43,650 if head of household. | **44** | |

45 Enter the amount from line 7 of the Qualified Dividends and Capital Gain Tax Worksheet in the instructions for Form 1040, line 44, or the amount from line 14 of the Schedule D Tax Worksheet on page D-10 of the instructions for Schedule D (Form 1040), whichever applies (as figured for the regular tax. If you did not complete either worksheet for the regular tax, enter -0- | **45** | |

46 Subtract line 45 from line 44. If zero or less, enter -0- | **46** | |

47 Enter the **smaller** of line 37 or line 38 | **47** | |

48 Enter the **smaller** of line 46 or line 47 | **48** | |

49 Subtract line 48 from line 47 | **49** | |

50 Multiply line 49 by 15% (.15) ▶ | | **50** |

If line 39 is zero or blank, skip lines 51 and 52 and go to line 53. Otherwise, go to line 51.

51 Subtract line 47 from line 41 | **51** | |

52 Multiply line 51 by 25% (.25) ▶ | | **52** |

53 Add lines 43, 50, and 52 | | **53** |

54 If line 37 is $175,000 or less ($87,500 or less if married filing separately), multiply line 37 by 26% (.26). Otherwise, multiply line 37 by 28% (.28) and subtract $3,500 ($1,750 if married filing separately) from the result | | **54** |

55 Enter the **smaller** of line 53 or line 54 here and on line 32. If you are filing Form 2555 or 2555-EZ, do not enter this amount on line 32. Instead, enter it on line 4 of the worksheet in the instructions | | **55** |

Form **6251** (2008)

Form **8829**	**Expenses for Business Use of Your Home**	OMB No. 1545-0074
Department of the Treasury Internal Revenue Service (99)	▶ File only with Schedule C (Form 1040). Use a separate Form 8829 for each home you used for business during the year.	**2008** Attachment Sequence No. **66**

Name(s) of proprietor(s)	Your social security number
Liz Brushstroke	333-44-5555

Part I Part of Your Home Used for Business

1	Area used regularly and exclusively for business, regularly for daycare, or for storage of inventory or product samples	1	190
2	Total area of home	2	1,085
3	Divide line 1 by line 2. Enter the result as a percentage	3	17.5115%

For daycare facilities not used exclusively for business, go to **line 4. All others go to line 7.**

4	Multiply days used for daycare during year by hours used per day	4		hr.
5	Total hours available for use during the year (366 days x 24 hours)	5		hr.
6	Divide line 4 by line 5. Enter the result as a decimal amount	6		
7	Business percentage. For daycare facilities not used exclusively for business, multiply line 6 by line 3 (enter the result as a percentage). All others, enter the amount from line 3 ▶	7	17.5115%	

Part II Figure Your Allowable Deduction

			(a) Direct expenses	(b) Indirect expenses		
8	Enter the amount from Schedule C, line 29, **plus** any net gain or (loss) derived from the business use of your home and shown on Schedule D or Form 4797. If more than one place of business, see instructions				8	3,575.
	See instructions for columns (a) and (b) before completing lines 9-21.					
9	Casualty losses	9				
10	Deductible mortgage interest	10				
11	Real estate taxes	11				
12	Add lines 9, 10, and 11	12				
13	Multiply line 12, column (b) by line 7			13		
14	Add line 12, column (a) and line 13				14	
15	Subtract line 14 from line 8. If zero or less, enter -0-				15	3,575.
16	Excess mortgage interest	16				
17	Insurance	17		308.		
18	Rent	18		13,850.		
19	Repairs and maintenance	19				
20	Utilities	20		1,077.		
21	Other expenses	21				
22	Add lines 16 through 21	22		15,235.		
23	Multiply line 22, column (b) by line 7			23	2,668.	
24	Carryover of operating expenses from 2007 Form 8829, line 42			24		
25	Add line 22 column (a), line 23, and line 24				25	2,668.
26	Allowable operating expenses. Enter the **smaller** of line 15 or line 25				26	2,668.
27	Limit on excess casualty losses and depreciation. Subtract line 26 from line 15				27	907.
28	Excess casualty losses			28		
29	Depreciation of your home from line 41 below			29		
30	Carryover of excess casualty losses and depreciation from 2007 Form 8829, line 43			30		
31	Add lines 28 through 30				31	
32	Allowable excess casualty losses and depreciation. Enter the **smaller** of line 27 or line 31				32	0.
33	Add lines 14, 26, and 32				33	2,668.
34	Casualty loss portion, if any, from lines 14 and 32. Carry amount to **Form 4684**, Section B				34	0.
35	**Allowable expenses for business use of your home.** Subtract line 34 from line 33. Enter here and on Schedule C, line 30. If your home was used for more than one business, see instructions ▶				35	2,668.

Part III Depreciation of Your Home

36	Enter the **smaller** of your home's adjusted basis or its fair market value	36	
37	Value of land included on line 36	37	
38	Basis of building. Subtract line 37 from line 36	38	
39	Business basis of building. Multiply line 38 by line 7	39	
40	Depreciation percentage	40	%
41	Depreciation allowable. Multiply line 39 by line 40. Enter here and on line 29 above	41	

Part IV Carryover of Unallowed Expenses to 2009

42	Operating expenses. Subtract line 26 from line 25. If less than zero, enter -0-	42	
43	Excess casualty losses and depreciation. Subtract line 32 from line 31. If less than zero, enter -0-	43	

820301 12-24-08 LHA **For Paperwork Reduction Act Notice, see instructions.**

Form **8829** (2008)

Form **4562**	SCHEDULE C-1	OMB No. 1545-0172
Department of the Treasury Internal Revenue Service (99)	**Depreciation and Amortization** (Including Information on Listed Property) ▶ See separate instructions. ▶ Attach to your tax return.	**2008** Attachment Sequence No. **67**

Name(s) shown on return	Business or activity to which this form relates	Identifying number
Liz Brushstroke	Liz Brushstroke Art Studio	333-44-5555

Part I Election To Expense Certain Property Under Section 179 **Note:** *If you have any listed property, complete Part V before you complete Part I.*

1	Maximum amount. See the instructions for a higher limit for certain businesses	1	250,000.
2	Total cost of section 179 property placed in service (see instructions)	2	3,893.
3	Threshold cost of section 179 property before reduction in limitation	3	800,000.
4	Reduction in limitation. Subtract line 3 from line 2. If zero or less, enter -0-	4	0.
5	Dollar limitation for tax year. Subtract line 4 from line 1. If zero or less, enter -0-. If married filing separately, see instructions	5	250,000.

6	(a) Description of property	(b) Cost (business use only)	(c) Elected cost
	Digital Camera	399.	399.

7	Listed property. Enter the amount from line 29 7		
8	Total elected cost of section 179 property. Add amounts in column (c), lines 6 and 7	8	399.
9	Tentative deduction. Enter the **smaller** of line 5 or line 8	9	399.
10	Carryover of disallowed deduction from line 13 of your 2007 Form 4562	10	
11	Business income limitation. Enter the smaller of business income (not less than zero) or line 5	11	54,517.
12	Section 179 expense deduction. Add lines 9 and 10, but do not enter more than line 11	12	399.
13	Carryover of disallowed deduction to 2009. Add lines 9 and 10, less line 12 ▶ 13		

Note: *Do not use Part II or Part III below for listed property. Instead, use Part V.*

Part II Special Depreciation Allowance and Other Depreciation (Do not include listed property.)

14	Special depreciation for qualified property (other than listed property) placed in service during the tax year	14	
15	Property subject to section 168(f)(1) election	15	
16	Other depreciation (including ACRS)	16	

Part III MACRS Depreciation (Do not include listed property.) (See instructions.)

Section A

17	MACRS deductions for assets placed in service in tax years beginning before 2008	17	316.
18	If you are electing to group any assets placed in service during the tax year into one or more general asset accounts, check here ▶ ☐		

Section B - Assets Placed in Service During 2008 Tax Year Using the General Depreciation System

(a) Classification of property	(b) Month and year placed in service	(c) Basis for depreciation (business/investment use only - see instructions)	(d) Recovery period	(e) Convention	(f) Method	(g) Depreciation deduction
19a 3-year property						
b 5-year property						
c 7-year property		3,494.	7 Yrs.	MQ	200DB	257.
d 10-year property						
e 15-year property						
f 20-year property						
g 25-year property			25 yrs.		S/L	
h Residential rental property	/		27.5 yrs.	MM	S/L	
	/		27.5 yrs.	MM	S/L	
i Nonresidential real property	/		39 yrs.	MM	S/L	
	/			MM	S/L	

Section C - Assets Placed in Service During 2008 Tax Year Using the Alternative Depreciation System

20a Class life					S/L	
b 12-year			12 yrs.		S/L	
c 40-year	/		40 yrs.	MM	S/L	

Part IV Summary (See instructions.)

21	Listed property. Enter amount from line 28	21	
22	**Total.** Add amounts from line 12, lines 14 through 17, lines 19 and 20 in column (g), and line 21. Enter here and on the appropriate lines of your return. Partnerships and S corporations - see instr.	22	972.
23	For assets shown above and placed in service during the current year, enter the portion of the basis attributable to section 263A costs	23	

816251 11-08-08 **LHA For Paperwork Reduction Act Notice, see separate instructions.** Form **4562** (2008)

Form 4562 (2008) **Liz Brushstroke** 333-44-5555 Page **2**

Part V	Listed Property (Include automobiles, certain other vehicles, cellular telephones, certain computers, and property used for entertainment, recreation, or amusement.)

Note: *For any vehicle for which you are using the standard mileage rate or deducting lease expense, complete only 24a, 24b, columns (a) through (c) of Section A, all of Section B, and Section C if applicable.*

Section A - Depreciation and Other Information (Caution: *See the instructions for limits for passenger automobiles.)*

24a Do you have evidence to support the business/investment use claimed? ☐ Yes ☐ No **24b** If "Yes," is the evidence written? ☐ Yes ☐ No

(a) Type of property (list vehicles first)	(b) Date placed in service	(c) Business/ investment use percentage	(d) Cost or other basis	(e) Basis for depreciation (business/investment use only)	(f) Recovery period	(g) Method/ Convention	(h) Depreciation deduction	(i) Elected section 179 cost
25 Special depreciation allowance for qualified listed property placed in service during the tax year and used more than 50% in a qualified business use						**25**		
26 Property used more than 50% in a qualified business use:								
	: :	%						
	: :	%						
	: :	%						
27 Property used 50% or less in a qualified business use:								
	010107	25.91 %				S/L -		
	: :	%				S/L -		
	: :	%				S/L -		

28 Add amounts in column (h), lines 25 through 27. Enter here and on line 21, page 1 **28**

29 Add amounts in column (i), line 26. Enter here and on line 7, page 1 **29**

Section B - Information on Use of Vehicles

Complete this section for vehicles used by a sole proprietor, partner, or other "more than 5% owner," or related person.
If you provided vehicles to your employees, first answer the questions in Section C to see if you meet an exception to completing this section for those vehicles.

	(a) Vehicle		(b) Vehicle		(c) Vehicle		(d) Vehicle 1		(e) Vehicle		(f) Vehicle	
30 Total business/investment miles driven during the year (**do not** include commuting miles)							4,210					
31 Total commuting miles driven during the year												
32 Total other personal (noncommuting) miles driven							12,041					
33 Total miles driven during the year. Add lines 30 through 32							16,251					
34 Was the vehicle available for personal use during off-duty hours?	Yes	No	Yes	No	Yes	No	Yes	No	Yes	No	Yes	No
35 Was the vehicle used primarily by a more than 5% owner or related person?												
36 Is another vehicle available for personal use?												

Section C - Questions for Employers Who Provide Vehicles for Use by Their Employees

Answer these questions to determine if you meet an exception to completing Section B for vehicles used by employees who **are not** more than 5% owners or related persons.

	Yes	No
37 Do you maintain a written policy statement that prohibits all personal use of vehicles, including commuting, by your employees?		
38 Do you maintain a written policy statement that prohibits personal use of vehicles, except commuting, by your employees? See the instructions for vehicles used by corporate officers, directors, or 1% or more owners		
39 Do you treat all use of vehicles by employees as personal use?		
40 Do you provide more than five vehicles to your employees, obtain information from your employees about the use of the vehicles, and retain the information received?		
41 Do you meet the requirements concerning qualified automobile demonstration use?		

Note: *If your answer to 37, 38, 39, 40, or 41 is "Yes," do not complete Section B for the covered vehicles.*

Part VI	Amortization

(a) Description of costs	(b) Date amortization begins	(c) Amortizable amount	(d) Code section	(e) Amortization period or percentage	(f) Amortization for this year
42 Amortization of costs that begins during your 2008 tax year:					
Website Costs	070108	1,945.		36M	324.
	: :				
43 Amortization of costs that began before your 2008 tax year				**43**	
44 Total. Add amounts in column (f). See the instructions for where to report				**44**	324.

816252 11-08-08 Form **4562** (2008)

13

Liz Brushstroke 333-44-5555

| Form 1040 | Standard Deduction Worksheet | Statement | 1 |

1. Enter the amount shown below for your filing
 status.
 Single or married filing separately - $5,450
 Married filing jointly or Qualifying
 widow(er) - $10,900 5,450.
 Head of household - $8,000
2. Can you (or your spouse if filing jointly) be
 claimed as a dependent?
 [X] No. Skip line 3; enter the amount from
 line 1 on line 4
 [] Yes. Go to line 3.
3. Is your earned income* more than $600?
 [] Yes. Add $300 to your earned income.
 Enter the total
 [] No. Enter $900
4. Enter the smaller of line 1 or line 3 5,450.
5. If born before January 2, 1944, or blind, multiply the
 number on Form 1040, line 39a by $1,050 ($1,350 if single
 or head of household). Otherwise, enter -0-
6. Enter any net disaster loss from Form 4684, line 18a. If
 more than zero, check the box on Form 1040, line 39c
7. Enter the state and local real estate taxes
 you paid that would be deductible on
 Schedule A, line 6, if you were itemizing
 your deductions. See the instructions for
 Schedule A, line 6. Do not include foreign
 real estate taxes
8. Enter $500 ($1,000 if married filing jointly). 500.
9. Enter the smaller of line 7 or line 8. If more than zero,
 check the box on Form 1040, line 39c 0.

10. Add lines 4, 5, 6 and 9. Enter the total here and on
 Form 1040, line 40 5,450.

| Schedule C | Other Income | Statement | 2 |

Description	Amount
Juror Stipend	100.
Total to Schedule C, line 6	100.

Liz Brushstroke 333-44-5555

Schedule C	Other Expenses	Statement 3

Description	Amount
Graphics Design Fee	395.
Printing	498.
Photo Costs	525.
Film & Slide Processing	314.
ISP	304.
Cell Phone	241.
Museum Memberships	220.
Gallery Costs	89.
Shipping & Postage	1,341.
Publications	177.
Dues & Memberships	215.
Show Entry Fees	195.
Art History Masterclass - Education (Ireland)	622.
Amortization	324.
Total to Schedule C, line 48	5,460.

Schedule C	Other Costs of Goods Sold	Statement 4

Description	Amount
Printing	2,000.
Framing	6,000.
Total to Schedule C, line 39	8,000.

Schedule SE	Non-Farm Income	Statement 5

Description	Amount
Visual Arts	907.
Total to Schedule SE, line 2	907.

Liz Brushstroke 333-44-5555

Form 6251 Depreciation on Assets Placed in Service After 1986 Statement 6

Description	Amount
Flat Files	15.
Notebook Computer	23.
Studio Vent & Installation	50.
Total to Form 6251, line 18	88.

Form 4562 Part I - Business Income Statement 7

Income Type	Amount
Wages	53,211.
Schedule C	907.
Section 179 expense	399.
Total business income used in Form 4562, line 11	54,517.

6.

For Writers

In this chapter I will look in detail at the activities of our good friend Guy Focal and the kind of income and deductions he had for the year.

First, let's walk through some of the expense items for writers specifically. I will note in parentheses the type of record keeping the IRS would require:

1. Union dues, professional societies & organizations (invoices & checks)

2. Professional fees for agents, attorneys & accountants (invoices & checks)

3. Classes, education and seminars (bills, credit card receipt & checks)

4. Personal photographs and resumes (bills, credit card receipt & checks)

5. Stationery and Postage (bills, credit card receipt & checks)

6. Books on writing – these may need to be allocated between employment income and contract income (sales receipts, credit card receipt & checks).

7. Telephone and cellular phone – actual business calls on your home phone are deductible, but the IRS does not allow the allocation of the base monthly rate. You can deduct only the actual long distance charges. The same rule is true with your cellular phone service. If you get a second phone line strictly for business then it can be considered 100% deductible (bills & checks).

8. Internet service – for research purposes, business e-mail and e-mail while traveling. Be sure to allocate some of the costs for personal use (bills, checks, invoices & credit card receipt).

9. Purchasing books – be sure to allocate some book purchases to personal use. After all you must sometimes be reading for personal enjoyment, it can't be all business. While the IRS typically hates this deduction you can easily argue that the writer must read competitors' books to keep abreast of trends and dynamics within their profession. In an IRS audit you would need to explain specifically what the professional value was (bills, invoices & checks).

10. Viewing theatre and films (live and via DVD, video and cable) – This is for screen and play writers. I often call this expense line item "research"; others refer to it as "performance audit." Whatever you call it, like the purchase of books listed above make sure to not get "piggy." I often quote to clients the old Wall Street saying, "the pigs get fat and the hogs get slaughtered." As with the previous entry, the IRS dislikes the deduction, but you can easily argue that the stage & screenwriter must engage in these viewings to keep abreast of trends and dynamics within their profession. In an audit you would need to explain specifically what the professional value was (ticket stubs, receipts & diary entries).

11. Office rent – you must be able to prove you need an outside office; you cannot maintain a tax deductible home studio if you rent outside space (bills, invoices & checks).

12. Repair of equipment - Computers, typewriters, etc. (bills, checks, invoices & credit card receipt)

13. Tax preparation, bookkeeping & accounting fees (bills, invoices & checks)

14. Advertisement and listing in publications and on the Internet (bills, checks, invoices & credit card receipt)

15. Professional magazines (bills, checks, invoices & credit card receipt)

16. Insurance – This can include riders on you home policy that relate directly to your home office (bills, invoice & check).

17. Copyright fees (invoice & check)

18. Equipment purchases – Computer and office equipment (bills, checks, invoices & credit card receipt)

19. Office supplies and fixtures (bills, checks, invoices & credit card receipt)

Now, let's see what kind of year our writer Guy had. Luckily for his Enrolled Agent he downloaded our Excel® spreadsheet found at www.artstaxinfo.com for writers and loaded it on his computer at the beginning of the tax year and carefully tracked his expenses all year!

We will now review Guy's 1040 income tax return in detail—and remember you can download the current year version from our website – www.artstaxinfo.com.

As you will remember Guy has a primary job as a staff writer for a local magazine *Swamp Life Living*, for which he receives a W-2, this is found on line 7 of his form 1040.

In the winter, Guy attended an annual conference of the writer's organization PEN in New York City. Guy is a professional member of PEN and represented New Orleans writers at the conference. The trip gave him a chance to network with fellow writers and talk to some of the publishers that were present. The organization sponsors a series of educational events for the participants every day and Guy presented an article on post-Katrina wetlands issues that he had written for *Swamp Life Living* magazine. Guy was at the conference for the entire three days he was away. He made sure that he brought home the conference schedule and related literature and noted which events he attended. Guy can clearly show a business purpose as it relates to his primary employment; he will be able to deduct the entire trip on his Form 2106. His employer did not offer any reimbursement for this trip.

Over the summer Guy got a freelance assignment to write a travel article on Texas. Although he was familiar with Texas he decided a visit would help in writing the article, and he contacted the Texas Department of Tourism for help. He informed them that he only had a few days in which to travel in the state. They arranged a route that allowed him to hit the high spots in the least amount of time. He incurred the costs of travel, auto rental, meals & hotel, because the magazine that hired him did not directly pick up any of the costs of the trip. The trip had a clearly defined business purpose so the costs were 100% deductible against the income he received from the article on his Schedule C.

The president of a national bookstore chain contacted Guy to ask if he would be interested in making some appearances at her stores. She liked Guy's children's books and felt his visit could help in promoting the chain's children's book departments. She wanted Guy to come to her stores in San Francisco, Cleveland, New York and Boston and do a reading and sign books for the children in each one. The owner did not want to get involved

in reimbursing expenses, so she offered Guy a straight fee for the appearances from which he would cover all his expenses. All the costs associated with the travel, meals, etc. would be deductible against the income. Like the preceding example, the income from this activity would be reported on Guy's Schedule C.

Guy decided that he wanted a personal website where he could post his resume, excerpts and reviews from his books and articles, etc. He will also use the website to directly sell copies of his children's books. His illustrator agreed to let him post copies of some of the illustrations she did for his books. The costs of setting up the website, registering the domain name and hosting the site are all deductible. Guy will be able to deduct the costs of having photos taken and transferred to digital images and of scanning the book illustrations for use on the site. The IRS stipulates that website development is written off (amortized) over three years. So all the costs of designing and setting up the site will be added up (capitalized) and expensed over three years.

In the fall, a well-known TV host asked Guy to appear on a panel on her show to discuss the current state of children's books in America. Guy was to be paid a small stipend and all his costs would be covered directly by the television network. To be on the show Guy flew to California one day and came back the next day, incurring absolutely no tax-deductible expenses on the trip.

In his home Guy has a room set up as an office that he exclusively uses to write in. He uses Form 8829 to take a home office deduction for the office. This form allows him to take a portion of all his general home expenses as a deduction against his freelance writing income. If he makes alterations to the room specifically for the writing he can take those expenses 100%. This year Guy had to upgrade his electrical system to power the office equipment he now has in the office; he also installed a cable modem for Internet access. Guy's accountant will depreciate both of these items. In order to preserve the IRS rules regarding "exclusive use" Guy will have to be very careful about family use of the home office room. The home office is deducted on Form 8829.

An extensive children's book collection came on the market in the fall; some of the books were very valuable and collectable, some were not. Guy called his tax advisor to ask if this purchase would be deductible and the advisor told him that it was not a clear cut deduction, that Guy would have to explain to the IRS how he was actually using the collection in his work as a

children's author. Otherwise the IRS would consider the books to be collectors' items and not deductible. If he could justify the deduction, it would be depreciated over five years on his Schedule C.

One of Guy's children's books was up for an ABA award and he decided to take the trip to Los Angeles with his wife for the November ceremony. So, they flew to LA on Friday evening. They wanted to be in time for the related conference being held Saturday. They attended the award ceremony on Saturday evening; the couple spent Sunday in LA and returned home Sunday night. The airline ticket home on Sunday would be deductible as it was impractical for the couple to fly home late on Saturday night. All the costs of the trip will be deductible for Guy on his Schedule C; none of the costs for his wife's travel will be deductible. He will have to subtract the cost of her airline ticket and adjust for the extra cost of a double room at the hotel. He will also only be able to take the cost of *his* meals.

Over the course of the year Guy kept writing and submitting work to various magazines and publishers throughout the country. His accountant recommended that Guy send all submissions via registered mail with copies attached of the piece and retain all responses from the editors and publishers. These could be very important if Guy is ever hit with a "hobby loss" audit. Of course all the postage, copies, etc would be deductible against Guy's schedule C income.

When Guy met with his accountant at year-end to do some tax planning and check on his estimated tax payments for the year, he had more income than he had anticipated. Guy had royalty income from his books as well as income from magazine articles, the book tour and the stipend from his TV appearance. His accountant asked if there were some expenses that he could accelerate into the current year; a way he would get the tax benefit of the deductions in the current year. Guy had been thinking about buying a new computer. He decided to purchase the new computer before December 31. By purchasing before year-end he was able to use the Section 179 election and write it off 100% in the current year if he needed to. He can do this, even if he charges the computer on his credit card and pays it off in the next year, as long as the computer is "in use" before December 31.

For some work on one of his books Guy had paid one of his illustrators $1,450 during the year. His accountant told him that he needed to issue the illustrator a 1099-MISC, because the amount was in excess of $600. Guy called the illustrator, verified her name, address and got her social security number, so that the accountant could prepare the form and mail it to her by the January 31st deadline.

Writers

Continuing Education

Association & Union Dues	
Credentials	
License	
Professional Associations	
Union Dues	
Other: _____	

Promotional Expenses

Correspondence Course Fees	
College Courses	
Courses Registration	
Materials & Supplies	
Photocopy Expense	
Reference Material	
Books Purchased for Research	
Seminar Fees	
Textbooks	
Other: _____	

Supplies & Other Expenses

Briefcase	
Business Meals (enter 100% of expenses)	
Business Cards	
Clerical Service	
Computer Software	
Computer Supplies	
Customer Lists	
Entertainment (enter 100% of expense)	
Equipment Repair	
FAX Supplies	
Gifts & Greeting Cards	
On-Line Charges	
Legal & Professional Services	

Office Expenses

Photocopying

Postage & Shipping

DVDs, Films, & Videos for Research

Stationery

Website Development & Hosting

Other: _____

Auto Travel (in miles)

Between Jobs or Locations

Client & Publisher Meetings

Continuing Education

Job Seeking

Out-Of-Town Business Trips

Purchasing Job Supplies & Materials

Professional Society Meetings

Parking Fees & Tolls

Other: _____

Travel - Out of Town

Airfare

Car Rental, Taxi, Bus, Train, and Subway

Parking & Tolls

Lodging & Housing (do not combine with meals)

Meals (do not combine with lodging)

Porter, Bell Captain, and Laundry

Telephone Calls (including home)

Other: _____

Telephone Costs

FAX Transmissions

Paging Service

Toll, Cellular & Pay Calls

Other: _____

Equipment Purchases

Cellular Phone	
FAX machine, Calculator, & Copier	
Pager, Recorder, PDA, & Phone	
Computers & Printers	
Modems & Computer Peripherals	
Other: _____	

Miscellaneous Expenses

Liability Insurance - Business	
Subscriptions	
Resume	

```
Schedule C - Meals Detail - Line 24B

   Texas - Meals $39*4 (standard)      156.00
   Book Tour - Meals $39*10 days       390.00
   LA - Meals 2 days x $64             128.00
                                      _____
                                       674.00
                                      =======

Schedule C - Travel Detail - Line 24A

   Texas - Hotels                      389.00
   Texas - Auto Rental                 377.00
   Book Tour - Hotel                   874.00
   Book Tour - Airfare               1,504.00
   LA - Hotels                         388.00
   LA - Airfare (Guy only)             408.00
                                     _____
                                     3,940.00
                                     ========

Form 2106 - Meals Detail - Line 5

   NYC - 3 days x $64                  192.00
                                      _____
                                       192.00
                                      =======

Form 2106 - Travel Detail - Line 3

   NYC Airfare                         489.00
   NYC Hotel                           689.00
                                     _____
                                     1,178.00
                                     ========
```

Form 1040 **U.S. Individual Income Tax Return** **2008** (99) IRS Use Only - Do not write or staple in this space.

For the year Jan. 1-Dec. 31, 2008, or other tax year beginning _____ , 2008, ending _____ , 20 ___ OMB No. 1545-0074

Label

(See instructions on page 14.)

Use the IRS label.

Otherwise, please print or type.

Your first name and initial	Last name	Your social security number
Guy	Focal	444 55 6666
If a joint return, spouse's first name and initial	Last name	Spouse's social security number
Mary	Focal	555 66 7777

Home address (number and street). If you have a P.O. box, see page 14. Apt. no. **You must enter ▲ your SSN(s) above. ▲**

Camp Place

City, town or post office, state, and ZIP code. If you have a foreign address, see page 14.

New Orleans, LA 70130

Checking a box below will not change your tax or refund.

Presidential Election Campaign ▶ Check here if you, or your spouse if filing jointly, want $3 to go to this fund (see page 14) ▶ □ You □ Spouse

Filing Status

Check only one box.

1. □ Single
2. ☒ Married filing jointly (even if only one had income)
3. □ Married filing separately. Enter spouse's SSN above and full name here. ▶
4. □ Head of household (with qualifying person). If the qualifying person is a child but not your dependent, enter this child's name here. ▶
5. □ Qualifying widow(er) with dependent child (see page 16)

Exemptions

6a ☒ Yourself. If someone can claim you as a dependent, **do not** check box 6a Boxes checked on 6a and 6b **2**

b ☒ Spouse

c Dependents:

(1) First name Last name	(2) Dependent's social security number	(3) Dependent's relationship to you	(4) ✓ if qualifying child for child tax credit (see page 17)

No. of children on 6c who:
- lived with you
- did not live with you due to divorce or separation (see page 18)

Dependents on 6c not entered above

If more than four dependents, see page 17.

d Total number of exemptions claimed Add numbers on lines above ▶ **2**

Income

Attach Form(s) W-2 here. Also attach Forms W-2G and 1099-R if tax was withheld.

If you did not get a W-2, see page 21.

Enclose, but do not attach, any payment. Also, please use Form 1040-V.

7	Wages, salaries, tips, etc. Attach Form(s) W-2	7	90,640.		
8a	Taxable interest. Attach Schedule B if required	8a	147.		
b	Tax-exempt interest. Do not include on line 8a	8b			
9a	Ordinary dividends. Attach Schedule B if required	9a			
b	Qualified dividends (see page 21)	9b			
10	Taxable refunds, credits, or offsets of state and local income taxes	10			
11	Alimony received	11			
12	Business income or (loss). Attach Schedule C or C-EZ	12	3,443.		
13	Capital gain or (loss). Attach Schedule D if required. If not required, check here ▶ □	13			
14	Other gains or (losses). Attach Form 4797	14			
15a	IRA distributions	15a	b Taxable amount	15b	
16a	Pensions and annuities	16a	b Taxable amount	16b	
17	Rental real estate, royalties, partnerships, S corporations, trusts, etc. Attach Schedule E	17			
18	Farm income or (loss). Attach Schedule F	18			
19	Unemployment compensation	19			
20a	Social security benefits	20a	b Taxable amount (see page 26)	20b	
21	Other income. List type and amount (see page 28)	21			
22	Add the amounts in the far right column for lines 7 through 21. This is your **total income** ▶	22	94,230.		

Adjusted Gross Income

23	Educator expenses (see page 28)	23	
24	Certain business expenses of reservists, performing artists, and fee-basis government officials. Attach Form 2106 or 2106-EZ	24	
25	Health savings account deduction. Attach Form 8889	25	
26	Moving expenses. Attach Form 3903	26	
27	One-half of self-employment tax. Attach Schedule SE	27	244.
28	Self-employed SEP, SIMPLE, and qualified plans	28	
29	Self-employed health insurance deduction (see page 29)	29	
30	Penalty on early withdrawal of savings	30	
31a	Alimony paid b Recipient's SSN ▶	31a	
32	IRA deduction (see page 30)	32	
33	Student loan interest deduction (see page 33)	33	
34	Tuition and fees deduction. Attach Form 8917	34	
35	Domestic production activities deduction. Attach Form 8903	35	
36	Add lines 23 through 31a and 32 through 35	36	244.
37	Subtract line 36 from line 22. This is your **adjusted gross income** ▶	37	93,986.

810001 11-10-08

LHA For Disclosure, Privacy Act, and Paperwork Reduction Act Notice, see page 88. Form **1040** (2008)

Form 1040 (2008)	Guy & Mary Focal			444-55-6666		Page **2**

Tax and Credits	38	Amount from line 37 (adjusted gross income)			38	93,986.

Standard Deduction for –

- **People who checked any box on line 39a, 39b, or 39c or who can be claimed as a dependent.**

- **All others:**

Single or Married filing separately, $5,450

Married filing jointly or Qualifying widow(er), $10,900

Head of household, $8,000

	39a	Check if:	You were born before January 2, 1944, ☐ Blind. **Total boxes** Spouse was born before January 2, 1944, ☐ Blind. checked ▶ 39a			
	b	If your spouse itemizes on a separate return or you were a dual-status alien, see page 34 and check here ▶ 39b ☐				
	c	Check if standard deduction includes real estate taxes or disaster loss (see page 34) ▶ 39c ☐				
	40	Itemized deductions (from Schedule A) **or your standard deduction** (see left margin)			40	13,173.
	41	Subtract line 40 from line 38			41	80,813.
	42	If line 38 is over $119,975, or you provided housing to a Midwestern displaced individual, see page 36. Otherwise, multiply $3,500 by the total number of exemptions claimed on line 6d			42	7,000.
	43	**Taxable income.** Subtract line 42 from line 41. If line 42 is more than line 41, enter -0-			43	73,813.
	44	**Tax.** Check if any tax is from: a ☐ Form(s) 8814 b ☐ Form 4972			44	11,144.
	45	**Alternative minimum tax. Attach Form 6251**			45	0.
	46	Add lines 44 and 45		▶	46	11,144.
	47	Foreign tax credit. Attach Form 1116 if required	47			
	48	Credit for child and dependent care expenses. Attach Form 2441	48			
	49	Credit for the elderly or the disabled. Attach Schedule R	49			
	50	Education credits. Attach Form 8863	50			
	51	Retirement savings contributions credit. Attach Form 8880	51			
	52	Child tax credit (see page 42). Attach Form 8901 if required	52			
	53	Credits from Form: a ☐ 8396 b ☐ 8839 c ☐ 5695	53			
	54	Other credits from Form: a ☐ 3800 b ☐ 8801 c ☐	54			
	55	Add lines 47 through 54. These are your **total credits**			55	
	56	Subtract line 55 from line 46. If line 55 is more than line 46, enter -0-		▶	56	11,144.

Other Taxes	57	Self-employment tax. Attach Schedule SE			57	487.
	58	Unreported social security and Medicare tax from Form: a ☐ 4137 b ☐ 8919			58	
	59	Additional tax on IRAs, other qualified retirement plans, etc. Attach Form 5329 if required			59	
	60	Additional taxes: a ☐ AEIC payments b ☐ Household employment taxes. Attach Schedule H			60	
	61	Add lines 56 through 60. This is your **total tax**		▶	61	11,631.

Payments	62	Federal income tax withheld from Forms W-2 and 1099	62	13,269.		
	63	2008 estimated tax payments and amount applied from 2007 return	63			
If you have a qualifying child, attach Schedule EIC.	64a	**Earned income credit (EIC)**	64a			
	b	Nontaxable combat pay election ▶ 64b				
	65	Excess social security and tier 1 RRTA tax withheld (see page 61)	65			
	66	Additional child tax credit. Attach Form 8812	66			
	67	Amount paid with request for extension to file (see page 61)	67			
	68	Credits from Form: a ☐ 2439 b ☐ 4136 c ☐ 8801 d ☐ 8885	68			
	69	First-time homebuyer credit. Attach Form 5405	69			
	70	Recovery rebate credit (see worksheet on pages 62 and 63)	70			
	71	Add lines 62 through 70. These are your **total payments**		▶	71	13,269.

Refund	72	If line 71 is more than line 61, subtract line 61 from line 71. This is the amount you **overpaid**			72	1,638.
Direct deposit? See page 63 and fill in 73b, 73c, and 73d, or Form 8888.	73a	Amount of line 72 you want **refunded to you.** If Form 8888 is attached, check here ▶ ☐			73a	1,638.
	b	Routing number	c	Type: ☐ Checking ☐ Savings	d Account number	
	74	Amount of line 72 you want **applied to your 2009 estimated tax** ▶	74			

Amount You Owe	75	**Amount you owe.** Subtract line 71 from line 61. For details on how to pay, see page 65		▶	75	
	76	Estimated tax penalty (see page 65)	76			

Third Party Designee	Do you want to allow another person to discuss this return with the IRS (see page 66)? ☒ **Yes.** Complete the following. ☐ No		
	Designee's name ▶ Preparer	Phone no. ▶	Personal identification number (PIN)

Sign Here	Under penalties of perjury, I declare that I have examined this return and accompanying schedules and statements, and to the best of my knowledge and belief, they are true, correct, and complete. Declaration of preparer (other than taxpayer) is based on all information of which preparer has any knowledge.			
Joint return? See page 15. Keep a copy for your records.	Your signature	Date	Your occupation Writer	Daytime phone number
	Spouse's signature. If a joint return, **both** must sign.	Date	Spouse's occupation Teacher	

Paid Preparer's Use Only	Preparer's signature ▶ Peter Jason Riley, CPA	Date 12/13/09	Check if self-employed ☐	Preparer's SSN or PTIN P00413102
810002 11-10-08	Firm's name (or yours if self-employed), address, and ZIP code	Riley & Associates, P.C. P.O. Box 157 Newburyport, MA 01950-0157	EIN 04-3577120 Phone no. 978-463-9350	

SCHEDULES A&B (Form 1040)	**Schedule A - Itemized Deductions**	OMB No. 1545-0074

SCHEDULES A&B
(Form 1040)
Department of the Treasury
Internal Revenue Service (99)

Schedule A - Itemized Deductions
(Schedule B is on page 2)
► **Attach to Form 1040.** ► **See Instructions for Schedules A&B (Form 1040).**

OMB No. 1545-0074
2008
Attachment
Sequence No. **07**

Name(s) shown on Form 1040

Guy & Mary Focal

Your social security number

444 55 6666

Medical and Dental Expenses		Caution. Do not include expenses reimbursed or paid by others.			
	1	Medical and dental expenses (see page A-1)		1	
	2	Enter amount from Form 1040, line 38 ...	2		
	3	Multiply line 2 by 7.5% (.075)		3	
	4	Subtract line 3 from line 1. If line 3 is more than line 1, enter -0-		4	
Taxes You Paid (See page A-2.)	5	State and local **(check only one box):** a [X] Income taxes, or b [] General sales taxes		5	4,329.
	6	Real estate taxes (see page A-5)		6	2,704.
	7	Personal property taxes		7	
	8	Other taxes. List type and amount ►		8	
	9	Add lines 5 through 8		9	7,033.
Interest You Paid (See page A-5.) **Note.** Personal interest is not deductible.	10	Home mortgage interest and points reported to you on Form 1098 Stmt 1	10		5,515.
	11	Home mortgage interest not reported to you on Form 1098. If paid to the person from whom you bought the home, see page A-6 and show that person's name, identifying no., and address ►	11		
	12	Points not reported to you on Form 1098	12		
	13	Qualified mortgage insurance premiums (See page A-6)	13		
	14	Investment interest. Attach Form 4952 if required. (See page A-6.)	14		
	15	Add lines 10 through 14		15	5,515.
Gifts to Charity If you made a gift and got a benefit for it, see page A-7.	16	Gifts by cash or check	16		375.
	17	Other than by cash or check. If any gift of $250 or more, see page A-8. You **must** attach Form 8283 if over $500	17		250.
	18	Carryover from prior year	18		
	19	Add lines 16 through 18		19	625.
Casualty and Theft Losses	20	Casualty or theft loss(es). Attach Form 4684. (See page A-8.)		20	
Job Expenses and Certain Miscellaneous Deductions (See page A-9.)	21	Unreimbursed employee expenses - job travel, union dues, job education, etc. Attach Form 2106 or 2106-EZ if required. (See page A-9.) ►From Form 2106-EZ 1,856.	21	1,856.	
	22	Tax preparation fees	22		
	23	Other expenses - investment, safe deposit box, etc. List type and amount ►	23		
	24	Add lines 21 through 23	24	1,856.	
	25	Enter amount from Form 1040, line 38	25 93,986.		
	26	Multiply line 25 by 2% (.02)	26	1,880.	
	27	Subtract line 26 from line 24. If line 26 is more than line 24, enter -0-		27	0.
Other Miscellaneous Deductions	28	Other - from list on page A-10. List type and amount ►		28	
Total Itemized Deductions	29	Is Form 1040, line 38, over $159,950 (over $79,975 if married filing separately)? [X] **No.** Your deduction is not limited. Add the amounts in the far right column for lines 4 through 28. Also, enter this amount on Form 1040, line 40. [] **Yes.** Your deduction may be limited. See page A-10 for the amount to enter.	►	29	13,173.
	30	If you elect to itemize deductions even though they are less than your standard deduction, check here ► []			

LHA 819501 11-10-08 **For Paperwork Reduction Act Notice, see Form 1040 instructions.** Schedule A (Form 1040) 2008

3

Schedules A&B (Form 1040) 2008 OMB No. 1545-0074 Page **2**

Name(s) shown on Form 1040. Do not enter name and social security number if shown on page 1. Your social security number

Guy & Mary Focal 444 55 6666

Schedule B - Interest and Ordinary Dividends Attachment Sequence No. **08**

			Amount
Part I **Interest**	1	List name of payer. If any interest is from a seller-financed mortgage and the buyer used the property as a personal residence, see page B-1 and list this interest first. Also, show that buyer's social security number and address ▶	
		Bank of Louisiana	147.
Note. If you received a Form 1099-INT, Form 1099-OID, or substitute statement from a brokerage firm, list the firm's name as the payer and enter the total interest shown on that form.	1		
	2	Add the amounts on line 1	**2** 147.
	3	Excludable interest on series EE and I U.S. savings bonds issued after 1989. Attach Form 8815	**3**
	4	Subtract line 3 from line 2. Enter the result here and on Form 1040, line 8a ▶	**4** 147.

Note. If line 4 is over $1,500, you must complete Part III.

			Amount
Part II **Ordinary Dividends**	5	List name of payer ▶	
Note: If you received a Form 1099-DIV or substitute statement from a brokerage firm, list the firm's name as the payer and enter the ordinary dividends shown on that form.	5		
	6	Add the amounts on line 5. Enter the total here and on Form 1040, line 9a ▶	**6**

Note. If line 6 is over $1,500, you must complete Part III.

			Yes	No
Part III **Foreign Accounts and Trusts**		You must complete this part if you **(a)** had over $1,500 of taxable interest or ordinary dividends; or **(b)** had a foreign account; or **(c)** received a distribution from, or were a grantor of, or a transferor to, a foreign trust.		
	7a	At any time during 2008, did you have an interest in or a signature or other authority over a financial account in a foreign country, such as a bank account, securities account, or other financial account? See page B-2 for exceptions and filing requirements for Form TD F 90-22.1		X
	b	If "Yes," enter the name of the foreign country ▶		
	8	During 2008, did you receive a distribution from, or were you the grantor of, or transferor to, a foreign trust? If "Yes," you may have to file Form 3520. See page B-2		X

827501 11-11-08

LHA **For Paperwork Reduction Act Notice, see Form 1040 instructions.** Schedule B (Form 1040) 2008

4

SCHEDULE C
(Form 1040)
Department of the Treasury
Internal Revenue Service (99)

Profit or Loss From Business
(Sole Proprietorship)
► **Partnerships, joint ventures, etc., generally must file Form 1065 or 1065-B.**
► **Attach to Form 1040, 1040NR, or 1041.** ►**See Instructions for Schedule C (Form 1040).**

OMB No. 1545-0074

2008

Attachment
Sequence No. **09**

Name of proprietor	Social security number (SSN)
Guy Focal	444-55-6666

A Principal business or profession, including product or service (see page C-3)
Writer

B Enter code from pages C-9, 10, & 11 ► 711510

C Business name. If no separate business name, leave blank.
Guy Focal

D Employer ID number (EIN), if any

E Business address (including suite or room no.) ► Camp Place
City, town or post office, state, and ZIP code New Orleans, LA 70130

F Accounting method: (1) [X] Cash (2) ☐ Accrual (3) ☐ Other (specify) ► _____

G Did you "materially participate" in the operation of this business during 2008? If "No," see page C-4 for limit on losses [X] Yes ☐ No

H If you started or acquired this business during 2008, check here ► ☐

Part I Income

1	Gross receipts or sales. **Caution.** See page C-4 and check the box if:		
	• This income was reported to you on Form W-2 and the "Statutory employee" box on that form was checked, or		
	• You are a member of a qualified joint venture reporting only rental real estate income not subject to self-employment tax. Also see page C-4 for limit on losses. ► ☐	1	22,744.
2	Returns and allowances	2	
3	Subtract line 2 from line 1	3	22,744.
4	Cost of goods sold (from line 42 on page 2)	4	2,757.
5	**Gross profit.** Subtract line 4 from line 3	5	19,987.
6	Other income, including federal and state gasoline or fuel tax credit or refund (see page C-4) See Statement 2	6	350.
7	**Gross income.** Add lines 5 and 6 ►	7	20,337.

Part II Expenses. Enter expenses for business use of your home **only** on line 30.

8	Advertising	8		18	Office expense	18	187.
9	Car and truck expenses			19	Pension and profit-sharing plans	19	
	(see page C-5)	9	1,253.	20	Rent or lease (see page C-6):		
10	Commissions and fees	10	1,520.	a	Vehicles, machinery, and equipment	20a	
11	Contract labor			b	Other business property	20b	
	(see page C-5)	11		21	Repairs and maintenance	21	120.
12	Depletion	12		22	Supplies (not included in Part III)	22	288.
13	Depreciation and section 179			23	Taxes and licenses	23	
	expense deduction (not included in			24	Travel, meals, and entertainment:		
	Part III) (see page C-5)	13	2,516.	a	Travel	24a	3,940.
14	Employee benefit programs (other			b	Deductible meals and		
	than on line 19)	14			entertainment (see page C-7)	24b	337.
15	Insurance (other than health)	15		25	Utilities	25	
16	Interest:			26	Wages (less employment credits)	26	
a	Mortgage (paid to banks, etc.)	16a		27	Other expenses (from line 48 on		
b	Other	16b			page 2)	27	3,106.
17	Legal and professional						
	services	17	250.				

28	**Total expenses** before expenses for business use of home. Add lines 8 through 27 ►	28	13,517.
29	Tentative profit or (loss). Subtract line 28 from line 7	29	6,820.
30	Expenses for business use of your home. Attach Form 8829	30	3,377.
31	**Net profit or (loss).** Subtract line 30 from line 29.		
	• If a profit, enter on both **Form 1040, line 12,** and **Schedule SE, line 2,** or on **Form 1040NR, line 13** (if you checked the box on line 1, see page C-7). Estates and trusts, enter on **Form 1041, line 3.**	31	3,443.
	• If a loss, you **must** go to line 32.		
32	If you have a loss, check the box that describes your investment in this activity (see page C-8).		
	• If you checked 32a, enter the loss on both **Form 1040, line 12,** and **Schedule SE, line 2,** or on **Form 1040NR, line 13** (if you checked the box on line 1, see the line 31 instructions on page C-7). Estates and trusts, enter on **Form 1041, line 3.**	32a ☐ All investment is at risk.	
	• If you checked 32b, you **must** attach **Form 6198.** Your loss may be limited.	32b ☐ Some investment is not at risk.	

LHA **For Paperwork Reduction Act Notice, see page C-9 of the instructions.**

Schedule C (Form 1040) 2008

820001 11-20-08

Schedule C (Form 1040) 2008 **GUY FOCAL** 444-55-6666 Page **2**

Part III | Cost of Goods Sold (see page C-8)

33 Method(s) used to
 value closing inventory: **a** ☐ Cost **b** ☐ Lower of cost or market **c** ☐ Other (attach explanation)

34 Was there any change in determining quantities, costs, or valuations between opening and closing inventory? If
 "Yes," attach explanation .. ☐ Yes ☐ No

35	Inventory at beginning of year. If different from last year's closing inventory, attach explanation	35	
36	Purchases less cost of items withdrawn for personal use	36	
37	Cost of labor. Do not include any amounts paid to yourself	37	
38	Materials and supplies	38	
39	Other costs See Statement 3	39	2,757.
40	Add lines 35 through 39	40	2,757.
41	Inventory at end of year	41	
42	**Cost of goods sold.** Subtract line 41 from line 40. Enter the result here and on page 1, line 4	42	2,757.

Part IV | Information on Your Vehicle. Complete this part **only** if you are claiming car or truck expenses on line 9 and are not required
to file Form 4562 for this business. See the instructions for line 13 on page C-5 to find out if you must file Form 4562.

43 When did you place your vehicle in service for business purposes? (month, day, year) ▶ ___ / ___ / ___ .

44 Of the total number of miles you drove your vehicle during 2008, enter the number of miles you used your vehicle for:

 a Business _____ **b** Commuting _____ **c** Other _____

45 Was your vehicle available for personal use during off-duty hours? .. ☐ Yes ☐ No

46 Do you (or your spouse) have another vehicle available for personal use? ☐ Yes ☐ No

47 a Do you have evidence to support your deduction? ... ☐ Yes ☐ No
 b If "Yes," is the evidence written? .. ☐ Yes ☐ No

Part V | Other Expenses. List below business expenses not included on lines 8-26 or line 30.

Merchant Accounts Fees (website)	143.
Image Scanning	395.
ISP	205.
Publications	877.
Research - DVDs, etc	204.
Dues	305.
Cell & Telephone	287.
Postage & Shipping	381.
Amortization	309.

48 **Total other expenses.** Enter here and on page 1, line 27 ... 48 | 3,106.

820002 11-20-08 Schedule C (Form 1040) 2008

2008 DEPRECIATION AND AMORTIZATION REPORT
Guy Focal

SCHEDULE C - 1

Asset No.	Description	Date Acquired	Method	Life	Line No.	Unadjusted Cost Or Basis	Bus % Excl	Reduction In Basis	Basis For Depreciation	Accumulated Depreciation	Current Sec 179	Current Year Deduction
2	Website Costs	070108		36M	42	1,850.			1,850.			309.
3	Computer/Technology Equipment	070105	200DB	5.00	17	3,941.			3,941.	2,877.		426.
4	Electrical Upgrades	070108	200DB	5.00	19B	833.			833.			167.
5	Cable Modem	070108	200DB	5.00	19B	129.			129.			26.
6	Library (historical books)	070108	SL	5.00	16	6,480.			6,480.			648.
34	Notebook Computer	070108	200DB	5.00	19B	1,249.		1,249.	0.		1249.	1,249.
	Total Sch C Depr. & Amortization					14,482.		1,249.	13,233.	2,877.	1249.	2,825.
	Current Year Activity											
	Beginning balance					3,941.		0.	3,941.	2,877.		
	Acquisitions					10,541.		1,249.	9,292.	0.		
	Dispositions					0.		0.	0.	0.		
	Ending balance					14,482.		1,249.	13,233.	2,877.		

(D) - Asset disposed

* ITC, Section 179, Salvage, Bonus, Commercial Revitalization Deduction, GO Zone

6.1

828102
04-25-08

SCHEDULE SE		OMB No. 1545-0074

SCHEDULE SE
(Form 1040)
Department of the Treasury
Internal Revenue Service (99)

Self-Employment Tax

▶ **Attach to Form 1040.** ▶ **See Instructions for Schedule SE (Form 1040).**

OMB No. 1545-0074

2008

Attachment
Sequence No. **17**

Name of person with **self-employment** income (as shown on Form 1040)	Social security number of person with **self-employment** income ▶	444 55 6666

Guy Focal

Who Must File Schedule SE

You must file Schedule SE if:

- You had net earnings from self-employment from **other than** church employee income (line 4 of Short Schedule SE or line 4c of Long Schedule SE) of $400 or more, **or**
- You had church employee income of $108.28 or more. Income from services you performed as a minister or a member of a religious order **is not** church employee income (see page SE-1).

Note. Even if you had a loss or a small amount of income from self-employment, it may be to your benefit to file Schedule SE and use either "optional method" in Part II of Long Schedule SE (see page SE-4).

Exception. If your only self-employment income was from earnings as a minister, member of a religious order, or Christian Science practitioner **and** you filed Form 4361 and received IRS approval not to be taxed on those earnings, **do not** file Schedule SE. Instead, write "Exempt-Form 4361" on Form 1040, line 57.

May I Use Short Schedule SE or Must I Use Long Schedule SE?

Note. Use this flowchart **only if** you must file Schedule SE. If unsure, see *Who Must File Schedule SE,* above.

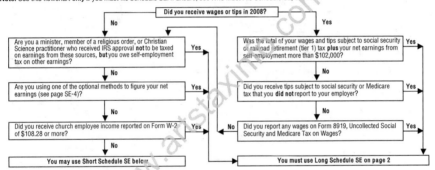

Section A-Short Schedule SE. Caution. Read above to see if you can use Short Schedule SE.

1a	Net farm profit or (loss) from Schedule F, line 36, and farm partnerships, Schedule K-1 (Form 1065), box 14, code A	**1a**	
b	If you received social security retirement or disability benefits, enter the amount of Conservation Reserve Program payments included on Schedule F, line 6b, or listed on Schedule K-1 (Form 1065), box 20, code X	**1b**	
2	Net profit or (loss) from Schedule C, line 31; Schedule C-EZ, line 3; Schedule K-1 (Form 1065), box 14, code A (other than farming); and Schedule K-1 (Form 1065-B), box 9, code J1. Ministers and members of religious orders, see pg SE-1 for types of income to report on this line. See pg SE-3 for other income to report Stmt 4	**2**	3,443.
3	Combine lines 1a, 1b, and 2	**3**	3,443.
4	**Net earnings from self-employment.** Multiply line 3 by 92.35% (.9235). If less than $400, **do not** file this schedule; you do not owe self-employment tax ▶	**4**	3,180.
5	**Self-employment tax.** If the amount on line 4 is:		
	• $102,000 or less, multiply line 4 by 15.3% (.153). Enter the result here and on **Form 1040, line 57.**		
	• More than $102,000, multiply line 4 by 2.9% (.029). Then, add $12,648 to the result. Enter the total here and on **Form 1040, line 57**	**5**	487.
6	**Deduction for one-half of self-employment tax.** Multiply line 5 by 50% (.5). Enter the result here and on **Form 1040, line 27** **6**	244.	

LHA **For Paperwork Reduction Act Notice, see Form 1040 instructions.**

Schedule SE (Form 1040) 2008

824501
11-11-08

Does not apply

Form 6251

Department of the Treasury
Internal Revenue Service (99)

Alternative Minimum Tax - Individuals

▶ Attach to Form 1040 or Form 1040NR.

OMB No. 1545-0074

2008

Attachment Sequence No. **32**

Name(s) shown on Form 1040 or Form 1040NR

Guy & Mary Focal

Your social security number

444 55 6666

Part I Alternative Minimum Taxable Income

1	If filing Schedule A (Form 1040), enter the amount from Form 1040, line 41 (minus any amount on Form 8914, line 2), and go to line 2. Otherwise, enter the amount from Form 1040, line 38 (minus any amount on Form 8914, line 2), and go to line 7. (If less than zero, enter as a negative amount.)	**1** 80,813.
2	Medical and dental. Enter the **smaller** of Schedule A (Form 1040), line 4, **or** 2.5% (.025) of Form 1040, line 38. If zero or less, enter -0-	**2**
3	Taxes from Schedule A (Form 1040), line 9	**3** 7,033.
4	Enter the home mortgage interest adjustment, if any, from line 6 of the worksheet on page 2 of the instructions	**4**
5	Miscellaneous deductions from Schedule A (Form 1040), line 27	**5**
6	If Form 1040, line 38, is over $159,950 (over $79,975 if married filing separately), enter the amount from line 11 of the **Itemized Deductions Worksheet** on page A-10 of the instructions for Schedule A (Form 1040)	**6**
7	If claiming the standard deduction, enter any amount from Form 4684, line 18a, as a negative amount	**7**
8	Tax refund from Form 1040, line 10 or line 21	**8**
9	Investment interest expense (difference between regular tax and AMT)	**9**
10	Depletion (difference between regular tax and AMT)	**10**
11	Net operating loss deduction from Form 1040, line 21. Enter as a positive amount	**11**
12	Interest from specified private activity bonds exempt from the regular tax	**12**
13	Qualified small business stock (7% of gain excluded under section 1202)	**13**
14	Exercise of incentive stock options (excess of AMT income over regular tax income)	**14**
15	Estates and trusts (amount from Schedule K-1 (Form 1041), box 12, code A)	**15**
16	Electing large partnerships (amount from Schedule K-1 (Form 1065-B), box 6)	**16**
17	Disposition of property (difference between AMT and regular tax gain or loss)	**17**
18	Depreciation on assets placed in service after 1986 (difference between regular tax and AMT) Stmt 5	**18** -181.
19	Passive activities (difference between AMT and regular tax income or loss)	**19**
20	Loss limitations (difference between AMT and regular tax income or loss)	**20**
21	Circulation costs (difference between regular tax and AMT)	**21**
22	Long-term contracts (difference between AMT and regular tax income)	**22**
23	Mining costs (difference between regular tax and AMT)	**23**
24	Research and experimental costs (difference between regular tax and AMT)	**24**
25	Income from certain installment sales before January 1, 1987	**25**
26	Intangible drilling costs preference	**26**
27	Other adjustments, including income-based related adjustments	**27**
28	Alternative tax net operating loss deduction	**28**
29	**Alternative minimum taxable income.** Combine lines 1 through 28. (If married filing separately and line 29 is more than $214,900, see instructions.)	**29** 87,665.

Part II Alternative Minimum Tax (AMT)

30	Exemption. (If you were under age 24 at the end of 2008, see instructions.)	

IF your filing status is...	AND line 29 is not over...	THEN enter on line 30...
Single or head of household	$112,500	$46,200
Married filing jointly or qualifying widow(er)	150,000	69,950
Married filing separately	75,000	34,975

	If line 29 is **over** the amount shown above for your filing status, see instructions.	**30** 69,950.
31	Subtract line 30 from line 29. If more than zero, go to line 32. If zero or less, enter -0- here and on lines 34 and 36 and skip the rest of Part II	**31** 17,715.
32	• If you are filing Form 2555 or 2555-EZ, see page 9 of the instructions for the amount to enter. • If you reported capital gain distributions directly on Form 1040, line 13; you reported qualified dividends on Form 1040, line 9b; **or** you had a gain on both lines 15 and 16 of Schedule D (Form 1040) (as refigured for the AMT, if necessary), complete Part III on page 2 and enter the amount from line 55 here. • **All others:** If line 31 is $175,000 or less ($87,500 or less if married filing separately), multiply line 31 by 26% (.26). Otherwise, multiply line 31 by 28% (.28) and subtract $3,500 ($1,750 if married filing separately) from the result.	**32** 4,606.
33	Alternative minimum tax foreign tax credit (see instructions)	**33**
34	Tentative minimum tax. Subtract line 33 from line 32	**34** 4,606.
35	Tax from Form 1040, line 44 (minus any tax from Form 4972 and any foreign tax credit from Form 1040, line 47). If you used Sch J to figure your tax, the amount from line 44 of Form 1040 must be refigured without using Sch J	**35** 11,144.
36	**AMT.** Subtract line 35 from line 34. If zero or less, enter -0-. Enter here and on Form 1040, line 45	**36** 0.

819481 12-02-08 LHA **For Paperwork Reduction Act Notice, see instructions.** Form **6251** (2008)

8

Form 6251 (2008) **Guy & Mary Focal** 444-55-6666 Page **2**

| **Part III** | **Tax Computation Using Maximum Capital Gains Rates** |

37 Enter the amount from Form 6251, line 31. If you are filing Form 2555 or 2555-EZ, enter the amount from line 3 of the worksheet in the instructions .. | **37** |

38 Enter the amount from line 6 of the Qualified Dividends and Capital Gain Tax Worksheet in the instructions for Form 1040, line 44, or the amount from line 13 of the Schedule D Tax Worksheet on page D-10 of the instructions for Schedule D (Form 1040), whichever applies (as refigured for the AMT, if necessary) (see the instructions). If you are filing Form 2555 or 2555-EZ, see instructions for the amount to enter | **38** |

39 Enter the amount from Schedule D (Form 1040), line 19 (as refigured for the AMT, if necessary) (see instructions). If you are filing Form 2555 or 2555-EZ, see instructions for the amount to enter | **39** |

40 If you did not complete a Schedule D Tax Worksheet for the regular tax or the AMT, enter the amount from line 38. Otherwise, add lines 38 and 39, and enter the **smaller** of that result or the amount from line 10 of the Schedule D Tax Worksheet (as refigured for the AMT, if necessary). If you are filing Form 2555 or 2555-EZ, see instructions for the amount to enter | **40** |

41 Enter the **smaller** of line 37 or line 40 ... | **41** |

42 Subtract line 41 from line 37 .. | **42** |

43 If line 42 is $175,000 or less ($87,500 or less if married filing separately), multiply line 42 by 26% (.26). Otherwise, multiply line 42 by 28% (.28) and subtract $3,500 ($1,750 if married filing separately) from the result ... ▶ | **43** |

44 Enter:
- $65,100 if married filing jointly or qualifying widow(er),
- $32,550 if single or married filing separately, or
- $43,650 if head of household. | **44** |

45 Enter the amount from line 7 of the Qualified Dividends and Capital Gain Tax Worksheet in the instructions for Form 1040, line 44, or the amount from line 14 of the Schedule D Tax Worksheet on page D-10 of the instructions for Schedule D (Form 1040), whichever applies (as figured for the regular tax). If you did not complete either worksheet for the regular tax, enter -0- | **45** |

46 Subtract line 45 from line 44. If zero or less, enter -0- .. | **46** |

47 Enter the **smaller** of line 37 or line 38 .. | **47** |

48 Enter the **smaller** of line 46 or line 47 .. | **48** |

49 Subtract line 48 from line 47 .. | **49** |

50 Multiply line 49 by 15% (.15) .. ▶ | **50** |

If line 39 is zero or blank, skip lines 51 and 52 and go to line 53. Otherwise, go to line 51.

51 Subtract line 47 from line 41 .. | **51** |

52 Multiply line 51 by 25% (.25) .. ▶ | **52** |

53 Add lines 43, 50, and 52 .. | **53** |

54 If line 37 is $175,000 or less ($87,500 or less if married filing separately), multiply line 37 by 26% (.26). Otherwise, multiply line 37 by 28% (.28) and subtract $3,500 ($1,750 if married filing separately) from the result ... | **54** |

55 Enter the **smaller** of line 53 or line 54 here and on line 32. If you are filing Form 2555 or 2555-EZ, do not enter this amount on line 32. Instead, enter it on line 4 of the worksheet in the instructions | **55** |

Form **6251** (2008)

819591
12-02-08

9

Form **8829**	**Expenses for Business Use of Your Home**	OMB No. 1545-0074
Department of the Treasury Internal Revenue Service (99)	▶ File only with Schedule C (Form 1040). Use a separate Form 8829 for each home you used for business during the year.	**2008** Attachment Sequence No. **66**

Name(s) of proprietor(s)	Your social security number
Guy Focal	444-55-6666

Part I Part of Your Home Used for Business

1	Area used regularly and exclusively for business, regularly for daycare, or for storage of inventory or product samples	1	236
2	Total area of home	2	1,688
3	Divide line 1 by line 2. Enter the result as a percentage	3	13.9810%
	For daycare facilities not used exclusively for business, go to line 4. All others go to line 7.		
4	Multiply days used for daycare during year by hours used per day	4 hr.	
5	Total hours available for use during the year (366 days x 24 hours)	5 hr.	
6	Divide line 4 by line 5. Enter the result as a decimal amount	6	
7	Business percentage. For daycare facilities not used exclusively for business, multiply line 6 by line 3 (enter the result as a percentage). All others, enter the amount from line 3 ▶	7	13.9810%

Part II Figure Your Allowable Deduction

			(a) Direct expenses	(b) Indirect expenses		
8	Enter the amount from Schedule C, line 29, **plus** any net gain or (loss) derived from the business use of your home and shown on Schedule D or Form 4797. If more than one place of business, see instructions				8	6,820.
	See instructions for columns (a) and (b) before completing lines 9-21.					
9	Casualty losses	9				
10	Deductible mortgage interest	10		6,411.		
11	Real estate taxes	11		3,144.		
12	Add lines 9, 10, and 11	12		9,555.		
13	Multiply line 12, column (b) by line 7	13		1,336.		
14	Add line 12, column (a) and line 13				14	1,336.
15	Subtract line 14 from line 8. If zero or less, enter -0-				15	5,484.
16	Excess mortgage interest	16				
17	Insurance	17		2,966.		
18	Rent	18				
19	Repairs and maintenance	19		841.		
20	Utilities	20		2,977.		
21	Other expenses	21				
22	Add lines 16 through 21	22		6,784.		
23	Multiply line 22, column (b) by line 7		23	948.		
24	Carryover of operating expenses from 2007 Form 8829, line 42		24			
25	Add line 22 column (a), line 23, and line 24				25	948.
26	Allowable operating expenses. Enter the smaller of line 15 or line 25				26	948.
27	Limit on excess casualty losses and depreciation. Subtract line 26 from line 15				27	4,536.
28	Excess casualty losses		28			
29	Depreciation of your home from line 41 below		29	1,093.		
30	Carryover of excess casualty losses and depreciation from 2007 Form 8829, line 43		30			
31	Add lines 28 through 30				31	1,093.
32	Allowable excess casualty losses and depreciation. Enter the **smaller** of line 27 or line 31				32	1,093.
33	Add lines 14, 26, and 32				33	3,377.
34	Casualty loss portion, if any, from lines 14 and 32. Carry amount to **Form 4684**, Section B				34	0.
35	**Allowable expenses for business use of your home.** Subtract line 34 from line 33. Enter here and on Schedule C, line 30. If your home was used for more than one business, see instructions ▶				35	3,377.

Part III Depreciation of Your Home

36	Enter the **smaller** of your home's adjusted basis or its fair market value	36	370,000.
37	Value of land included on line 36	37	65,000.
38	Basis of building. Subtract line 37 from line 36	38	305,000.
39	Business basis of building. Multiply line 38 by line 7	39	42,639.
40	Depreciation percentage	40	2.5640%
41	Depreciation allowable. Multiply line 39 by line 40. Enter here and on line 29 above	41	1,093.

Part IV Carryover of Unallowed Expenses to 2009

42	Operating expenses. Subtract line 26 from line 25. If less than zero, enter -0-	42	
43	Excess casualty losses and depreciation. Subtract line 32 from line 31. If less than zero, enter -0-	43	

820301
12-24-08 LHA **For Paperwork Reduction Act Notice, see instructions.** Form **8829** (2008)

11

2008 DEPRECIATION AND AMORTIZATION REPORT

Guy Focal

FORM 8829 - 1

Asset No.	Description	Date Acquired	Method	Life	Line No.	Unadjusted Cost Or Basis	Bus % Excl	Reduction In Basis*	Basis For Depreciation	Accumulated Depreciation	Current Sec 179	Current Year Deduction
18	Home	070103	SL	39.00	17	305,000.	.8602		305,000.			7,821.
	Less Exclusion					-262361.			-262361.			-6,728.
19	Land	070103	L			65,000.	.8602		65,000.			0.
	Less Exclusion					-55,913.			-55,913.			0.
	Total 8829 Depr. & Amortization					51,726.			51,726.			1,093.

826 t02
04-25-08

11.1

(D) - Asset disposed

* ITC, Section 179, Salvage, Bonus, Commercial Revitalization Deduction, GO Zone

Form **4562**	**Depreciation and Amortization**		OMB No. 1545-0172
Department of the Treasury Internal Revenue Service (99)	**(Including Information on Listed Property)** SUMMARY ▶ See separate instructions. ▶ Attach to your tax return.		**2008** Attachment Sequence No. **67**

Name(s) shown on return	Business or activity to which this form relates	Identifying number
Guy & Mary Focal	ALL BUSINESS ACTIVITIES	444-55-6666

Part I Election To Expense Certain Property Under Section 179 Note: *If you have any listed property, complete Part V before you complete Part I.*

1	Maximum amount. See the instructions for a higher limit for certain businesses	1	250,000.
2	Total cost of section 179 property placed in service (see instructions)	2	2,211.
3	Threshold cost of section 179 property before reduction in limitation	3	800,000.
4	Reduction in limitation. Subtract line 3 from line 2. If zero or less, enter -0-	4	0.
5	Dollar limitation for tax year. Subtract line 4 from line 1. If zero or less, enter -0-. If married filing separately, see instructions	5	250,000.

6	(a) Description of property	(b) Cost (business use only)	(c) Elected cost
	Notebook Computer	1,249.	1,249.

7	Listed property. Enter the amount from line 29	7		
8	Total elected cost of section 179 property. Add amounts in column (c), lines 6 and 7		8	1,249.
9	Tentative deduction. Enter the **smaller** of line 5 or line 8		9	1,249.
10	Carryover of disallowed deduction from line 13 of your 2007 Form 4562		10	
11	Business income limitation. Enter the smaller of business income (not less than zero) or line 5		11	95,332.
12	Section 179 expense deduction. Add lines 9 and 10, but do not enter more than line 11		12	1,249.
13	Carryover of disallowed deduction to 2009. Add lines 9 and 10, less line 12 ▶	13		

Note: *Do not use Part II or Part III below for listed property. Instead, use Part V.*

Part II Special Depreciation Allowance and Other Depreciation (Do not include listed property.)

14	Special depreciation for qualified property (other than listed property) placed in service during the tax year	14	
15	Property subject to section 168(f)(1) election	15	
16	Other depreciation (including ACRS)	16	

Part III MACRS Depreciation (Do not include listed property.) (See instructions.)

Section A

17	MACRS deductions for assets placed in service in tax years beginning before 2008	17	
18	If you are electing to group any assets placed in service during the tax year into one or more general asset accounts, check here ▶ ☐		

Section B - Assets Placed in Service During 2008 Tax Year Using the General Depreciation System

(a) Classification of property	(b) Month and year placed in service	(c) Basis for depreciation (business/investment use only - see instructions)	(d) Recovery period	(e) Convention	(f) Method	(g) Depreciation deduction	
19a	3-year property						
b	5-year property						
c	7-year property						
d	10-year property						
e	15-year property						
f	20-year property						
g	25-year property			25 yrs.		S/L	
h	Residential rental property	/		27.5 yrs.	MM	S/L	
		/		27.5 yrs.	MM	S/L	
i	Nonresidential real property	/		39 yrs.	MM	S/L	
		/			MM	S/L	

Section C - Assets Placed in Service During 2008 Tax Year Using the Alternative Depreciation System

20a	Class life					S/L	
b	12-year			12 yrs.		S/L	
c	40-year	/		40 yrs.	MM	S/L	

Part IV Summary (See instructions.)

21	Listed property. Enter amount from line 28	21	
22	**Total.** Add amounts from line 12, lines 14 through 17, lines 19 and 20 in column (g), and line 21. Enter here and on the appropriate lines of your return. Partnerships and S corporations - see instr.	22	
23	For assets shown above and placed in service during the current year, enter the portion of the basis attributable to section 263A costs	23	

816251
11-08-08 LHA **For Paperwork Reduction Act Notice, see separate instructions.** Form **4562** (2008)

Form **4562**	SCHEDULE C-1 **Depreciation and Amortization** (Including Information on Listed Property)	OMB No. 1545-0172 **2008**
Department of the Treasury Internal Revenue Service (99)	▶ See separate instructions. ▶ Attach to your tax return.	Attachment Sequence No. **67**

Name(s) shown on return	Business or activity to which this form relates	Identifying number
Guy & Mary Focal	Guy Focal	444-55-6666

Part I Election To Expense Certain Property Under Section 179 **Note:** *If you have any listed property, complete Part V before you complete Part I.*

1	Maximum amount. See the instructions for a higher limit for certain businesses	1	250,000.
2	Total cost of section 179 property placed in service (see instructions)	2	
3	Threshold cost of section 179 property before reduction in limitation	3	800,000.
4	Reduction in limitation. Subtract line 3 from line 2. If zero or less, enter -0-	4	
5	Dollar limitation for tax year. Subtract line 4 from line 1. If zero or less, enter -0-. If married filing separately, see instructions	5	

6	(a) Description of property	(b) Cost (business use only)	(c) Elected cost

7	Listed property. Enter the amount from line 29	7	
8	Total elected cost of section 179 property. Add amounts in column (c), lines 6 and 7	8	
9	Tentative deduction. Enter the **smaller** of line 5 or line 8	9	
10	Carryover of disallowed deduction from line 13 of your 2007 Form 4562	10	
11	Business income limitation. Enter the smaller of business income (not less than zero) or line 5	11	
12	Section 179 expense deduction. Add lines 9 and 10, but do not enter more than line 11	12	1,249.
13	Carryover of disallowed deduction to 2009. Add lines 9 and 10, less line 12 ▶	13	

Note: *Do not use Part II or Part III below for listed property. Instead, use Part V.*

Part II Special Depreciation Allowance and Other Depreciation (Do not include listed property.)

14	Special depreciation for qualified property (other than listed property) placed in service during the tax year	14	
15	Property subject to section 168(f)(1) election	15	
16	Other depreciation (including ACRS)	16	648.

Part III MACRS Depreciation (Do not include listed property.) (See instructions.)

Section A

17	MACRS deductions for assets placed in service in tax years beginning before 2008	17	426.
18	If you are electing to group any assets placed in service during the tax year into one or more general asset accounts, check here ▶ ☐		

Section B - Assets Placed in Service During 2008 Tax Year Using the General Depreciation System

(a) Classification of property	(b) Month and year placed in service	(c) Basis for depreciation (business/investment use only - see instructions)	(d) Recovery period	(e) Convention	(f) Method	(g) Depreciation deduction	
19a	3-year property						
b	5-year property		962.	5 Yrs.	HY	200DB	193.
c	7-year property						
d	10-year property						
e	15-year property						
f	20-year property						
g	25-year property			25 yrs.		S/L	
h	Residential rental property	/		27.5 yrs.	MM	S/L	
		/		27.5 yrs.	MM	S/L	
i	Nonresidential real property	/		39 yrs.	MM	S/L	
		/			MM	S/L	

Section C - Assets Placed in Service During 2008 Tax Year Using the Alternative Depreciation System

20a	Class life					S/L	
b	12-year			12 yrs.		S/L	
c	40-year	/		40 yrs.	MM	S/L	

Part IV Summary (See instructions.)

21	Listed property. Enter amount from line 28	21	
22	**Total.** Add amounts from line 12, lines 14 through 17, lines 19 and 20 in column (g), and line 21. Enter here and on the appropriate lines of your return. Partnerships and S corporations - see instr.	22	2,516.
23	For assets shown above and placed in service during the current year, enter the portion of the basis attributable to section 263A costs	23	

816251 11-08-08 **LHA For Paperwork Reduction Act Notice, see separate instructions.** Form **4562** (2008)

13

Form 4562 (2008) **Guy & Mary Focal** 444-55-6666 Page **2**

Part V	Listed Property (Include automobiles, certain other vehicles, cellular telephones, certain computers, and property used for entertainment, recreation, or amusement.)

Note: *For any vehicle for which you are using the standard mileage rate or deducting lease expense, complete only 24a, 24b, columns (a) through (c) of Section A, all of Section B, and Section C if applicable.*

Section A - Depreciation and Other Information (Caution: *See the instructions for limits for passenger automobiles.***)**

24a Do you have evidence to support the business/investment use claimed? ☐ Yes ☐ No **24b** If "Yes," is the evidence written? ☐ Yes ☐ No

(a) Type of property (list vehicles first)	(b) Date placed in service	(c) Business/ investment use percentage	(d) Cost or other basis	(e) Basis for depreciation (business/investment use only)	(f) Recovery period	(g) Method/ Convention	(h) Depreciation deduction	(i) Elected section 179 cost
25 Special depreciation allowance for qualified listed property placed in service during the tax year and used more than 50% in a qualified business use						**25**		
26 Property used more than 50% in a qualified business use:								
	: :	%						
	: :	%						
	: :	%						
27 Property used 50% or less in a qualified business use:								
	010107	12.10 %				S/L -		
	: :	%				S/L -		
	: :	%				S/L -		
28 Add amounts in column (h), lines 25 through 27. Enter here and on line 21, page 1						**28**		
29 Add amounts in column (i), line 26. Enter here and on line 7, page 1							**29**	

Section B - Information on Use of Vehicles

Complete this section for vehicles used by a sole proprietor, partner, or other "more than 5% owner," or related person.
If you provided vehicles to your employees, first answer the questions in Section C to see if you meet an exception to completing this section for those vehicles.

	(a) Vehicle	(b) Vehicle	(c) Vehicle	(d) Vehicle 1	(e) Vehicle	(f) Vehicle
30 Total business/investment miles driven during the year (**do not** include commuting miles)				2,108		
31 Total commuting miles driven during the year						
32 Total other personal (noncommuting) miles driven				15,313		
33 Total miles driven during the year. Add lines 30 through 32				17,421		
34 Was the vehicle available for personal use during off-duty hours?	Yes No	Yes No	Yes No	Yes No	Yes No	Yes No
35 Was the vehicle used primarily by a more than 5% owner or related person?						
36 Is another vehicle available for personal use?						

Section C - Questions for Employers Who Provide Vehicles for Use by Their Employees

Answer these questions to determine if you meet an exception to completing Section B for vehicles used by employees who **are not** more than 5% owners or related persons.

	Yes	No
37 Do you maintain a written policy statement that prohibits all personal use of vehicles, including commuting, by your employees?		
38 Do you maintain a written policy statement that prohibits personal use of vehicles, except commuting, by your employees? See the instructions for vehicles used by corporate officers, directors, or 1% or more owners		
39 Do you treat all use of vehicles by employees as personal use?		
40 Do you provide more than five vehicles to your employees, obtain information from your employees about the use of the vehicles, and retain the information received?		
41 Do you meet the requirements concerning qualified automobile demonstration use?		

Note: *If your answer to 37, 38, 39, 40, or 41 is "Yes," do not complete Section B for the covered vehicles.*

Part VI	**Amortization**

(a) Description of costs	(b) Date amortization begins	(c) Amortizable amount	(d) Code section	(e) Amortization period or percentage	(f) Amortization for this year
42 Amortization of costs that begins during your 2008 tax year:					
Website Costs	070108	1,850.		36M	309.
43 Amortization of costs that began before your 2008 tax year				**43**	
44 **Total.** Add amounts in column (f). See the instructions for where to report				**44**	309.

816252 11-08-08 Form **4562** (2008)

Form **2106-EZ**	**Unreimbursed Employee Business Expenses**	OMB No. 1545-0074
		2008
Department of the Treasury Internal Revenue Service (99)	▶ **Attach to Form 1040 or Form 1040NR.**	Attachment Sequence No. **129A**

Your name	Occupation in which you incurred expenses	Social security number
Guy Focal	Staff Writer	444-55-6666

You May Use This Form Only if All of the Following Apply.

- You are an employee deducting ordinary and necessary expenses attributable to your job. An ordinary expense is one that is common and accepted in your field of trade, business, or profession. A necessary expense is one that is helpful and appropriate for your business. An expense does not have to be required to be considered necessary.
- You **do not** get reimbursed by your employer for any expenses (amounts your employer included in box 1 of your Form W-2 are not considered reimbursements for this purpose).
- If you are claiming vehicle expense, you are using the standard mileage rate for 2008.

Caution: *You can use the standard mileage rate for 2008* **only if: (a)** *you owned the vehicle and used the standard mileage rate for the first year you placed the vehicle in service,* **or (b)** *you leased the vehicle and used the standard mileage rate for the portion of the lease period after 1997.*

Part I	**Figure Your Expenses**		

1	Vehicle expense using the standard mileage rate. Complete Part II and then go to line 1a below.			
a	Multiply business miles driven **before** July 1, 2008, by 50.5¢ (.505)	**1a**		
b	Multiply business miles driven **after** June 30, 2008, by 58.5¢ (.585)	**1b**		
c	Add lines 1a and 1b ..		**1c**	
2	Parking fees, tolls, and transportation, including train, bus, etc., that **did not** involve overnight travel or commuting to and from work ..		**2**	287
3	Travel expense while away from home overnight, including lodging, airplane, car rental, etc. **Do not** include meals and entertainment ..		**3**	1,178
4	Business expenses not included on lines 1c through 3. **Do not** include meals and entertainment **Statement 7**		**4**	295
5	Meals and entertainment expenses: $ _____192._____ x 50% (.50). (Employees subject to Department of Transportation (DOT) hours of service limits: Multiply meal expenses incurred while away from home on business by 80% (.80) instead of 50%. For details, see instructions.)		**5**	96
6	**Total expenses.** Add lines 1c through 5. Enter here and on **Schedule A (Form 1040), line 21** (or on **Schedule A (Form 1040NR, line 9)**). (Armed Forces reservists, fee-basis state or local government officials, qualified performing artists, and individuals with disabilities: See the instructions for special rules on where to enter this amount.)		**6**	1,856

Part II	**Information on Your Vehicle.** Complete this part **only** if you are claiming vehicle expense on line 1.		

7 When did you place your vehicle in service for business use? (month, day, year) ▶ ___ / ___ / ___

8 Of the total number of miles you drove your vehicle during 2008, enter the number of miles you used your vehicle for:

a Business _____ **b** Commuting (see instructions) _____ **c** Other _____

9 Was your vehicle available for personal use during off-duty hours? ... ☐ Yes ☐ No

10 Do you (or your spouse) have another vehicle available for personal use? ... ☐ Yes ☐ No

11a Do you have evidence to support your deduction? ... ☐ Yes ☐ No

b If "Yes," is the evidence written? ... ☐ Yes ☐ No

LHA **For Paperwork Reduction Act Notice, see instructions.** Form **2106-EZ** (2008)

812011
11-11-08

Guy & Mary Focal 444-55-6666

Schedule A	Mortgage Interest and Points Reported on Form 1098	Statement 1

Description	Amount
From Form 8829 - Deductible home mortgage interest	5,515.
Total to Schedule A, line 10	5,515.

Schedule C	Other Income	Statement 2

Description	Amount
Stipend	350.
Total to Schedule C, line 6	350.

Schedule C	Other Costs of Goods Sold	Statement 3

Description	Amount
Illustrator	1,450.
Books Sold	1,307.
Total to Schedule C, line 39	2,757.

Schedule SE	Non-Farm Income	Statement 4

Description	Amount
Writer	3,443.
Total to Schedule SE, line 2	3,443.

Guy & Mary Focal 444-55-6666

Form 6251 Depreciation on Assets Placed in Service After 1986 Statement 5

Description	Amount
Computer/Technology Equipment	-230.
Electrical Upgrades	42.
Cable Modem	7.
Total to Form 6251, line 18	-181.

Form 4562 Part I - Business Income Statement 6

Income Type	Amount
Wages	90,640.
Schedule C	3,443.
Section 179 expense	1,249.
Total business income used in Form 4562, line 11	95,332.

Form 2106-EZ Other Business Expenses Statement 7

Staff Writer

Description	Amount
Conference Fees	195.
PEN Membership	100.
Total to Form 2106-EZ, Part I, line 4	295.

7.

Setting Up a Business Entity

I think of this as the "should I incorporate?" discussion because that invariably seems to be the opening volley on this topic. The artist will generally have talked to a colleague or family member who has them *they must incorporate immediately* for whatever purpose, most frequently for the extensive tax benefits offered. So let's look at the choices the artist has for setting up a business entity: Sole Proprietorship, Partnership, Corporation, Limited Liability Company.

The Sole Proprietorship

So far in this book I have focused on the sole proprietorship, which is how most artists operate. Until the artist sets up a formal entity, he or she is by default a sole proprietor. The sole proprietor simply means one owner (even though a husband-wife team can function as joint proprietors). You will be automatically set up as a sole proprietorship if you do nothing else. The main feature of this form is that it is identified and intertwined with you, which gives it both strengths and weaknesses. If the business makes a profit, it is automatically income for you. If the business incurs a debt, it is your personal debt. If the business gets sued, you will be sued personally as well. It gives you complete flexibility that enables you to instantly shift the direction, policies and focus of your company. But, if there is a problem, any damage can potentially extend into your personal life. To limit this potential liability you may choose to set up a "single-member" LLC (Limited Liability Company). The "single member" LLC customarily operates as a sole proprietor and might offer some liability protection (ask your attorney about this before moving forward).

The Partnership

When talking to clients I describe the partnership as a multi-person sole proprietorship because these two entities are taxed in a very similar manner. The sole proprietorship files its taxes as part of the owners Form 1040, whereas the partnership files its own separate income tax return (on

federal Form 1065) that reports the total income and expenses of the business. The partnership then passes the net, "bottom line" income or losses directly to the personal income tax returns of the partners via the federal Form K-1. This means that the partnership itself almost never pays any income tax directly, but passes the income or loss directly to the partners to be dealt with on their personal returns. You can see why partnerships are often referred to as "flow-through" entities, i.e. the income or loss "flows through" the partnership onto the partner's personal income tax return. The partnership does have the unique and critical tax advantage of "special allocations." Simply put, special allocations allow the partnership to customize the distribution of income and loss by mutual consent through he use of the partnership agreement. For instance, two partners may own the business 50%/50%, but choose to split any losses 75%/25% if that yields a better tax result for them. Partnerships can also, if properly structured, have tax advantages relating to film and sound recording activities.

Although easily formed on a handshake, a partnership is rarely as easy to dissolve. It pays to be very careful when forming a partnership. You will get to know all the good and the bad things about your partner. Bad partnerships can destroy friendships; and most importantly you are completely and personally liable for whatever your partner does (we are speaking here of the common general partnership; the exception to this is the limited partnership in which a limited partner has some liability protection). For instance, in a common general partnership, if our musician Sonny Phunky takes a partner and the partner signs him up to play a series of engagements with his band, and then skips town with all the money in the partnership bank account, not only will Sonny be out the money, he will also be liable for playing all the gigs.

Partnerships can certainly work when there is a clear division of responsibilities and abilities. If you are an actor, a musician, a visual artist, or a writer, but you lack management or promotional skills and your paperwork is usually a shambles, a potential partner who is a good agent, meticulous and detail oriented, but does not have your artistic abilities, may be natural match.

Partnerships are beneficial when you need to raise more capital. A partner's contribution may help to launch your business venture or project. Because of the sums of money involved, many major films are produced within the limited partnership (and Limited Liability Company or LLC) form of entity. In this case the partnership/LLC is a natural way to raise the money for a specific project like a movie, book or other artistic endeavor and

then split the profits from it. When the project is completed the partnership will typically dissolve.

If you do contemplate a partnership, have an attorney draw up a clearly defined partnership agreement. The agreement should address issues of operation and specify procedures for termination of one of the partners. What if one of the partners dies? Who will do what jobs within the operation of the partnership? How will decisions be made? What happens if you can't agree? Who will pay for what? Settle all these points in advance, before they have a chance to cause disruption in the business. Nothing kills a business faster than feuding partners.

The Corporation

The third form of business is the corporation. Incorporation gives two main advantages:

1. To raise money you can have people invest in your company.

2. Because a corporation exists legally as a separate entity, it provides a liability shield between you and your personal assets and the business. If the company gets sued, you have some (not ironclad) protection. Company debts are separate from your personal financial situation.

For tax purposes there are two main types of corporations, the subchapter "C" and the subchapter "S" (the letters refer to subchapters of the tax code). Both are corporations in the legal sense but the taxation of income and losses is handled differently.

The "C" Corporation is your standard. All companies listed on the stock exchange are "C" corporations. These corporations can have unlimited shareholders (investors). If a corporation sells 100,000 shares at $10 each, it has a million dollars in capital to work with. The investors can be individuals, mutual funds, companies, etc. "C" corporations pay income tax directly on their profits, which brings in the disadvantage to the "C" corporation: that of double taxation. For example, if your business earns $100,000 in profit, a corporate tax has to be paid first. Then if you draw a salary (for in a corporation you are in fact an employee), you must declare that salary and pay personal income tax. So, the same money gets taxed twice before you get to spend any of it. Recognizing that this was unfair to the small business, the "S" corporation was formed.

The "S" corporation is a "flow-through" entity, much as a partnership. Unlike the "C" corporation "S" Corporation will not pay income tax directly

on its profit. Its net income or loss is simply transferred onto the personal income tax returns of the shareholders via the federal Form K-1 (same as the partnership) and the shareholders will pay the income taxes on their share of the profits of the corporation. Be aware that the "S" corporation does not allow the "special allocations" of the partnership. If two shareholders own the corporation 50%/50%, the profits or losses have to be split 50%/50% too.

The standard "C" corporation files Federal form 1120 annually; the "S" corporation files Federal Form 1120S annually.

The Limited Liability Company

A newer form of business entity is the LLC, or Limited Liability Company. The Internal Revenue Service does not have an "LLC" tax form. Probably the most common form LLCs take for tax purposes is the form of a partnership, but they may also be "S" corporations and sole proprietorships. If you are considering setting up your business as a partnership, look long and hard at the LLC; it is generally preferable over the standard partnership. The LLC combines many of the features of a partnership with those of an "S" corporation, without the restrictions that applied to "S" corporations. It allows the reporting of income or loss directly on the personal income tax returns of the partners, (or "Members" in the parlance of an LLC), but provides some of the liability protection of a corporation. The LLC is also a "flow-through" entity that generally files the same federal income tax form as a partnership, Form 1065, and it does allow for the use of "special allocations" we discussed in the section on partnerships. As with a standard partnership you do need two individuals to set up an LLC, although a "single-person" LLC can be established for a sole proprietorship.

Which Entity Would the Artist Set Up, and When?

In essence artists have three choices of business entity: the sole proprietorship, partnership/LLC and corporation. First the artist decides whether he or she even needs to set up a separate business entity. Having decided, he or she must determine the type of entity to create. Deliberations should involve both an attorney and a tax professional. I would generally advise the artist to never set up a business entity without obtaining separate legal and financial/tax advice. Your attorney will explain the legal benefits of setting up a business entity as well as actually create the entity in the legal sense. Your accountant and tax advisor will clarify what new expenses, responsibilities and functions will be entailed in your new business entity. Commonly,

the attorney and tax professional will need to confer on behalf of their client because the legal and financial matters are interrelated.

What leads to considering the establishment of a business entity is that the artist has an issue or problem that cannot be solved any other way. Unless there is a clear need or reason to set up an entity, don't consider it. They are costly to set up and maintain unless they can serve a clear and identifiable purpose. Furthermore they complicate the operation of your business. Accounting and tax filings as well as the associated fees increase. With the help of an attorney and an accountant the artist needs to do a careful cost-benefit analysis, which will help him or her to decide whether it is worth setting up the business entity (a cost-benefit analysis helps you weigh the cost incurred vs. the benefit received). It might be that personal liability is the issue for the artist. A cost-benefit analysis may find that insurance is a more effective solution. An artist desiring to bring someone into the business might be better served by simply hiring an employee.

So, what are some of the situations or needs that might finally lead the artist to set up a separate business entity?

- Need for the liability protection provided by a corporation or LLC
- Need for more then one owner in the business
- To isolate some specific business venture or project, like a film, book, or musical
- To separate ownership and control of business operations
- To shift income to other family members, associates or friends to take advantage of those individual's lower income tax rates
- To raise capital for a specific venture or project by bringing in investors
- IRS audit concerns: for many years sole proprietorships have been and probably will continue to be #1 on the IRS audit hit list. Other formal business entities are less likely to be audit targets.
- Tax savings available in particular entities, such as potential payroll tax savings available in "S" corporations
- Working in a multi-state environment – corporations are probably the most portable and practical entity for artists working across state lines.

Taking our four artists, let's look at when and why an artist might choose to set up a separate business entity.

Example One

Actor Ima Starr is beginning to hit it big and make some serious money. She decides to set up a corporation for her acting business (sometimes referred to as "loan-out" corporations). With this setup the film companies would pay her corporation for her services and she would in turn be an employee of her own corporation. The benefits to Ima could be that (1) she is able to shift income to later tax years and allow her to delay payment of income taxes, (2) she might save payroll taxes (FICA taxes) by operating as an "S" corporation, (3) she may use the corporation to shift income to other members of her family or household (and into lower tax brackets). The corporation would help her limit her personal liability, and at the same time potentially lower her chances statistically of being audited, and it would isolate her business activity from the rest of her life. The IRS frequently zeros in on "loan out" corporations so they have to be structured with great care to sidestep the punitive personal holding company rules.

Ima is also considering an LLC to produce her own film, book or other project. The project would be produced inside the LLC; when the project was sold the LLC would distribute the profits to the investors/members and perhaps dissolve. If Ima already has the corporation, why would she set up a separate LLC for her film project? She would do this to isolate this one project from the rest of her business activities. From both a legal and financial point of view she would want to do this in order to avoid involving the individuals that are members of the LLC in her primary operations inside her corporation. Also since the LLC operates (for tax purposes) as a partnership, she may have some advantages in writing off the costs of the film.

Example Two

Musician Sonny Phunky needs some investor money in order to make a new recording with a big band. He could set up an LLC, much the way Ima did, to attract investors and isolate that activity, and later to channel the profits directly to the investors from the ultimate profits of the recording.

As we discussed in Chapter 4, Sonny's band, "The Over the Hill Gang," set up an LLC for a showcase US tour. The band subsequently had a song picked up as a theme for a hit cable TV show and had royalty income of over $100K. Having been discovered, a major tour is being planned and Sonny is worried about touring liabilities concerning his band and crew. His lawyer advises him that he could set up all the band members as "single member" LLCs and these in turn would be the members of the primary band LLC "The

Lido Shuffle." Income from the tour will be paid into the band LLC and the crew would be employees; band members would each be paid distributions directly to their own "single member" LLCs. This will help limit Sonny's personal liability in case of accidents and other unforeseen problems.

His tax advisor also discussed setting up a music equipment leasing company that would own all the equipment used by the band on the tour. Sonny's LLC would then lease (pay rent) to the leasing company for the use of the sound and lighting equipment. If the leasing company was an LLC it would give Sonny an additional layer of liability protection. The leasing company can be set up by Sonny and his attorney using a generic name. A generic name gives Sonny some privacy, in that people need not know that Sonny owns the leasing company. Such a move can be very tax efficient as it gives Sonny another means of receiving profits from the band's activities.

Should Sonny's songwriting continue to grow as it seems to be doing now, he is considering setting up a second LLC (or other business entity) to control his songwriting activities.

Example Three

Suppose our painter, Liz Brushstroke, befriends an individual who becomes her business manager and agent, and as such is a vital and essential part of her artistic activities. Liz decides to make this person a legal part of her business by setting up a corporation or LLC (either one would probably work, but the LLC would be more flexible and user friendly) and giving him or her a real equity stake in her artistic life. By making this individual a shareholder or member of her business Liz legally recognizes this person's importance in her business life and will be able, depending on how the entity is structured, to give him or her a share of the profits. Liz's advisors told her that she could simply hire her friend as an employee but Liz preferred setting up the business entity.

Liz has an investor interested in funding the publication of a limited edition book of her works, and for this her attorney and tax advisor both recommended an LLC. The LLC will be structured to receive cash from the investor. In turn, it will receive all the income for book sales, pay all the expenses of the publication, then distribute the net profits to Liz and the investor according to their LLC agreement. After all the books are sold, the final profits will be distributed, and the LLC would file a final income tax return and fold.

Example Four

Guy Focal has his first big year as a writer when one of his books is sold for a major film adaptation. He decides to incorporate his writing activities and sets up an "S" corporation. His agent or publisher will pay his royalties directly into the corporation from now on. The corporation will allow him to put some family members who are helping him with his correspondence and research on his payroll, thus diversifying his income into their lower tax brackets. The corporation will also give Guy some liability protection.

With knowledge gained from this recent film experience, Guy decides to try to adapt and make a film of another of his books. He finds some investors and sets up an LLC to act as a production company for the film project, because he does not want the investors to be a part of his "S" corporation. If the project doesn't succeed, the LLC investors/members will most likely be able to use the losses on their personal income tax returns. If it succeeds and sells, the income from the film will become income on the member's income taxes.

In closing

Some readers may wonder why I put this chapter nearer the end of the book. It may appear to them that this is the first matter we should discuss. Yet, at the beginning of their career very few artists would have any need to set up a formal business structure. Many successful artists never set up any formal business entity. At the early stage of an artist's career it would rarely be cost effective, and more importantly the direction and scope of the artist's ultimate activity would be insufficiently developed to make effective decisions regarding business structures.

By the way, most of what we have talked about in this book on rules relating to income and expenses still applies to any structure you may happen to operate in. While the mechanics may change, in general, the IRS view of taxable income and what it considers a justifiable expense does not alter much across the spectrum of different business entities.

Please keep in mind that we have barely scratched the surface on this very complex topic. You can see that this whole subject is a balancing act between financial, legal, estate and income tax concerns. Any decisions are subjective and relate directly to personal financial goals, so what works for the colleague you spoke to at a party may not work at all for you. Be *very* careful of anything that sounds like a boilerplate solution. I feel that most financial decisions are far more personal then many people realize, and business structure is very much in that camp. Make any decisions in this area after careful discussions of your personal desires, goals and concerns, which would include other strategic issues such as estate planning.

8.

The Audit Process, Recordkeeping, and Your Taxpayer Rights

An important fact to have firmly in mind as you approach your record keeping and documentation is that IRS audits generally occur 12 to 18 months *after* the end of the tax year being audited. You can very easily be in the position of having as IRS agent ask you detailed questions on a business meal, travel expense or other deduction that happened over two years ago!

Simple mistakes can cause a return to be questioned. These mistakes and oversights can include:

✓ Mathematical errors – Simple, you didn't add or subtract correctly!

✓ Income that was independently reported to the IRS and that its computers couldn't find on your tax return – These can be 1099s and W-2s that the IRS computer scans and cannot match on your return. Sometimes the IRS is correct, sometimes it is not.

✓ Social security number and name do not match – In the past several years the IRS has been matching the first three characters of all names against the individual's social security number using the Social Security Administration database. When there isn't a match between the name and social security number, you are sent a letter.

How is a return typically selected for audit? The IRS subjects all personal income tax returns to a computerized analysis based on a mathematical technique known as Discriminate Function (DIF), which identifies income tax returns with a high probability of error and a chance of significant

tax change. The DIF program evolved from a concern during the 1960s that too many "no change" audits were occurring, and that IRS audits should focus on returns likely to have errors. Under the DIF procedure, returns with high DIF scores or other special features are manually inspected to select some for audit. Thus, the DIF score acts as a red flag for IRS audits. The DIF formula is secret, known to only a very few senior IRS officials. Experience indicates that certain factors are likely to increase the DIF score and the possibility of an audit. Among these factors are high salaries or other compensation, high expenses relative to income, and the presence of certain types of deductions such as charitable contributions and medical expenses. DIF formula data is developed from a range of sources, including IRS audit experience. Unfortunately for many of the readers of this book, self-employed individuals are usually at the top of the IRS's "most audited" list.

Your business code can also subject you to audit. As you can see on our sample returns there is a box for an industry code on your schedule C (box B at the top of the form). This code identifies to the IRS the type of business you are in. Some IRS auditing is being done centering around this code rather than on the actual numbers on the return. In other words, the IRS in your district may be looking into "independent artists, writers & performers" code 711510, and your return could get chosen for a full-blown audit, regardless of your DIF score.

The DIF score is just the first stage of the potential audit process. Once the return is flagged, an IRS examiner will review it to see if he or she thinks it is worth auditing. This same IRS agent is generally the one who decides if your return will actually be audited. If the amounts "flagged" on your return just concern one or two line items, it may be subjected to a "desk audit," which causes you to get a letter asking for substantiation or detail on a particular line item on the return. This type of audit is all done via mail. The taxpayer sends in the supporting documentation, the agent reviews it, and if there are no further questions, the agent lets you know the result.

The second type of audit is of the live and in-person kind. Usually the IRS will ask you to come into their office bringing all your supporting documentation. In some instances, if the audit is big enough, they may choose to visit your place of business (virtually all LLC, Partnership or Corporate audits are "in person"). The audit notification will tell you in advance exactly what type of documentation is wanted and what line items on the return are being examined. The IRS does not allow the auditor to turn the audit into a fishing expedition.

The audit can be conducted with the taxpayer and/or with an authorized representative such as a CPA, Attorney or Enrolled Agent. The taxpayer may bring a professional with him or her.

Audits are usually straightforward affairs, starting with a detailed interview. The interview helps to develop a profile of you, your business and the manner in which you operate your business. You will also be asked questions about your finances as they relate to your tax return.

The audit process is fairly simple: The auditor points to a line on the tax return and asks for all the substantiating documents for that number. For instance, if you are self-employed the agent might ask you for copies of all your bank statements. The agent will add up all your bank deposits for the year and compare them to your total gross income on your Schedule C form. If your Schedule C form says that your gross income was $50,000 and you, in fact, deposited $75,000 in your bank accounts during the year you'd better be ready to do some explaining! Substantiation for expenses and deductions usually means actual receipts; the IRS does not as a rule accept canceled checks or credit card statements as receipts (though many auditors will in practice, especially when the taxpayer has noted the specifics of the expense on the memo section of the check or on the credit card receipt).

Let's take some examples of the more contentious and difficult areas and see how they might play out during an audit:

1. Meals and Entertainment expense – while we know that meals and entertainment are only 50% deductible, they are still a real audit target for the IRS. First the agent will want to see a list of all the meals for the year by amount. This list must equal the total amount for meals that has been put on the tax return and must include the "who, what and where" detail. You should bring your schedule book/diary with your notations for each meal to the audit so when the agent wants substantiation you can show him or her your entry and explain the reason for the deduction. If the situation was travel-related and you used the government per diem rates, the agent will ask you about the trip itself. If the trip is deductible, the meals are as well. The agent might ask to look at contracts for specific jobs to make sure that the producer or employer was not reimbursing for your meals expense.

2. Travel – the agent will want to know what the business purpose was. The less defined and flabbier your argument is, the more likely the agent is to disallow the deduction. Some play-acting on this

one might help. You may remember that actor Ima Starr and musician Sonny Phunky both did business trips to Los Angeles. Ima did her homework in advance and set up appointments, attended some auditions, and kept a good schedule and diary of events. Sonny just showed up in LA, hung out, talked to some folks, then came home. Against the advice of his accountant Sonny decided to deduct the full trip. His interview with the agent might go like this:

Agent – Sonny, what about this trip to LA?

Sonny – Yea, there is a great music scene out there and I wanted to check it out.

Agent – Can I see your schedule of the trip; did you plan the trip in advance?

Sonny – Well, I didn't have anything scheduled in advance. I just made some calls when I got there.

Agent – Did you have business activity everyday?

Sonny – Most days I did something, like I had lunch with Sam Smith; he owns a recording studio out there and I talked to him about getting studio work.

Agent – Do you have any evidence of this meeting, did you save his business card?

Sonny – I'm not sure if I still have it.

And Ima's interview might go this way:

Agent – Ima, what about this trip to LA?

Ima – I had recently worked on a film with Mel Fun and I made some connections in LA that I wanted to explore further.

Agent – Can I see your schedule of the trip?

Ima – Yes, I have outlined it on this calendar. Most of my appointments and lunch engagements were made in advance. I have business cards, copies of thank you letters I wrote to the participants and copies of their replies, if I received any.

Agent – Did you have business activity everyday?

Ima – Yes, I had a meeting and/or audition every day. I also spent some of the time in LA making phone calls, which I have recorded in my schedule as well.

Agent - Did you do anything after you called to follow up?

Ima – I had brought along some videos, my resume and a copy of my CD. These all had my website listed on them. If the phone call was positive, I dropped off my package right away and called back the next day to see if I could get an appointment before I left LA.

I think it is clear which trip the agent is likely to allow! Ima did her homework and focused on the trip in such a way that it would be difficult for the agent to disallow the deduction of her trip.

3. Mileage – The agent will want to see a listing of total mileage for business use for the year, which includes a line item for each trip, an estimate of miles driven, and a note on what the business purpose was. Though the IRS likes odometer readings it does not require them. It is my experience that a reasonable round trip estimate will usually suffice. It is the business purpose that is most important. Most items on your list will probably be straightforward, such as trips to your agent's office or to a gig or performance, but the agent might select a few to ask you about specifically. Obviously, the more business miles you write off, the more likely it is that the agent will question trips.

4. Research and Performance Audit – Much of what the IRS is looking for when its audits the artist is personal expense masquerading as business deductions. The agent will questions such things as:

 ✓ Writers buying books
 ✓ Actors & other show biz folks buying cable TV service & tickets to movies, plays and shows
 ✓ Musicians purchasing CDs and tickets to concerts
 ✓ Visual artists going to museums and galleries

If the agent has an issue with these allowable expenses, he or she might ask for a logbook or diary entry where you listed the exact business purpose of the particular item. A good example of deductible "research" might be when Ima Starr rented Mel Funn's movies in anticipation of performing in his movie, or when Sonny Phunky purchased some CDs and downloaded some tunes from iTunes to learn songs for his gig with the Butterball Kings.

Similarly, our writer Guy purchasing children's books that allow him to monitor his competition and Liz Brushstroke visiting galleries for the same reason. Keep in mind that the agent CAN ask for very specific documentation regarding, say, the rental of a DVD or the attendance to a play or museum, i.e., *specifically* what business purpose was served?

Unfortunately, what tends to happen in real life is that people simply take a percentage of these costs as "business." Such as the actor sitting with his or her accountant and saying something like, "My total cable bill was $545 and I'd say 40% was business." For an audit you may be able to prove something close to the chosen number, or the agent may feel that the amount appears reasonable and not even question it. The agent may in fact be thrilled that you did not get piggy and try to take the whole $545! But, beware—the agent can get real specific on these deductions and make your life miserable.

MSSP – The IRS Audit Training Manuals

It surprises many folks to learn that the IRS actually publishes its training manuals concerning audits, part of its "Market Segment Specialization Program." These manuals can be downloaded from our website – www.artstaxinfo.com, and are absolutely indispensable guides. Many industries are covered by the manuals but only three directly concern us.

1. Entertainment Industry

We learn that the IRS is fully cognizant that reimbursements are a common part of the industry. The guide talks at length about SAG, DGA and Equity and tells the agent how reimbursements are handled and what types of things are reimbursed. It instructs the agent to review all employment contracts, including those for product endorsements, to look for reimbursements and "perks" such as free products.

Another interesting audit target is the issue of the "tax home." In recent audits the IRS has been attempting to declare some folks in the entertainment industry "itinerant." If the IRS can declare you an itinerant, then all your travel and meals expenses are blown off the return. After all how can someone with no home deduct expenses for travel while away from home! IRS publication 463 explains the concept of "tax home" like this:

> If you do not have a regular or main place of business or work, use the following three factors to see if you have a tax home.
>
> 1. You perform part of your business in the area of your main home and use that home for lodging while doing business in the area.

2. You have living expenses at your main home that you duplicate because your business requires you to be away from that home.

3. You have not abandoned the area in which both your traditional place of lodging and your main home are located; you have a member or members of your family living at your main home; or you often use that home for lodging.

If you satisfy all three factors, your tax home is the home where you regularly live, and you may be able to deduct travel expenses. If you satisfy only two factors, you may have a tax home depending on all the facts and circumstances. If you satisfy only one factor, you are a transient; your tax home is wherever you work and you cannot deduct travel expenses.

The tax home issue can sneak up on you in an audit. While you are busy lining up your substantiation and getting worksheets for your expenses, the agent may be deciding to go for a bigger issue and eliminate the travel expense outright!

Because gift giving is so prevalent in the industry, the guide reminds the agent that business gifts are limited to $25 per person per year. On top of that you will still need a receipt and a diary entry describing the "why" of the gift.

Other deductions that the IRS is specifically targeting in its audit guide:

✓ Hairstyling

✓ Clothing and wardrobe, unless "period" clothing

✓ Laundry expense, unless used for deductible clothing

✓ Security, bodyguards, and limousines, except when needed for protection at public appearances

✓ Makeup, unless stage makeup unsuitable for any other use

✓ Physical fitness, except for the duration of employment requiring physical conditioning or if the actors' roles require the maintenance of body building and/or weight lifting skills

✓ Payments to business managers to the extent that the manager is engaged in personal bills & affairs

✓ Legal expenses if the claim is personal

✓ A coach, personal trainer or personal guru

✓ Toupees, false teeth, hearing aids, etc.

✓ Cosmetic surgery

2. Music Industry

This guide covers songwriters, publishers, managers, producers, music video production and musicians. The music industry guide has two of my favorite quotes in all IRS literature:

1. The performing artist is usually a very creative person as far as talent goes, but may lack knowledge in understanding bookkeeping, taxes and cash flow.

2. Musicians who have not reached an income level sufficient to hire business managers often have a poor record keeping system. This doesn't appear to be due to an intent to cheat or defraud the government; rather, it seems to be due to the taxpayer's basic lack of concern for these types of matters. These taxpayers are artists and are totally committed to their work and doing whatever it takes to become a success. Preparation of their yearly tax returns is an afterthought and the quality of the records they maintain to support their tax return often bears this out.

The manual is interesting in that it advises the agent not to get too carried away auditing musicians, because the agent can spend a great deal of time fixing "messy" books and then not come up with a deficiency (i.e., CASH!).

The music industry guide is concerned with many of the same items that we see in the entertainment guide, such as personal items being deducted as business expenses. The guide discusses the musical entertainer's argument that they must maintain a "look" for the benefit of their fans, and that it will be on this basis that the musician attempts to deduct a variety of clothing and other personal items. The guide warns that "while the taxpayer's argument is not totally without merit and can even sound reasonable," the agent should not allow the performer to deduct personal expenses.

A key focus for the auditor appears to be unreported income. The guide mentions that while royalties will be reported (Form 1099-MISC), the musician might well have freelance income from performing that will go unreported. The guide also acknowledges the prevalence of trades and trading in the music industry. The IRS considers trades are income too.

The guide tells the agent to review contracts to see if expenses were reimbursed. If the agent is auditing a "star" who paid all the expenses of the band and crew while on the road, it instructs the agent to selectively sample some returns from these folks, to see if they had double-dipped and taken travel expenses. The agent is informed that it may be necessary to cross check "related returns of taxpayers in the music industry due to the close working relationships between taxpayers in the industry."

3. Artist & Art Galleries

With this guide the IRS is mainly concerned with actual galleries and gallery owners more than with visual artists, but it does contain some items of interest. It tells the agent to be aware of the prevalence of trading between artists and gallery owners. The agent is told that the trades are often not even reported in the books of the gallery. Should the IRS audit a gallery that has unreported income from trades with artists, you can be sure that the next thing it is going to do is look at the artist's return to see whether the trade was reported there. In general, the guide warns the auditor to look out for unreported income. It mentions inventory as being an error prone item on the artist's return. The error arises because the visual artist does not correctly account for framing and supplies that are left unsold at year-end.

Audit Etiquette

Most IRS agents who I have dealt with are fair and reasonable people. This is not to say that you will not have arguments and subsequent appeals but many issues can be settled on the agent's level. Characteristically IRS agents are classic bureaucrats: they want to process your audit and get it off their desks as soon as possible. Usually that's how the taxpayer feels about the audit as well! Here are some pointers:

1. Be fully prepared with details on only the item the agent requested, and no more. Do not bring anything extra to the audit. Answer questions as simply and with as little embellishment as possible.

 In the long run you will benefit if you give detailed and complete information and are forthcoming in your answers. Approaching the audit this way will often keep the agent from delving deeper into the return. I liken IRS agents to thieves looking for a car with the keys still in the ignition. If you give the agent the feeling right off the bat that you have your act together and are fully prepared, it can have the effect of taking the agent off his or her guard.

 For instance, if one of the audit items is car mileage and you provide a neatly typed list outlining each trip, the miles driven, and the business purpose, the agent might not ask any specific questions, but simply take a copy of the list for his or her files. You would follow the same procedure for all the questioned items: have a list of each deduction, including amounts and description, to give the agent. Receipts should accompany each list. From a voluminous list, the agent might just pick a few receipts to audit.

2. An old canard suggests bringing in messy receipts and "letting them do the work." I don't agree with that. You should appear as neat and be as forthcoming as possible. Incidents have been reported of the agent being given less than complete records and receipts, but because the package was so neat and orderly, he or she assumed it was complete and didn't even review the package!

3. Never cop an attitude or try to "snow" the agent in any way! I know quite a few IRS agents and, believe me, they have seen and heard it all. Treat the experience as a task (however unpleasant) that has to be worked through. Treat the agent with respect and courtesy and make sure your tax professional does the same. Try to settle matters on the agent level. If you ultimately need to fight something, that's OK, just don't make it a first impulse.

4. **NEVER** go to any audit without a tax professional. As a tax professional I only have the taxpayer present if I feel the taxpayer is the best one to answer the larger questions relating to their business. A lot of responses to auditor questions do rely on some judicial "spin-doctoring" though. More play acting is in order here:

> *Agent – Ima, what about this meal with Joe the Plumber on October 15?*
>
> *Ima – Joe is casting a new film that has a part for a sultry lounge singer that I would be perfect for.*
>
> *Agent – So what did you do to try to get the part?*
>
> *Ima – I didn't want to directly discuss business during the lunch. I was just trying to get to know him a little and butter him up a bit. Right after the lunch I sent him a nice letter and copies of my resume, CD and a video of my singing with The Blue Jazzbos so he would know that I could sing as well as act. I also sent him a link to my website where he can view some video clips.*
>
> *Agent – So what happened?*
>
> *Ima – Unfortunately I did not get the part.*

This is how she should have responded:

> *Agent – Ima, what about this meal with Joe the Plumber on October 15?*
>
> *Ima – Joe is casting a new film that has a part for a sultry lounge singer that I would be perfect for.*
>
> *Agent – So what did you do to try to get the part?*
>
> *Ima – While we had lunch, I pitched him the idea of doing the part and gave him copies of my resume, CD and a video of my singing with The Blue Jazzbos so he would know that I could sing as well as act.*
>
> *Agent – So what happened?*
>
> *Ima – Unfortunately I didn't get the part.*

Don't forget, there has to be business transacted at some point during the meal or the IRS is going to disallow it. Whether Ima got the part does not matter; the deduction will stand or fall on its own merits. It doesn't really matter if there is a specific part she is going after, she can be taking Joe out to let him know she is available for consideration for any parts he may have.

Is it possible for an actor to be allowed a deduction for over-the-counter makeup, or the musician to be allowed a write-off for a business lunch where no business was transacted? Definitely yes! Could the visual artist get audited and not be questioned about ending inventory or the writer not have the IRS agent even ask about his travel deduction? Yes again! There is always a chance that the agent will not ask about a particular deduction. You might have an inexperienced agent who accepts your justification for a deduction as valid. Conversely, you may have an agent unfamiliar with your business as an artist who makes you justify and argue everything.

I don't necessarily try to "make friends" with the agent. At its core it is an adversarial relationship. A measure of cordial respectfulness is best.

Develop a strategy with your tax professional before you even meet with the agent and assess your weaknesses and strengths. By going to an audit with a strategy the process is less likely that will get out of control. Your tax professional may see from the outset the course the audit might follow. A writer with five years of continuous losses would want to be ready to deal with the "hobby loss" matter. A visual artist that had never listed an ending inventory would want to be ready to answer questions on that. A musician or film director with high travel and meals would want to be ready to address those questions.

Recordkeeping

We have discussed record keeping throughout the book without addressing how to actually do it. Our Website at www.artstaxinfo.com has some very handy and easy to use Microsoft® Excel® downloadable worksheets for simple organization of income and expenses throughout the year.

There are also many great computer programs for this purpose and I can recommend three that I like, and list the Websites where you can get some additional information on each one:

1. Quicken®– www.quicken.intuit.com

2. QuickBooks® – www.quickbooks.intuit.com (for those needing more advanced accounting features)

Once these programs are set up properly, they do a great job and are easy to operate; they will be an enormous help at year-end. Purchase an accordion files at an office supply store to keep your receipts in. Remember I have great free worksheets available on www.artstaxinfo.com as printable forms and Microsoft® Excel® downloadable worksheets. These spreadsheets are easy to customize and keep with you throughout the year to track your income and expenses.

Consider hiring a good bookkeeper if you are too busy in your professional life to do the record keeping. Bookkeeping help is relatively inexpensive and can save you a world of headaches.

Your Rights as a Taxpayer

Several years ago the IRS created a publication that explains your rights as a taxpayer. It includes an eight-part "Declaration of Taxpayer Rights," as well as a section on audits, appeals, collections and refunds. Here is the text of Publication 1:

DECLARATION OF TAXPAYER RIGHTS

I. PROTECTION OF YOUR RIGHTS

IRS employees will explain and protect your rights as a taxpayer throughout your contact with us.

II. PRIVACY AND CONFIDENTIALITY

The IRS will not disclose to anyone the information you give us, except as authorized by law. You have the right to know why we are asking

you for information, how we will use it, and what happens if you do not provide requested information.

III. PROFESSIONAL AND COURTEOUS SERVICE

If you believe that an IRS employee has not treated you in a professional, fair, and courteous manner, you should tell that employee's supervisor. If the supervisor's response is not satisfactory, you should write to the IRS director for your area or the center where you file your return.

IV. REPRESENTATION

You may either represent yourself or, with proper written authorization, have someone else represent you in your place. Your representative must be a person allowed to practice before the IRS, such as an attorney, certified public accountant, or enrolled agent. If you are in an interview and ask to consult such a person, then we must stop and reschedule the interview in most cases.

You can have someone accompany you at an interview. You may make sound recordings of any meetings with our examination, appeal, or collection personnel, provided you tell us in writing 10 days before the meeting.

V. PAYMENT OF ONLY THE CORRECT AMOUNT OF TAX

You are responsible for paying only the correct amount of tax due under the law--no more, no less. If you cannot pay all of your tax when it is due, you may be able to make monthly installment payments.

VI. HELP WITH UNRESOLVED TAX PROBLEMS

The Taxpayer Advocate Service can help you if you have tried unsuccessfully to resolve a problem with the IRS. Your local Taxpayer Advocate can offer you special help if you have a significant hardship as a result of a tax problem. For more information, call toll free 1-877-777-4778 (1-800-829-4059 for TTY/TDD) or write to the Taxpayer Advocate at the IRS office that last contacted you.

VII. APPEALS AND JUDICIAL REVIEW

If you disagree with us about the amount of your tax liability or certain collection actions, you have the right to ask the Appeals Office to review your case. You may ask a court to review your case.

VIII. RELIEF FROM CERTAIN PENALTIES AND INTEREST

The IRS will waive penalties when allowed by law if you can show you acted reasonably and in good faith or relied on the incorrect advice of an IRS employee. We will waive interest that is the result of certain errors or delays caused by an IRS employee.

EXAMINATIONS, APPEALS, COLLECTIONS, AND REFUNDS

EXAMINATIONS (AUDITS)

We accept most taxpayers' returns as valid. If we inquire about your return or select it for examination, it does not suggest that you are dishonest. The inquiry or examination may or may not result in more tax. We may close your case without change; or, you may receive a refund.

The process of selecting a return for examination usually begins in one of two ways. First, we use computer programs to identify returns that may have incorrect amounts. These programs may be based on information returns, such as Forms 1099 and W-2, on studies of past examinations, or on certain issues identified by compliance projects. Second, we use information from outside sources that indicates that a return may have incorrect amounts. These sources may include newspapers, public records, and individuals. If we determine that the information is accurate and reliable, we may use it to select a return for examination.

Publication 556, Examination of Returns, Appeal Rights, and Claims for Refund, explains the rules and procedures that we follow in examinations. The following sections give an overview of how we conduct examinations.

By Mail

We handle many examinations and inquiries by mail. We will send you a letter with either a request for more information or a reason why we believe a change to your return may be needed. You can respond by mail or you can request a personal interview with an examiner. If you mail us the requested information or provide an explanation, we may or may not agree with you, and we will explain the reasons for any changes. Please do not hesitate to write to us about anything you do not understand.

By Interview

If we notify you that we will conduct your examination through a personal interview, or you request such an interview, you have the right to ask that the examination take place at a reasonable time and place that is convenient for both you and the IRS. If our examiner proposes any changes to your return, he or she will explain the reasons for the changes. If you do not agree with these changes, you can meet with the examiner's supervisor.

Repeat Examinations

If we examined your return for the same items in either of the 2 previous years and proposed no change to your tax liability, please contact

us as soon as possible so we can see if we should discontinue the examination.

APPEALS

If you do not agree with the examiner's proposed changes, you can appeal them to the Appeals Office of IRS. Most differences can be settled without expensive and time-consuming court trials. Your appeal rights are explained in detail in both Publication 5. Your Appeal Rights and How To Prepare a Protest If You Don't Agree, and Publication 556, Examination of Returns, Appeal Rights, and Claims for Refund.

If you do not wish to use the Appeals Office or disagree with its findings, you may be able to take your case to the U.S. Tax Court, U.S. Court of Federal Claims, or the U.S. District Court where you live. If you take your case to court, the IRS will have the burden of proving certain facts if you kept adequate records to show your tax liability, cooperated with the IRS, and meet certain other conditions. If the court agrees with you on most issues in your case and finds that our position was largely unjustified, you may be able to recover some of your administrative and litigation costs. You will not be eligible to recover these costs unless you tried to resolve your case administratively; including going through the appeals system, and you gave us the information necessary to resolve the case.

COLLECTIONS

Publication 594, The IRS Collection Process, explains your rights and responsibilities regarding payment of federal taxes. It describes:

• What to do when you owe taxes. It describes what to do if you get a tax bill and what to do if you think your bill is wrong. It also covers making installment payments, delaying collection action, and submitting an offer in compromise.

• IRS collection actions. It covers liens, releasing a lien, levies, releasing a levy, seizures and sales, and release of property.

Your collection appeal rights are explained in detail in Publication 1660, Collection Appeal Rights.

Innocent Spouse Relief

Generally, both you and your spouse are responsible, jointly and individually, for paying the full amount of any tax, interest, or penalties due on your joint return. However, if you qualify for innocent spouse relief, you may not have to pay the tax, interest, and penalties related to your spouse (or former spouse). For information on innocent spouse relief and two other ways to get relief, see Publication 971, Innocent Spouse Relief, and Form 8857, Request for Innocent Spouse Relief (And Separation of Liability and Equitable Relief).

REFUNDS

You may file a claim for refund if you think you paid too much tax. You must generally file the claim within 3 years from the date you filed your original return or 2 years from the date you paid the tax, whichever is later. The law generally provides for interest on your refund if it is not paid within 45 days of the date you filed your return or claim for refund. Publication 556, Examination of Returns, Appeal Rights, and Claims for Refund, has more information on refunds.

If you were due a refund but you did not file a return, you must file within 3 years from the date the return was originally due to get that refund.

9.

Choosing a Tax Advisor

There are two main characteristics you look for in a tax professional. I call them the two "Cs":

1. Competence and

2. Communication.

The accountant/client relationship is a symbiotic association, where the accountant has the knowledge, and is able to communicate the information that the client needs to take full advantage of that knowledge.

There are two main designations for tax professionals that might affect your choice of one.

The first is the CPA (Certified Public Accountant). The CPA is an individual who has successfully completed the Uniform CPA Examination. This exam is a computer based exam given at various testing centers around the country, and consists of four sections: Auditing and Attestation, Regulation, Business Environment and Concepts, Financial Accounting and Reporting. The exam is not principally concerned with taxation; therefore the CPA designation, while important, does not necessarily guarantee competence in tax matters. The CPA is required to meet stringent standards of state licensing, ethics and educational requirements, and this should give the client some comfort that the CPA is honest and professional.

The second designation is that of the E.A. (Enrolled Agent), and is bestowed directly by the Internal Revenue Service. They explain it this way:

> An enrolled agent is a person who has earned the privilege of practicing, that is, representing taxpayers, before the Internal Revenue Service. Enrolled agents, like attorneys and certified public accountants (CPAs), are generally unrestricted as to which taxpayers they can represent, what types of tax matters they can handle, and which IRS offices they can practice before. In contrast, practice before the IRS is much more limited for other individuals such as unenrolled tax return preparers, family members, full time employees, partners, and corporate officers.

To become an Enrolled Agent the individual must take a grueling three-part test that centers on taxation. The Enrolled Agent, like the CPA, has ethical and educational requirements to uphold.

Only CPAs, Enrolled Agents and Attorneys are allowed to practice and fully represent clients before the IRS. In audit situations the difference in these designations can be significant as CPAs now have a limited attorney-client privilege that Enrolled Agents do not enjoy.

The best place to start your search for a tax professional is with a referral from a colleague. Ask who your friends are using and if they like that person, and why. You can also check with your state society of CPAs or with professional organizations such as Equity, SAG, ASCAP, ASJA, AFM, etc. They will often have referrals available. When you get the name of a few folks, decide who you want to talk to and make an appointment with each for a free consultation. I would not hire any professional if that person will not grant free consultation time. Try to interview several tax advisors before you decide.

You will probably ask first if the accountant has experience with and clients in your particular artistic endeavor. This is the most important question, and it will lead into a conversation that will let you know if this person "gets it." Feel free to ask for references. Bring along some specific questions about *your* return to ask; this allows you to really kick the tires. If you bring along a copy of your past year's return, you can ask the accountant to quickly review it and see if he or she has anything of interest to say about it. This is a great way to see if the accountant spots some missed deductions or comes up with some tax planning ideas.

I hate the question "What can you do for me?" and I'm sure I'm not alone. It's better to ask specific questions, such as:

- ✓ "Reviewing my returns from last year do you think I missed any deductions?"
- ✓ "Do my deductions from last year seem reasonable?"
- ✓ "Do you see any audit flags?"
- ✓ "Reviewing last year's return, do you have any ideas on how I could reduce my taxes this year?"
- ✓ "Do you consider tax planning a part of the preparation process?"
- ✓ "Are you available for questions during the year and do you charge extra for this service?"

✓ "Do you have a website?"

✓ "Do you have other clients that are in my profession and do you enjoy working with them?"

✓ "How do you bill, and when do you get paid?"

✓ "Approximately how much will it cost for you to prepare my tax return?"

✓ "I often have other states to file in. Are you familiar with tax returns from other states?"

✓ "How do you help clients that get audited?"

✓ "Have you ever read any of the IRS MSSP audit guides?"

✓ "Do you have checklists or other worksheets that will help me prepare my information for you?"

✓ "Will you be preparing my return personally?"

✓ "Do you make it a practice to sit with your clients and review the information before you prepare the return?"

✓ "How early should I make an appointment with you?"

✓ "How long does it usually take you to complete the return?"

✓ "Can I communicate with you directly via e-mail to make an appointment or to ask questions?"

When you finish an interview like this you will know if you have any rapport with the accountant (part of my second important "C" – communication). If you don't feel comfortable talking with your accountant, you won't be inclined to ask questions. When you do not ask questions, you will not get the best result on your tax return. It is through conversing with my clients that I have found we really ferret out all the deductions. Checklists are great but they only go so far.

A final reminder: Even thought you have someone else prepare your return, you are the person ultimately responsible for the information on it. There is a statement on your 1040 tax return printed over the place where you sign that reads: "Under penalties of perjury, I declare that I have examined this return, and accompanying schedules and statements, and to the best of my knowledge and belief they are true, correct and complete."

10.

Tax Planning

Due to the changing nature of tax law, I am not going to mention many specifics of tax planning. I will be posting weekly tax tips as well as annual tax brochures and our Online Advisor and other up-to-date information on the book's website www.artstaxinfo.com as well as our firm website www.cpa-services.com, so be sure to visit there before deciding on any of the strategies discussed here.

Tax planning should be a vital part of your work with your tax advisor and should accomplish two things:

1. Lower your tax liability
2. Remove any surprises from the tax liability you do have

By being proactive in developing tax strategies with your advisor, you will make changes in your business that will lower your tax liability. Your tax advisor will be able to estimate your liability so that you can plan your cash flow properly and not have any nasty surprises at year-end.

Tax planning has two main goals:

1. Delaying taxes
2. Lowering taxes

While most tax planning concerns delaying the payment of income taxes, there are some schemes that actually lower the tax you pay. Some strategies do both.

The very heart of this book has been essentially a tax planning exercise. By being aware of your income and expenses you find how to maximize your deductions and lower your taxes. When you understand your tax situation, you are much better prepared to strategize and be proactive with your finances.

Timing your Deductions

The basic technique in tax planning concerns the timing of deductions. I have touched on this throughout the book, as when I talked about purchasing equipment or moving deductions into the current year by spending money (or charging expenses) in December. This accelerates the expense into the current year. Now if the current year is a low-income year and you expect higher income next year, you may prefer not to do this. In that case it may be better for you to push the deduction forward into next year, and offset it against higher income and higher tax brackets. A decision such as this is an essential part of the important year-end meeting with your tax advisor. Work with your advisor to decide when major expenses should take place. You do need to have a good grasp of your finances and expected income first.

If the expense is the purchase of a computer, camera, musical instrument or some other asset you have the option of using the Section 179 election, an election that allows you to write off the purchase in a lump sum in one year rather than prorate the deduction over a number of years. This can be a tremendous late-in-the-year tax saving move, especially when you are surprised at year-end with more income than you were expecting. See our TaxQuikGuide on www.artstaxinfo.com for the latest rates and information.

I always enjoy questions that begin with "Should I buy..." Let's be clear, NEVER buy anything, anytime simply to save taxes. So I respond to the above questions, "Well do you need (whatever the expense or asset is)?" When I discuss spending money in December, I am talking about an expense or purchase that is definitely going to be made within the first two or three months of the next year. We are just considering whether to move it into the current year.

Artists tend to overlook what I call "cross-over" expenses. They must not forget personal assets that have been used in the production of income. Frequently expenses are not an "all or nothing" proposition. As we have already said, deductions such as Internet service, home office and cars are going to be allocated with some costs to your business and the balance to personal use. You will see this work out in our sample returns.

Certain expenses are deductible only to the extent they exceed set income "floors." You will recall that the Form 2106 used to deduct employee business expenses must exceed 2% of your adjusted gross income. For example, you will see on Guy Focal's 1040, on Schedule A, the trip to NYC

reported on his 2106 was not enough to rise above his "phase out" amount on line 27 of his Schedule A. If you find you are close to these income floors, try to bunch payment of as many expenses into one tax year as possible to secure your deduction.

Retirement Planning

You can set up a retirement plan if you are self-employed or have self-employment income such as royalties or other non-W-2 contract income. These plans allow you to start building a tax-deferred retirement fund and help to reduce current taxes in the process. Any funds you put into the plan are fully tax deductible for federal purposes (and sometimes for state purposes) and the earnings within the plan are not taxed until the money is taken out.

- **Simplified Employee Pensions (SEPs)** – The SEP is the most common retirement plan for self-employed individuals. The maximum deduction allowed contribution to a SEP is 20% of net earnings. Compensation for the self-employed individual is calculated as the net Schedule C income less the self-employment tax deduction from page one of the 1040.

- **Keogh/Profit Sharing Plans** – Keogh/Profit Sharing plans offer self-employed individuals an excellent way to set aside money for retirement. These plans must cover any eligible employees you may have. Contributions to the plan (within tax law limits) and any earnings on plan investments are not taxed until distributed from the plan. Keogh plans may be either defined contribution or defined benefit plans. Defined contribution plans provide for employer contributions to individual plan accounts for employees (and the self-employed owner). Defined benefit plans don't maintain individual accounts. Instead, the employer funds the plan based on projections of how much the plan will need to pay promised retirement benefits.

The above two retirement plans should be established by year-end, although tax-deductible contributions can be made anytime up until the return is timely filed (with extensions this can be delayed up to October 15 of the following year). Note: If you're close to retirement age, you may be able to build a retirement fund more quickly with a defined benefit than with a defined contribution plan.

- **401(k) Plans** - With a 401(k) plan, you contribute part of your pay to a plan account set up just for you thru your W-2. The maximum amount that you can contribute to your 401(k) in 2009 is $16,500 ($22,000 for workers over 50). These contribution limits are adjusted annually for inflation - see our TaxQuikGuide on www.artstaxinfo.com for the latest rates and information. You don't pay Federal or state taxes on the amount you contribute or on the investment earnings in your plan account until you withdraw funds from the plan, usually when you retire. If your employer matches any of your contribution, this is an added tax-deferred benefit. The IRS has recently allowed a newer type of 401(k) plan for sole proprietorships and small, family-owned corporations commonly called the "Solo" 401(k). This 401(k) follows essentially the same 401(k) rules discussed above and has become the plan of choice for many sole proprietors and closely held corporations.

- **SIMPLE Retirement Plans** - Self-employed individuals and small-business owners have a newer type of plan available to them. A "saving incentive match plan for employees" or "SIMPLE" retirement plan may be structured either as an Individual Retirement Account (IRA) for each employee or as a 401(K) salary deferral plan. Employers currently without a plan and employing one hundred or fewer employees earning at least $5K each in compensation during the previous year are eligible to adopt a SIMPLE retirement plan. In a SIMPLE Individual Retirement Account, employees (and self-employed persons) can elect to contribute up to $11,500 and an extra $2,500 for those over 50 in 2009 to the plan (adjusted annually for inflation - see our TaxQuikGuide on www.artstaxinfo.com for the latest rates and information). There is also an "employer match" of 3% of net compensation.

- **IRAs** are always an option if you already have a retirement plan available, but wish to put away some additional funds. You may contribute up to $5K annually in 2009 (with an extra $1K to those over 50 year of age) to an IRA account. The deductibility of your contribution is dependent on several factors: (1) your level of earned income (2) whether you or your spouse is eligible for an employer sponsored retirement plan and (3) your adjusted gross income. If you and your spouse are not eligible for an employer's sponsored or self-employment based plan your entire allowable IRA contribution

is deductible. If you and/or your spouse are able to participate in a plan, your deduction may be limited or eliminated altogether when your adjusted gross incomes exceed specific levels. Please check out the FAQ section of www.artstaxinfo.com for the latest phase out amounts concerning IRA deductions.

Many of you have no doubt read about ROTH IRAs. The Roth IRA is an IRA account to which individuals may make nondeductible IRA contributions. Distributions from Roth IRAs are generally federal and state tax free as long as they are made more than five tax years after the first tax year for which a contribution is made, and are made on or after the date on which the taxpayer turns 59 1/2.

This has been just a quick overview of some of the more common techniques and strategies employed in tax planning. You should always discuss any change with a qualified tax advisor who is familiar with your financial situation before making any decision. I would also caution you not to look at your work with your tax advisor as being a simple function of getting your tax return prepared at year-end. Make your work with him or her an ongoing process that balances planning and preparation.

11.

Tax Update –
2009 and Beyond

The velocity and frequency of annual tax changes has grown over the last few years, and this frantic pace appears it will continue. Many of the so called "Bush Tax Cuts" passed during the administration of President George W. Bush sunset at the end of 2010. This means that there will be more major tax bills during 2010 as Congress and President Obama are (essentially) forced to decide what the Federal tax code will look like moving forward into 2011. I have decided to include in this new addition some updates of the *general income tax changes* for 2009 & 2010 that are in effect as I write this.

Keep in mind that the bulk of this book is stable under virtually all tax codes; such things as the definition of income and what expenditures are deductable for the individual in the arts are unlikely to materially change. The structural treatment of self-employment income on Schedule C and employee business deductions as reported on Form 2106 has been in the code for decades, as have most aspects of the various tax entities (corporations, partnerships and LLC's). What changes in these cases is typically *how* the numbers are calculated.

The following list highlights some tax changes for 2009 and 2010:

Standard Business Mileage Rates – the Internal Revenue Service approved "per mile" deduction for business use of the automobile is 55 cents for 2009 and drops (!?!) to 50 cents in 2010 (if gas prices increase expect a mid-year change).

Per Diem Rates – The standard rate for meals in continental US (CONUS rates) are $39 in 2009 and $46 in 2010. High cost locals can run as high as $64 in 2009 and $71 in 2010. The standard per diem for lodging remains at

$70 for both years with higher amounts for listed "high-cost" locals. As always check with the General Services Administration (www.gsa.gov – click on "Per Diem Rates") for the latest information by state and city.

First Time Homebuyer's Credit - This tax credit is for 10 percent of the purchase price of a home (which must be your personal residence) up to a maximum credit of $8,000. An eligible taxpayer must buy, or enter into a binding contract to buy, a principal residence on or before April 30, 2010 and close on the home by June 30, 2010. For qualifying purchases in 2010, taxpayers have the option of claiming the credit on either their 2009 or 2010 return. To be eligible, you must not have owned a residence in the United States in the previous three years. The credit phases out between $150,000 and $170,000 of Adjusted Gross Income for joint filers, and $75,000 to $95,000 for single filers. The credit is refundable to the extent it exceeds your regular tax liability, which means that if it more than offsets your tax liability, you'll get a refund check. This credit has gone through various iterations since it entered the tax code in 2008 so check on the rules carefully depending on the date of the home purchase.

Existing Homeowner Credit - This credit equals 10 percent of the purchase price of a home, an eligible taxpayer must buy, or enter into a binding contract to buy, a principal residence on or before April 30, 2010 and close on the home by June 30, 2010. The maximum credit is $6,500 and is "refundable." Again, you would receive the amount of the credit, even if you have no tax liability. To qualify for this credit, you must have owned and used the same home as a primary residence for at least five consecutive years of the eight years immediately preceding the date of purchase. And the home you purchase must be your primary residence.

Payroll Tax Credit - For 2009 and 2010, Congress gave workers a credit of 6.2% of their earned income, capped at $400 for single filers and $800 for joint filers. For single filers, it starts phasing out at $75,000 of adjusted gross income and dries up at $95,000. The phaseout zone for couples is $150,000 to $190,000. Employees will get the credit in advance via lower income tax withholding in each paycheck, not as a rebate check.

Self-employed workers can reduce their quarterly estimated payments to get an advance benefit from the credit. The exact amount of the payroll tax credit for the year will be calculated on the filers' tax returns.

Sales Tax Deduction for New Vehicles - Buyers of new vehicles can deduct the sales tax paid on the purchase, even if they don't claim sales taxes as itemized deductions. They can add the tax they pay to their standard deduction. This break applies to new cars, motor homes, light trucks and motorcycles purchased after February 16, 2009 and before January 1, 2010. Sales tax paid on the first $49,500 of cost qualifies. The benefit begins phasing out for married couples with adjusted gross incomes over $250,000 and singles with AGI over $125,000, and is completely gone for single filers with AGI of $135,000 or more or joint filers with AGI of at least $260,000.

Itemizers who elect to deduct state sales taxes in lieu of state income taxes get no benefit from this change because the auto sales tax is already included in the sales tax deduction. Itemizers who deduct state income taxes will get a separate deduction for auto sales taxes; non-itemizers will add the sales tax amount to their standard deduction amount.

Indexed Tax Brackets - Thanks to higher inflation in the past year, the 10%, 15%, 25%, 28%, 33% and 35% tax brackets all kick in at approximately 5% higher levels of income than in 2008. As always click on the "TaxQuikGuide" @ www.cpa-services.com to get the latest tax rates.

Larger Personal Exemptions - For 2009, each personal exemption you can claim is worth $3,650, up by $150 from 2008. As always click on the "TaxQuikGuide" @ www.cpa-services.com to get the latest exemption amounts.

Higher Standard Deductions - For 2009, the standard deduction for married couples filing a joint return rises to $11,400, up by $500 from 2008. For single filers, the amount increases to $5,700 in 2009, up by $250 over 2008. And heads of household can claim $8,350 in 2009, a jump of $350 from 2008. Non-itemizers who pay real estate taxes can claim even larger standard deductions. Joint filers can add in up to $1,000 of property taxes paid. Singles can add in up to $500 of real estate tax payments. Non-itemizers can also add any casualty losses that occurred in presidentially declared disaster areas. As always click on the "TaxQuikGuide" @ www.cpa-services.com to get the latest standard deduction amounts.

Increased Section 179 Expense Deduction - The maximum amount of equipment placed in service in 2009 that businesses can expense stays at $250,000. And the annual investment limit remains $800,000. Thus, you

won't begin to lose the benefit of expensing until you place more than $800,000 of assets in service in 2009.

Tax Credit for College Tuition - For 2009 and 2010, the Hope credit is replaced by a new credit of up to $2,500 per student a year for four years of college, not just the first two years. It now also covers the cost of books and begins to phase out at $80,000 of adjusted gross income for single filers and $160,000 for joint filers. If the credit is more than your income tax liability, 40% of it is refundable. Also, the full credit is allowed against the alternative minimum tax.

Child Tax Credit - If the credit exceeds the filer's tax liability, all or part of the credit will be refunded if the filer earns more than $3,000 in 2009 and 2010, down from $12,550.

Higher Income Limits for Deductible IRAs and for Roth IRAs - If you are covered by a retirement plan at work, you can take a full IRA deduction in 2009 if your modified adjusted gross income is less than $89,000 (married filing jointly) or $55,000 (single or head of household).

A partial deduction is allowed until your adjusted gross income reaches $109,000 if you are married filing jointly or $75,000 if you are single or a head of household. Also, the opportunity to contribute to a Roth IRA is now phased out as your modified adjusted gross income rises between $166,000 and $176,000 if you are married filing jointly or $105,000 to $120,000 if you are single or a head of household.

Increased Contribution Limit for 401(k) Plans - The maximum employee contribution rises to $16,500 from $15,500 in 2009 for these and similar workplace retirement plans including 403(b)s and the Federal Thrift Savings Plan. Workers age 50 and older in 2009 can put in an additional $5,500 this year, also a $500 increase from 2007. Thus, their maximum contribution is $22,000.

Higher Annual Gift Tax Exemption - For 2009, you can give any individual up to $13,000 without owing any gift tax, a $1,000 increase over 2008.

Credit for Residential Energy-efficient Property - The credit for 30% of the cost of installing solar water heating equipment, solar electric equipment,

geothermal heat pumps or small wind turbines in your primary residence or a second home is no longer limited to $2,000 after 2008. But the credit for fuel cell property still cannot exceed $500 per half-kilowatt capacity.

Credit for Energy-saving Home Improvements - The old 10% tax credit of the cost of energy saving home improvements is increased to 30% for 2009 and 2010, up to a maximum of $1,500 in the two-year period. It applies to skylights, windows, outside doors, biomass fuel stoves and high-efficiency furnaces, water heaters and central air conditioners. In addition, the dollar limits on the particular type of improvement, such as a $200 cap on the credit for windows, are repealed.

Converting a Second Home to a Primary Home - If you convert a second home into a principal residence after 2008, you may not be able to exclude all of your gain. A portion of the gain on a subsequent sale of the home will be ineligible for the home-sale exclusion of up to $500,000, even if the seller meets the two-year ownership and use tests.

The portion of the profit that's subject to tax is based on the ratio of the time after 2008 when the house was a second home or a rental unit to the total time you owned it. So if you have owned a vacation home for 18 years and make it your main residence in 2011 for two years before selling it, only 10% of the gain (two years of non-qualified second home use divided by 20 years of total ownership) is taxed. The rest qualifies for the home-sale exclusion of up to $500,000.

Refundable Child Tax Credit - The $8,500 income threshold needed to qualify to claim the child tax credit if it exceeds your regular income tax bill decreases to $3,000 for 2009.

Partial Exclusion for Unemployment Benefits - For 2009, the first $2,400 of unemployment benefits you received is tax free.

As I stated at the beginning of this chapter this is where we stand at year end 2009 regarding major changes in federal tax code. As always please consult your tax advisor regarding ANY of these issues before moving forward as the tax code is a constantly shifting landscape these days. It is also important to consult a qualified tax advisor in regards to the specific tax laws in your resident state as state tax treatment is often different then federal.

To keep apprised of all the tax changes in 2010 please visit our website at **www.artstaxinfo.com** (our "TaxQuikGuide" always has the latest raw data on tax rates, deductions, exemptions, etc) or go directly to the source at **www.irs.gov.** As always, feel free to e-mail me directly at **contact@cpa-services.com** with any specific questions.

12.

In Closing

My goal in writing this book was to give you an understanding of the basic elements of your tax return, especially your professional income and deductions. It was never intended to be comprehensive and should not be taken that way. Federal and state taxation is complicated and very much subject to interpretation. Your personal circumstances, record keeping and organization can weigh in heavily on whether a particular expense is deductible or not.

In this new edition I have added representative tax returns for each of my four players. These returns will be updated each year on our website www.artstaxinfo.com so that you will be able to follow any changes year by year. There is also a wealth of tax help on both www.artstaxinfo.com and our firm website www.cpa-services.com. This information is updated constantly, so I hope you will avail yourself of this resource.

I hope that by reading this volume you walk away with enough of a feel for taxation that you will be ready to be proactive in organizing, planning and discussing your personal situation intelligently with your tax professional. I also hope that you will get your record keeping in order and be ready for an audit, should it come about. Above all, I hope you will NEVER forget any deductions and NEVER pay a dollar more in taxes than you have to!

While we have covered much ground, some things were beyond our scope, such as the very complicated subject of foreign earnings, which changes depending on the country involved. I have only slightly addressed the matter of state taxation; many states follow federal law closely, but not all.

Tax laws, of course, are affected by the whimsy of our government, and because of this most of the issues I have discussed in this book are subject to change. I have tried to keep to the general matters that are unlikely to alter a lot, but some things will invariably change. To help you keep current with

changes between updates of the book I will be posting information on the book's website, www.artstaxinfo.com.

Lastly, I welcome your comments and questions concerning the book. Let me know what you would change, or like to see added in subsequent editions. You may contact me through the book's website or directly via e-mail at peter@cpa-services.com. As my noble predecessor R. Brendan Hanlon said, I want to "keep this the best book of its kind on the market." With your help I think I can.

Appendix A:
Internet Resources

The Internet has become a tremendous source of information – these are some of the Websites I have found useful:

The first, of course, is the official Website of this very book – www.arts-taxinfo.com - there you can print and download various checklists, worksheets and links to the Websites listed below and get updates on all the latest tax changes that affect actors and other show biz folk.

Actors, Directors, Dancers and Other Show Biz Folk

www.backstage.com - Complete Online Performing Arts Website
www.magicmagazine.com - Independent Magazine for Magicians
www.playbill.com - Playbill Magazine Online
www.stage-directions.com - Stage Directions Magazine
www.stagebill.com - Stagebill
www.showbusinessweekly.com - Show Business Online
www.curtainup.com - The Internet Theatre Magazine of News and Reviews
www.dancemagazine.com - Dance Magazine
www.danceronline.com - Dancer Online
www.pointemagazine.com - Pointe Magazine, Ballet at its Best
www.allmovie.com - The great All Movie Guide on the Web
www.aftra.org - The American Federation of Television and Radio Artists
www.actorsequity.org - Actors' Equity Association
www.dga.org - Directors Guild of America
www.onstage.org - Onstage, The Performers Resource
www.sag.com - Screen Actors Guild
www.filmmag.com - Filmmaker Magazine
www.billboardtalentnet.com - Billboard Talent Net
www.ascap.org - American Society of Composers, Authors & Publishers
www.wga.org - Writers Guild of America
www.variety.com - Variety Magazine
www.backstagecasting.com - Backstage Magazine

www.bmi.com - Broadcast Music, Inc.

www.vcu.edu/artweb/playwriting - The Dramatists Guild

www.macnyc.com - Manhattan Association of Cabarets & Clubs

www.hollywoodreporter.com - The Hollywood Reporter

www.hcdonline.com - Hollywood Creative Directory

www.ifp.org - Independent Feature Project

www.emmyonline.org - National Academy of Television Arts & Sciences

www.mpaa.org - Motion Picture Association of America

www.oscars.org - Academy of Motion Picture Arts & Sciences

www.afionline.org - The American Film Institute

www.performingbiz.com –The Musician's and Performing Artists' Guide to Successful Touring.

www.theatrebooks.com - TheatreBooks Online.

www.womensproject.org - Women's Project. Resource for women in theater.

www.dmoz.org/Arts/Performing_Arts/Organizations/ - Open Directory Project.

www.refdeck.com - The single best source of facts on the Internet

www.lcweb.loc.gov/copyright - The US Government Copyright Office

www.taxresources.com/ - The Internets best single source of tax related links

www.irs.gov - The Internal Revenue Service

www.info.gov - FCIC National Contact Center - Portal to US Government information

www.switchboard.com/ - Find people, get directions, etc.

Musicians & Singers

www.billboard-online.com - Billboard Magazine

www.recordingmag.com - Music Maker Publications online

www.professional-sound.com - Professional Sound Magazine online

www.livesoundint.com - Live Sound International

www.tourdates.com - Tourdates.com

www.riaa.com - Recording Industry Association of America

www.billboardtalentnet.com - Billboards Talent Net

www.bmi.com - Broadcast Music, Inc.

www.aes.org - Audio Engineering Society

www.afm.org - American Federation of Musicians

www.cmj.com/ - CMJ New Music Report Website

www.americansongwriter.com/ - American Songwriter Magazine
www.csusa.org - Copyright Society of USA
www.songnet.com/nmbd - Music Business Directory
www.musicindie.org - Association for Independent Music
www.mpa.org - Music Publishers Association
www.songwritersguild.com - The Songwriters Guild
www.nmpa.org - National Music Publishers Association
www.filmscoremonthly.com - Film Score Monthly
www.filmmusicmag.com - Film Music Magazine
www.taximusic.com – Taxi Music, Independent A&R Company
www.ascap.org - American Society of Composers, Authors & Publishers
www.performingbiz.com - The Musician's and Performing Artists' Guide to
		Successful Touring
www.recordlabelresource.com – Record Label Resource. Start independent
		record labels.
www.mbsolutions.com - Music Business Solutions
www.musicianscontact.com - Musicians Contact Service. Paying gigs for
		musicians.
www.jpfolks.com - Just Plain Folks. Music community networking
		resource.
www.musicdish.com - MusicDish. E-journal of the online/digital music
		industry.
www.allmusic.com - The All Music Guide on the Web
www.pollstar.com - The Concert Hotwire - touring info on the Web
www.ubl.com - the Ultimate Band List on the Web
www.taxresources.com - The Internets best single source of tax related links
www.irs.gov - The Internal Revenue Service
www.info.gov - FCIC National Contact Center - Portal to US Government
		information
www.switchboard.com - Find people
www.refdesk.com - The best single source of information on the Internet
www.lcweb.loc.gov/copyright - The US Government Copyright Office

Visual Artists

www.wwar.com - Worldwide Arts Resources
www.nyfa.org - New York Foundation for the Arts
www.passion4art.com - Passion4art Website
www.artaccess.com - Art Access Website

www.artmarketing.com - ArtNetwork

www.art.net - Art on the Net

www.ilpi.com/artsource - ArtSource Website

www.tfaoi.com/newsmus.htm - Resource Library Magazine listing of art museums

www.galleryguide.org - The official Gallery Guide website

www.absolutearts.com - Home of "absolutearts.com"

www.artnewsonline.com - ARTnews Magazine

www.artchive.com - The Artchive

www.artcalendar.com - Art Calendar Magazine – Business Magazine for Visual Artists

www.artmuseumnetwork.com - The Museums Website

www.icom.org/vlmp - The Virtual Library Museums Page

www.photomarketing.com - Photo Marketing Association International

www.photoinsider.com - Photo Insider Magazine

www.gag.org - Graphics Artist Guild

www.artbusinessnews.com – Art Business News

www.artbusiness.com – ArtBusiness.Com

http://arts-careers.com - The Business of Art

http://art-support.com - Art Support.

http://bx.businessweek.com/street-painting-art-business - The business of street painting

www.istockphoto.com - Buy & sell stock photography – free membership

www.danheller.com/bizfaq.html - Info on the business of photography

www.kenrockwell.com - Independent reviews of photographic equipment, articles, tips & teaching

www.taxresources.com - The Internets best single source of tax related links

www.irs.gov - The Internal Revenue Service

www.info.gov - FCIC National Contact Center - Portal to US Government information

www.switchboard.com - Find people

www.refdesk.com - The single best source of information on the Internet

www.lcweb.loc.gov/copyright - The US Government Copyright Office

Writers

www.scriptfly.com - Great sources and links, particularly for screenwriters

www.nwu.org - National Writers Union

www.publaw.com - Publishing Law Center

www.writerstoolbox.com - The Writers Toolbox
www.poewar.com - The Writer's Resource Center
www.ascap.com - The American Society of Composers, Authors and
 Publishers
www.wga.org - Writers Guild of America
www.writerswrite.com - The Writers Write Resource
www.bookweb.org - The American Booksellers Association
www.asja.org - The American Society of Journalists and Authors
www.authorsandpublishers.org - The National Association of Authors and
 Publishers
www.authorsguild.org - The Authors Guild
www.webcom.com/registry - The Authors Registry
www.the-efa.org- The Editorial Freelancers Association
www.bookwire.com – BookWire. Book industry resource.
www.nationalwriters.com - The National Writers Association
www.pen.org - PEN's official Website
www.writersdigest.com - Writers Digest
www.spawn.org - The Small Publishers, Artists and Writers Network
www.spj.org - The Society of Professional Journalists
www.forwriters.com – Forwriters.com. Huge collection of links for writers.
www.right-writing.com – Right-Writing. Compiled by agent/editor/writer
 W. T. Whalen.
www.nwp.org -- National Writing Project
www.smart-writers.com – Smart Writers.com
www.pw.org -- Poets & Writers. Contests, grants, awards, job listings, etc.
www.iamtw.org -- The International Association of Media Tie-in Writers.
 For writers using pre-existing movie, TV, book, game & cartoon
 characters.
www.refdeck.com - The Single Best Source of Facts on the Internet
www.lcweb.loc.gov/copyright - The US Government Copyright Office
www.taxresources.com/ - The Internet's best single source of tax related
 links
www.irs.gov - The Internal Revenue Service
www.info.gov - FCIC National Contact Center - Portal to US Government
 information
www.switchboard.com/ - Find people

Appendix B:
IRS Publications and
other Resources

These are some of the publications that are available free from IRS. You can call the IRS and order them or download them directly from the IRS Website – www.irs.gov

- Publication 334 Tax Guide for Small Business
- Publication 17 Your Federal Income Tax Guide
- Publication 463 Travel, Entertainment, Gift, and Car Expenses
- Publication 525 Taxable and Nontaxable Income
- Publication 529 Miscellaneous Deductions
- Publication 547 Casualties, Disasters, and Thefts
- Publication 587 Business Use of Your Home
- Publication 936 Home Mortgage Interest Deduction
- Publication 946 How To Depreciate Property
- Publication 535 Business Expenses
- Publication 1542 Per Diem Rates
- Publication 917 Business Use of Your Car
- Publication 526 Charitable Contributions
- Publication 556 Examination of Returns, Appeal Rights and Refund Claims
- Publication 501 Exemptions and Standard Deductions
- Publication 910 Guide to Free Tax Services
- Publication 521 Moving Expenses
- Publication 560 Self-employed Retirement Plans
- Publication 533 Self-employment Tax

- Publication 54 Guide to US Citizens and Resident Aliens Abroad
- Publication 505 Tax Withholding and Estimated Tax
- Publication 929 Tax Rules for Children and Dependents
- Publication 514 Foreign Tax Credit for Individuals
- Publication 530 Tax Information for First Time Home Owners
- Publication 552 Recordkeeping for Individuals
- Publication 531 Reporting Tip Income
- Publication 593 Tax Highlights for US Citizens and Residents Going Abroad
- Publication 970 Tax Benefits for Higher Education

Other books you may wish to look at:

- *J.K. Lasser's* ™ *"Your Income Tax"* published annually by John Wiley & Sons, Inc. In my opinion the best overall, single income tax guide available.

- *What the IRS Doesn't Want You to Know* by Martin Kaplan, CPA published by Wiley Books. A great common sense book giving insight into the operations and quirks of the IRS. Essential reading if you are audited!

- *Tax Deductions A to Z for Writers, Artists, and Performers* by Anne Skalka, Certified Public Accountant published by Boxed Books. Great, easy to use and super comprehensive listing of tax deductions for artists.

- *422 Tax Deductions for Businesses & Self-Employed Individuals* by Bernard B. Kamoroff, CPA, published by Bell Springs Publishing. Mr. Kamoroff is the first person that I have run across who attempts an alphabetical encyclopedia of tax deductions. Excellent and amazingly easy to read. Mr. Kamoroff is also the author of the excellent *Small Time Business Operator, 10th Edition: How to Start Your Own Business, Keep Your Books, Pay Your Taxes & Stay Out of Trouble*

- *Taxation of the Entertainment Industry* by Schuyler M. Moore, Esq., published by CCH. The most comprehensive and professional book on the market.

- *U.S. Master Tax Guide* published by CCH Inc. This is the bible of the tax preparation industry, published annually and used by tax professionals the world over. CCH also publishes the excellent *State Tax Guide* annually, which is a superb quick reference to taxation state by state. These are beyond the needs of most laymen but may serve as an excellent reference to have on your shelf.